SHARING
THE WISDOM OF TIME

BY POPE FRANCIS AND FRIENDS

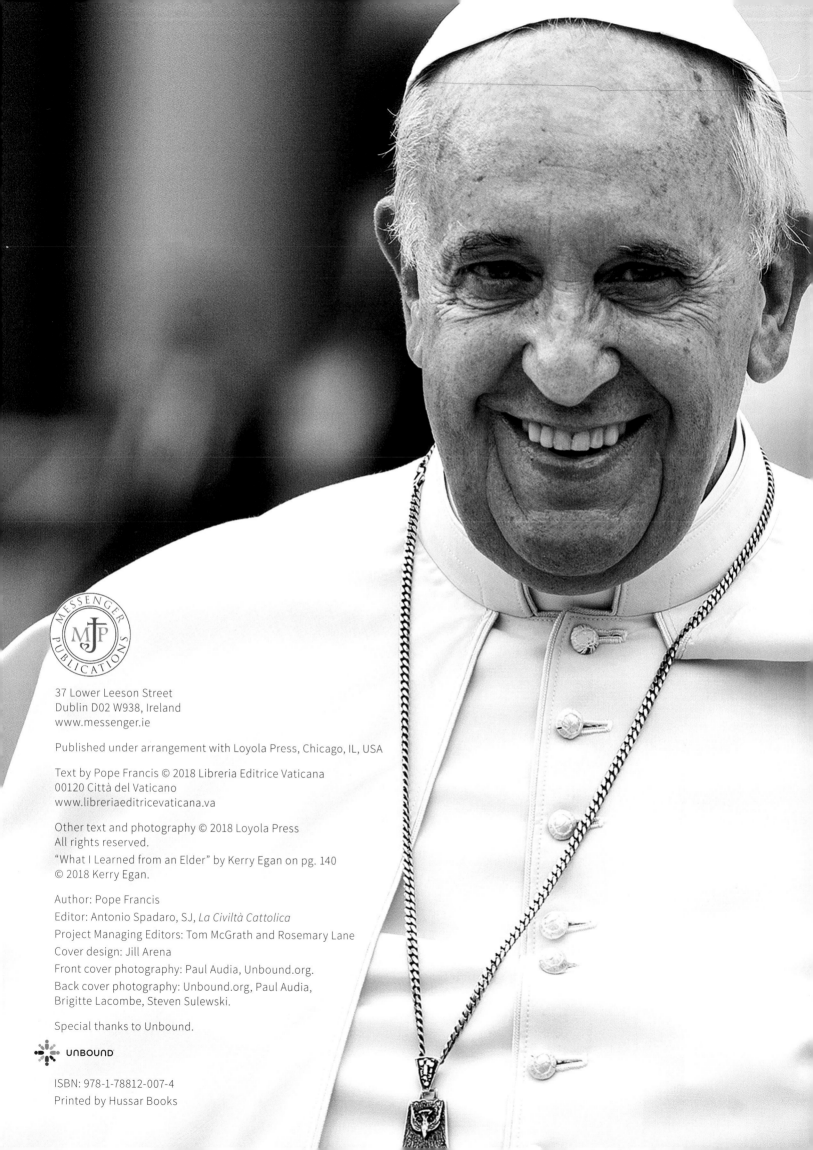

MESSENGER MJP PUBLICATIONS

37 Lower Leeson Street
Dublin D02 W938, Ireland
www.messenger.ie

Published under arrangement with Loyola Press, Chicago, IL, USA

Author: Pope Francis
Editor: Antonio Spadaro, SJ, *La Civiltà Cattolica*
Project Managing Editors: Tom McGrath and Rosemary Lane
Cover design: Jill Arena
Front cover photography: Paul Audia, Unbound.org.
Back cover photography: Unbound.org, Paul Audia,
Brigitte Lacombe, Steven Sulewski.

Special thanks to Unbound.

UNBOUND

ISBN: 978-1-78812-007-4
Printed by Hussar Books

"The elderly have wisdom. They are entrusted with a great responsibility: to transmit their life experience, their family history, the history of a community, of a people."

—Pope Francis, December 12, 2017

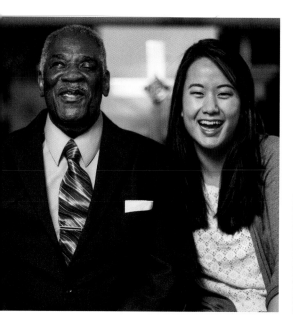

EDITORS' NOTE

This book began in prayer and grew as a labor of love. In 2016, during one of his daily prayer sessions, Pope Francis received an inspiration: to shine a light on the vital role of grandparents and other elders. He began to preach frequently about the world's need to pay close attention to our elders and heed their wisdom. He also wanted a book that would highlight the voices of those who have lived the longest, affirming that they have valuable, life-changing wisdom to share.

Based on the successful collaboration on *Dear Pope Francis,* the *New York Times* best seller in which the Pope responded to children's questions with wise and gentle humor, Pope Francis asked for Loyola Press's help on another book. This project would shift the attention to the grandparents, mothers, fathers, widows, widowers, and single individuals who have known decades of joy and sorrow, loss and change. Pope Francis views elders as reservoirs of wisdom and historical memory and believes their insights will offer future generations much-needed understanding and direction.

Loyola Press eagerly accepted the Pope's request. We soon realized how complicated it would be to gather suitable stories from around the world. Elders, after all, don't meet in schools every day as children do. In fact, the eldest in society are often in the background, invisible, silent. We needed help—so we reached out. We were greatly aided in that quest by many individuals (acknowledged on page 174), but two groups warrant special mention because of what they added to the project.

Ten Jesuit publishers answered our call and helped us locate wise elders in the countries in which they publish. They interviewed contributors and translated and edited their stories, many of which appear in this book. We also partnered with Unbound (unbound.org), a nonprofit sponsorship organization that serves more than 300,000 elders and children in 18 countries around the world. They generously brought to the project a network of authentic, respectful relationships with elders and a corps of professional social workers, writers, photographers, translators, and editors who gathered stories of great honesty and vulnerability from people we would otherwise never have been able to reach.

In July 2017, Loyola Press sent a collection of stories to the Vatican. We selected stories that encompassed universal themes—recollections of love, loss, survival, hope, peace in the face of unimaginable tragedy, and above all, faith. Pope Francis received every story, prayed over

 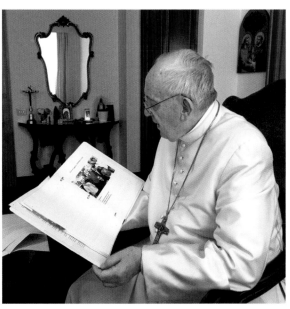

them, and, over the course of three meetings with Fr. Antonio Spadaro, SJ, responded with sensitivity and grace to 31 of the stories and the issues they raise. Pope Francis played three roles in this book. In his Preface, he lays out the reasons that prompt his desire for this collection of wisdom stories and the movement he hopes it inspires. He also contributes as a fellow elder, offering a story from his own life at the start of each chapter to illustrate wisdom he's gained on each of the five themes of the book. And in his own wise and compassionate way, he serves as a spiritual shepherd, commenting on dozens of heartfelt stories.

Because Pope Francis has been eager to foster communication between the generations, the voices of the young are also represented in this book. We've included a feature, "What I Learned from an Elder," in which a young person shares a valuable lesson learned from a grandparent, former teacher, or dear friend.

Everyone involved in the editing and production of this book has taken great care to preserve the words and intent of the people who shared their stories. We also honored how they wanted to be identified or described. In some cases, names were changed and alternate photos were used to respect an elder's privacy. We understood what a gift and act of trust it was for elders to share the most difficult, intimate, and loving moments of their lives, and we have sought to capture them faithfully.

Over a year and a half, we interviewed more than 250 people. Not all stories could fit into the book, but no effort was wasted. Every single contribution helped shape this book, which is Pope Francis's gift of appreciation to all the elders of the world and to younger generations whose lives their wisdom may inspire.

Given the nature of this project, it seems appropriate that the making of *Sharing the Wisdom of Time* was led by a veteran journalist approaching the end of his career and a young journalist bringing her fresh ideas and the perspective of someone who came of age in a digital world. The conversations between us have been honest, robust, and enlightening, and we trust that our shared vision has brought depth and richness to the project. We hope you will be as moved as we were by the people you are about to meet.

—Rosemary Lane and Tom McGrath

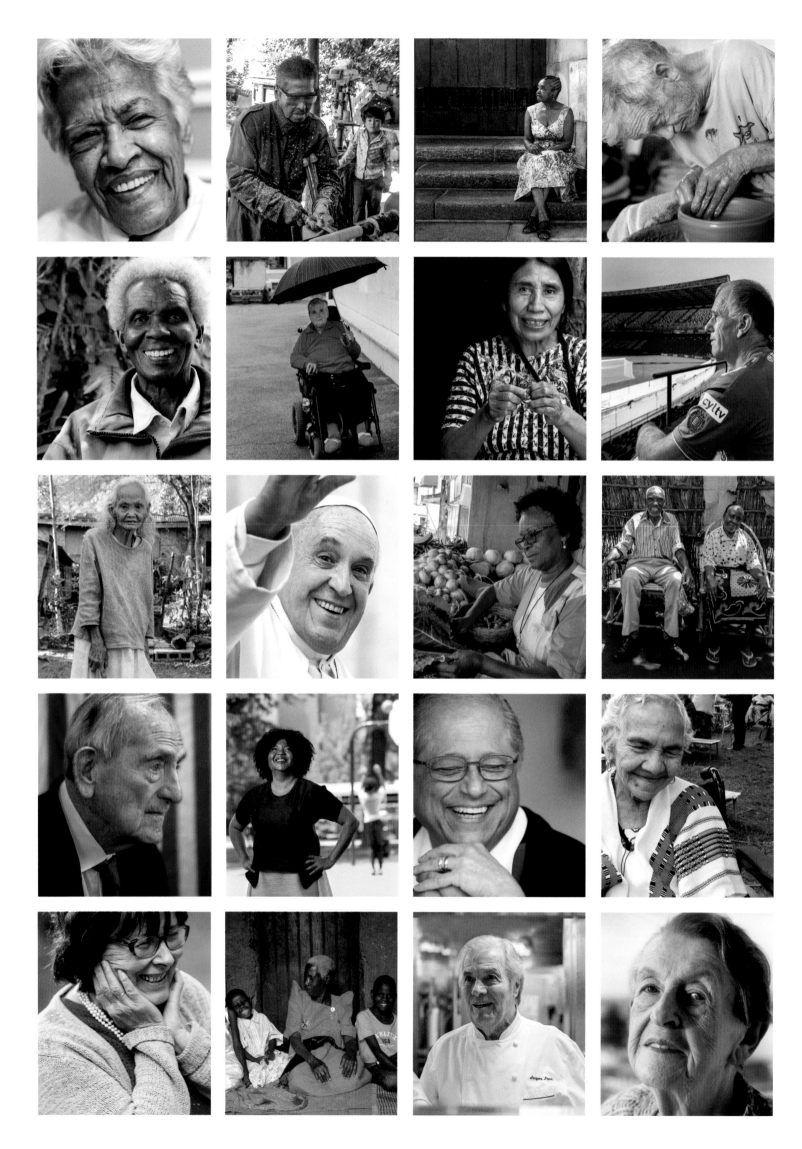

contents

Fr. Antonio Spadaro, SJ, with Alessio Gulino, 11, whose interview with his grandfather appears on page 146.

INTRODUCTION

I arrive at Santa Marta at 4:45 p.m. on July 28, 2017. As soon as I enter, Pope Francis asks me if I want water or fruit juice. He points to a small refrigerator for me to serve myself. I take some water and, while filling the glass, I see a lit candle on the front side of the cupboard. It is a votive candle of St. John XXIII. It stands next to a statue of Our Lady of Luján that I know well. On entering, I had noticed a statue of a sleeping St. Joseph, under which Pope Francis puts letters or notes about difficult questions. The letters are now a pile, a tall column that the statue holds in place.

I present the draft of this book to the Pope and speak to him about the stories gathered from all over the world. I tell him about the many people who have worked on the project, and I explain the five themes around which we have collected stories. I continue the explanations and get lost among the pages, but Francis tells me immediately: "I saw the titles. There are concrete things I want to say. And I will say them as a tribute to some elders I know. Let's get started!"

July 29, 2017, 4:45 p.m. Back at Santa Marta, we resume the work where we left off. The sense of listening to human experiences summarized in a few lines puts us in an attitude of great reverence but also great familiarity. Francis, responding as if he were speaking to the elders directly, focuses his eyes on the story of each person. He holds their photos, and his gaze settles on their faces and hands, which are like passwords that reveal their hearts and their passage of years. He recalls powerful memories of his own grandparents, his grandmother Rosa in particular. "She had experienced the sudden loss of those she loved so many times, but she always held her head high," he says. "She said a few simple, wise things. She was not one to offer too much advice, but you could see that she was always thinking and praying a lot." It is this "big-picture perspective" that Francis looks for in the elderly. We spend two hours together. Then the Pope tells me that he would like to have time to pray before dinner.

July 30, 2017, 4:45 p.m. I arrive at Santa Marta, where Pope Francis is on the phone. He smiles and gestures for me to enter. We dedicate two more hours to our project. Then he hands me a preface that summarizes his thoughts on the link between the young and old. He adds a personal comment: he never imagined he would feel like a "grandfather" to the Church when he became Pope. Stepping into that role meant growing in human and spiritual awareness.

At the end, I ask the Pope if he is happy with the work we have done, with these hours spent together talking about the experiences of so many people. He tells me that he seems to have said very simple, ordinary things. I answer that that is true, but it is those simple things that can touch the soul. He answers me with a sunny look: "I feel at peace."

Antonio Spadaro, SJ
Editor in Chief of La Civiltà Cattolica

"Pope Francis's gaze settles on their faces and hands, which are like passwords that reveal their hearts and their passage of years."

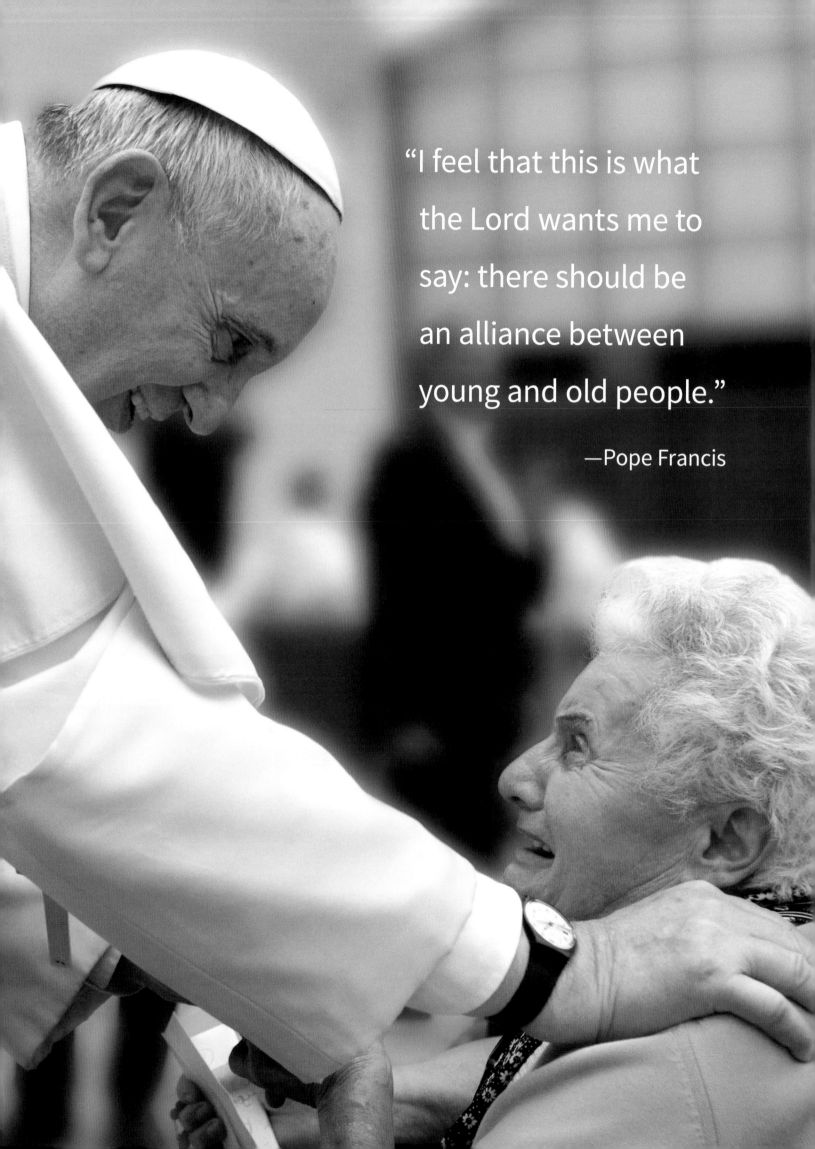

"I feel that this is what the Lord wants me to say: there should be an alliance between young and old people."

—Pope Francis

Sharing Wisdom: The Beginning of a New Alliance

I have a very wonderful memory of when I visited the Philippines. People greeted me by chanting, *"Lolo Kiko!"* which means "Grandpa Francesco"! *Lolo Kiko,* they were yelling! I was really happy to see that they felt so close to me—like a grandfather.

Our society has silenced the voices of grandparents. We pushed them out of the way. We didn't give them the chance to share their experiences, to tell their stories, and to speak about their lives. We put them aside, and so we have lost the treasure of their wisdom. We want to avoid our own fear of weakness and vulnerability; but in doing so, we increase the suffering of our older people who don't feel our support and come to feel abandoned. Instead, we ought to reawaken a respectful sense of gratitude, appreciation, and hospitality that can make the elders among us feel that they truly belong to the community. When we marginalize our grandparents, we lose the chance to learn their secret, the secret that has allowed them to navigate their way through the adventure of life. And so, we lack role models and the benefits of their lived experiences. We get lost. We miss the wisdom of people who have not only stayed the course over time but who have maintained gratitude in their hearts for everything they have experienced.

On the other hand, imagine how awful it is when an older person becomes cynical. They become unwilling to share their experience. They look down on young people. They are always complaining. They cannot share wisdom. They can only look back fruitlessly on earlier times.

Yet how wonderful is the encouragement that an elder can bestow on a young man or a young woman who is searching for the meaning of life!

This is the mission of grandparents. It is a real and true vocation, as we hear, for example, in the Book of Sirach: Do not dismiss what the old people have to say, for they too were taught by their parents; from them you will learn discernment, and how to respond in time of need (8:9). Our elders hold a reservoir of wisdom for our society. Paying attention to our elders shapes our life together.

Our grandparents' words hold something special for the young. This is how faith is transmitted—through the witness of the elders who have made their faith the leaven of their life. I know this from personal experience. I still carry with me the words my grandmother Rosa wrote to me on the day of my priestly ordination. I carry them with me always, tucked inside my breviary. I read them often, and they do me good.

For some time now, I have been carrying a thought in my heart. I feel that this is what the Lord wants me to say: that there should be an alliance between young and old people. This is the time when grandparents must dream so that the young can have visions. This idea became clear to me when I considered the words of the prophet Joel, who says, in God's name, I will pour out my spirit upon everyone, and your sons and daughters shall become prophets; your elders will dream dreams, your young people will see visions (Joel 3:1).

What does this mean? Only if our grandparents have the courage to dream, and our young people imagine great things, will our society go on. If we want to have a vision for our future, let our grandparents tell us, let them share their dreams with us. We need grandparents who dream! They will be able to inspire young people to move forward creatively as they envision a future.

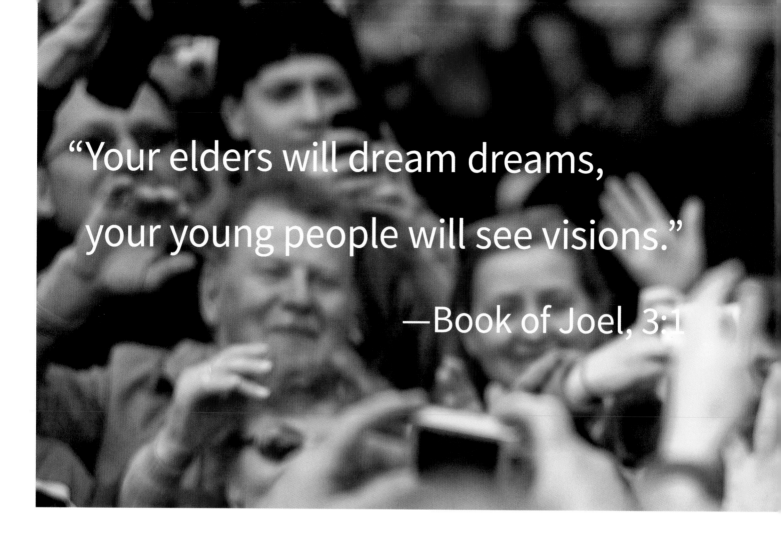

"Your elders will dream dreams,
your young people will see visions."

—Book of Joel, 3:1

Today, young people need the dreams of the elders so they can hope in a future. Older people and young people move forward together, and they need each other.

When the Child Jesus was brought to the temple, he was welcomed by two elders, a woman and a man, who told their dreams: in Simeon's dream, the Holy Spirit had promised him that he would see the Lord. Simeon and Anna were waiting for the coming of God every day for many years and with great fidelity. They longed to see that day come. That constant wait—despite perhaps tiredness and frustration—filled their whole lives. Behold, when Mary and Joseph reached the temple to fulfill the law, Simeon and Anna jumped to their feet. They were moved by the Holy Spirit. This elderly couple recognized the child and discovered a new inner strength that allowed them to bear witness. Simeon became a poet and began to sing his canticle. Anna became the first preacher of Jesus, speaking of the child to those who were awaiting the redemption of Jerusalem.

In fact, the lack of grandparents like Simeon and Anna who share their dreams hinders the younger generation's ability to envision a future. And so they end up stuck. Without the witness of their elders' lives, the plans of young people will have neither roots nor wisdom. Today more than ever, the future generates anxiety, insecurity, mistrust, and fear. Only the testimony of their elders will help young people look above the horizon to see the stars. Just learning that it was worth fighting for something will help young people face the future with hope.

What do I ask of the elders among whom I count myself? I call us to be memory keepers ("*memoriosi della storia*"). We grandfathers and grandmothers need to form a choir. I envision elders as a permanent choir of a great spiritual sanctuary, where prayers of supplication and songs of praise support the larger community that works and struggles in the field of life.

But I also urge that we take action! I ask that we push back, in any way we can, against the "culture of waste" that is imposed on us worldwide. There is something terribly wrong in this addiction

to the culture of waste. When we get old, we recognize the gaps and lacks of a society so bent on efficiency. As elders, we can thank the Lord for the many benefits we have received. We can fill the void of ingratitude that surrounds us. Not only that: we can honor the memory and sacrifices of the past. We can remind today's young people, who have their own blend of heroic ambitions and insecurities, that a life without love is an arid life. We can tell fearful young people that anxiety about the future can be overcome. We can teach those young people, sometimes so focused on themselves, that there is more joy in giving than in receiving and that love is not only shown in words but also in actions. Clearly, we elders at this time and moment of our lives need to reinvent ourselves, because old age, as it is today, is a new phenomenon. That is what pushes us to be creative.

And what do I ask of young people? I feel sorry for a young person whose dreams are mired in bureaucracy, who, like the wealthy young man of the Gospel, goes through life sad and empty. I ask them to listen to and bond with their elders.

I ask them not to pull back into a quiet "desktop existence" that hems them in with projects that have no hope and no heroism. I ask them to look up at the stars. I ask that they dream of a better world and let that dream inspire and energize them.

I like this book very much because it gives voice to people with years of experience. It lets them talk and tell their experiences. I also liked looking at the images of their faces. I found myself mentally speaking with some of them as if in a conversation between friends. Reading their stories did me much good. I entrust this book to the young so the dreams of their elders will bring them to a better future. To walk toward the future, the past is needed; deep roots are needed to help live the present and its challenges. Memory is needed, courage is needed, a healthy vision of the future is needed.

Here is what I would like: a world that lives in a new alliance of young and old.

July 31, 2017, Feast of St. Ignatius of Loyola

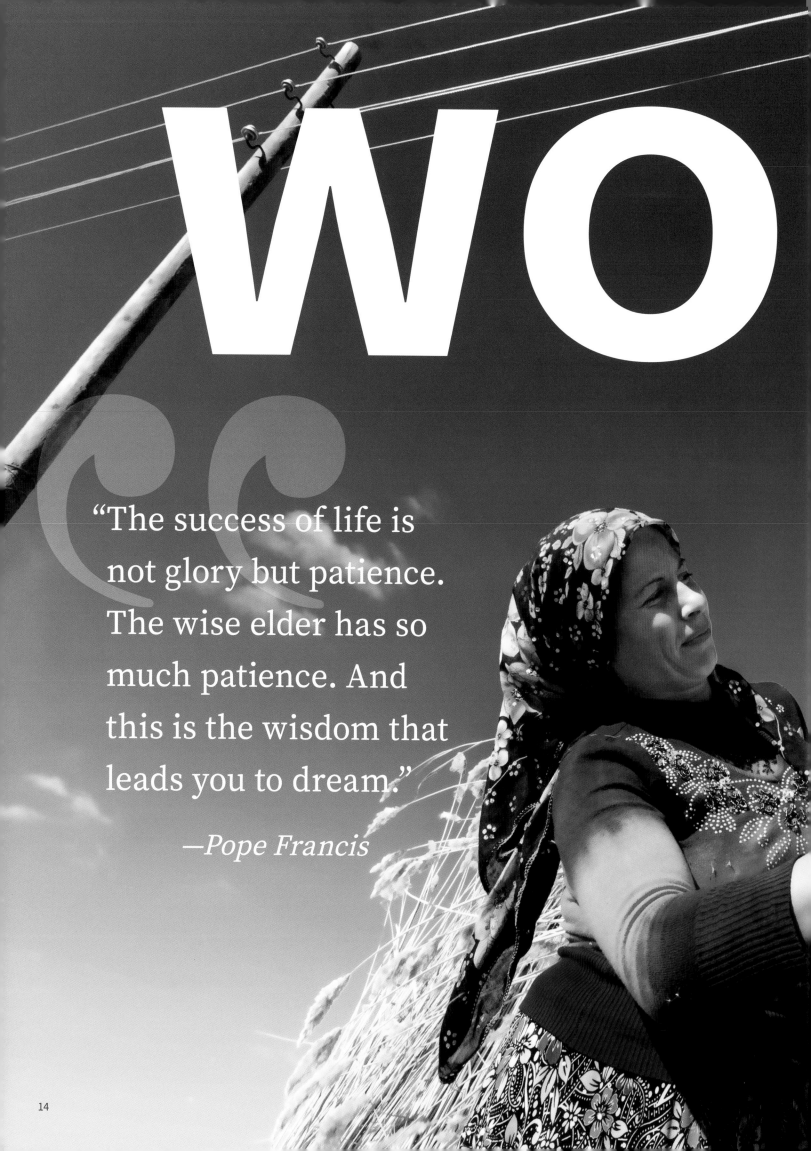

WO

"The success of life is not glory but patience. The wise elder has so much patience. And this is the wisdom that leads you to dream."

—*Pope Francis*

WORK

Pope Francis

How good to see elders who have been working all their lives and who arrive in old age with a lived sense of reality and life. Work enables them to engage with the world, with people, with the earth, and with so many circumstances so they are not just talking to themselves. Work always opens us to dialogue. Older people who have worked to build a home and raise their children, who have struggled, who have earned a sense of dignity, provide a wonderful witness to young people. They followed their dream and worked to achieve it as best they could.

I can recall so many of the older people I have met. I remember an elderly couple I dearly loved. He worked as an employee of an electric or gas company, I do not remember which. He arrived home tired each evening after walking door to door all day long. His name was Domenico. His wife, Dora, waited for him with a cup of *mate*, which is a very popular Argentine tea. His two daughters would be there too. The family was happy. In his free time, he cared for his chickens. He kept them in the garden behind the house. He loved his wife, and she loved him. You could tell. He spent his life working. Then his daughters got married. The grandchildren were born: five or six. I remember that he was very smart and had sparkling, cheerful eyes.

In time, he fell ill, but he managed to recover from it pretty well. I asked him once if he was afraid of death. He replied that he had never been afraid of death. He might be afraid to see it come but was not afraid of death itself. I had seen him show this same wisdom in his job. His wife lived longer than him, and she always went to the cemetery with flowers. She remembered this man she loved. The love of a whole life. A love that built a home and a family.

"Older people provide a wonderful witness to young people."

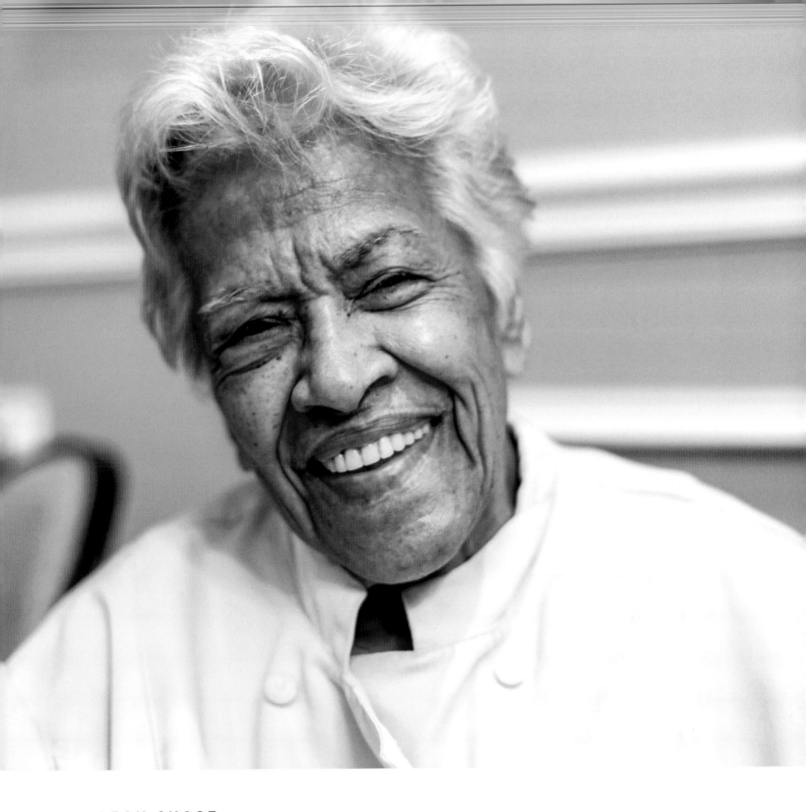

LEAH CHASE

95 | Chef, "Queen of Creole Cuisine," and Film Inspiration, USA

INTERVIEWED BY ROSEMARY LANE

One time, not too long ago, a food critic came through here. And boy, I was four beans—and four beans is a good rating for a restaurant in New Orleans. She took me down to one. I mean, she just tore me to pieces.

It was tough, but I learned to take that criticism and correct it. You don't buckle, because that's what life's all about, darlin'. Somebody's always trying to break you. You can try to do that to me, but I'm gonna come back swinging all the time.

That's what young people have to learn to do today. If you're criticized, look at it. Then correct it if you can and move on. You don't stop. You don't stop when people criticize you. You keep going, and you do better every time.

EUSTAQUIA MAY DZIB

77 | Recycler, Mexico

I started recycling 14 years ago after my husband's accident [he was disabled by a gunshot wound]. It was the only thing I could think of doing because I can't find a job if I can't read or write. Very few people recycled; there was a lot of stuff out in the street that I could pick up and sell. My work has brought food to our table for 14 years. I am grateful that I can do it.

I ride my tricycle every day and pick up plastic bottles. I also knock on doors, asking for stuff that can be recycled: iron, glass, and cardboard. A kilo of plastic is worth $0.15, iron $0.20, and cardboard $0.25. I collect between $2.50 and $3.50 a day. With that money, I am able to buy corn, beans, and tortillas for both of us. This is our livelihood.

Recycling not only brings food to our home, but it also helps the environment. We should give our trash a second chance. It will help keep our community clean. Our trash will be transformed into something useful again.

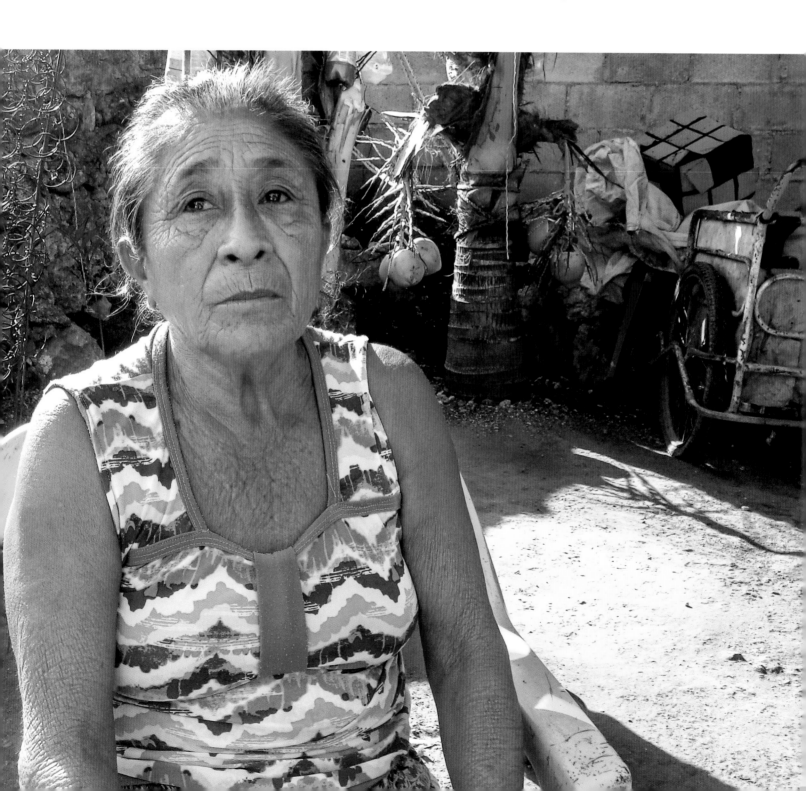

POPE FRANCIS RESPONDS

Eustaquia does wonderful work. She does not just clean. She does something much more important: she repurposes what others throw away. This woman does not waste, but from what is thrown away, she finds items of value. She selects scraps to offer them a new usefulness. How much wisdom there is in this simple gesture! So much care and discernment. Nowadays, it seems everyone just wants to throw things away. That is the triumph of the culture of the garbage bin, which, in the end, renders each one of us no more than a piece of plastic thrown into the garbage can or a used and crushed bottle that is no longer useful. Even many of our children end up discarded like that. We become numbed day by day to the "existential waste" in our culture. And what's more, because of our narcissism, our elders, too, are seen as disposable. People long to see themselves in what is beautiful and new. And so what does not seem useful anymore we throw away.

The elder who ages well is like a fine wine. As wine ages, it gets better: in fact, much better! We do not throw it away. But when wine ages poorly, it becomes vinegar. You must age well, with wisdom, to be able to convey wisdom.

Will we be able to redeem our youth from this culture of the garbage bin that seems to dominate us? This little gesture of Eustaquia's offers a vision of a different humanity: to give new life to what seems to be "just waste."

"You must age well, with wisdom, to be able to convey wisdom."

MARIA NITEO FONNEGUA

72 | Candy Seller, Colombia INTERVIEWED BY ROSEMARY LANE

In the morning, I set up my little store. I put everything on a table just outside my house in a space that I rent. At 6 p.m., I go inside and sell from my window.

I was selling only candy and snacks, but a neighbor gave me the idea to also sell cigarettes, beer, and pens to expand my business. I was on a busy street and sold a lot of beer. I made a lot more money that way. But where I am now, business is much slower. They opened a big store across the street, and now I sell very little. But I ask God to help me keep going, and I don't feel sad. I am OK if one day I hardly sell anything. I always think that tomorrow I will sell more.

People also give me beads, and I make earrings, bracelets, necklaces. I sell them too! I cannot make a living with the things I sell, but everything helps. There is a saying in Colombia that goes, *grain by grain the chicken fills its stomach* (*de grano en grano llena el buche la gallina*). With the little I make, and the little my children send, and the help I get from the government and from my sponsor [Unbound, a nonprofit sponsorship organization], I have been able to pay my rent and buy my own food. I have been on my own for seven years and always had enough money to pay the rent and the bills. I am not the kind of person who waits for help. I have always had initiative and found ways to earn a living.

Even though I don't have good health, I am happy because God has big things for me.

JOAN LAWSON

80 | Retired Nurse, USA INTERVIEWED BY BRIDGET GAMBLE

My worst experience with racism was at the Cook County School of Nursing. I was 18 years old. The instructor for anatomy and physiology, a white woman, gave me a C. I don't get Cs. In my naïveté I went with all my papers to talk to her and try to correct this. I was a freshman and hadn't been there three months. She looked me in the eye and said, "My dear, because of your race, you will never get the grades you deserve." I'd never experienced anything like that before.

I went upstairs, and I was packing to leave. Nobody was gonna talk to me like that! But I had a relative who was not educated with books but who had a lot of life experience. He said, "Can you get through that school with a C?" I said, "That's not the point!" He said, "That *is* the point. They let you in, but then they find ways to get rid of you, to say that you can't make it." So I stayed, and I got Cs all the way through. When I went to DePaul University for my master's, I made the dean's list, so I got real smart in between.

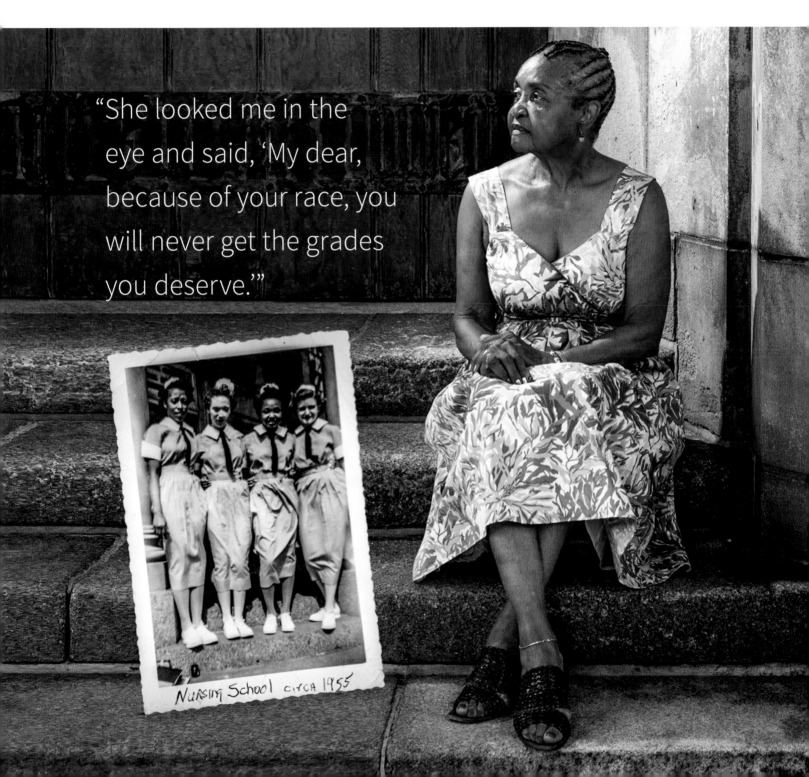

"She looked me in the eye and said, 'My dear, because of your race, you will never get the grades you deserve.'"

Nursing School circa 1955

"If you fight and struggle for what you believe in, you can achieve a lot."

JESÚS LANDÁBURU SAGÜILLO

62 | Former Professional Soccer Player, Spain

INTERVIEWED BY JOSÉ MARÍA RODRÍGUEZ OLAIZOLA, SJ

My first season with Barcelona (1979–1980) was very good. I played in all the matches, scored goals, and debuted with the National Selection. Nevertheless, when another coach took over the club the next year, he didn't play me. I didn't fit his game plan. I reacted like a little kid who gets mad and decides not to eat: I stopped making an effort in practices. Everything got worse. I played less and got out of shape. Fortunately, another coach started to play me again.

Years later, when I was playing with Atlético de Madrid, the same thing happened. I'd had a very good season (1986–1987), and again, a new coach decided not to play me. In the preseason, I hardly played, and in the first match, I was not even on the roster. This time, however, I had matured. Instead of sulking and reacting like a child, I decided to make a greater effort. I showed my ability. I trained doubly hard. In the afternoons, I ran in the Retiro [a park in Madrid]. A few games later, I was playing again, first string, having demonstrated my worth.

The lesson I learned through the years was that it is necessary to be able to handle frustration. If you whine and sulk, you will not get anywhere. But if you fight and struggle for what you believe in, you can achieve a lot.

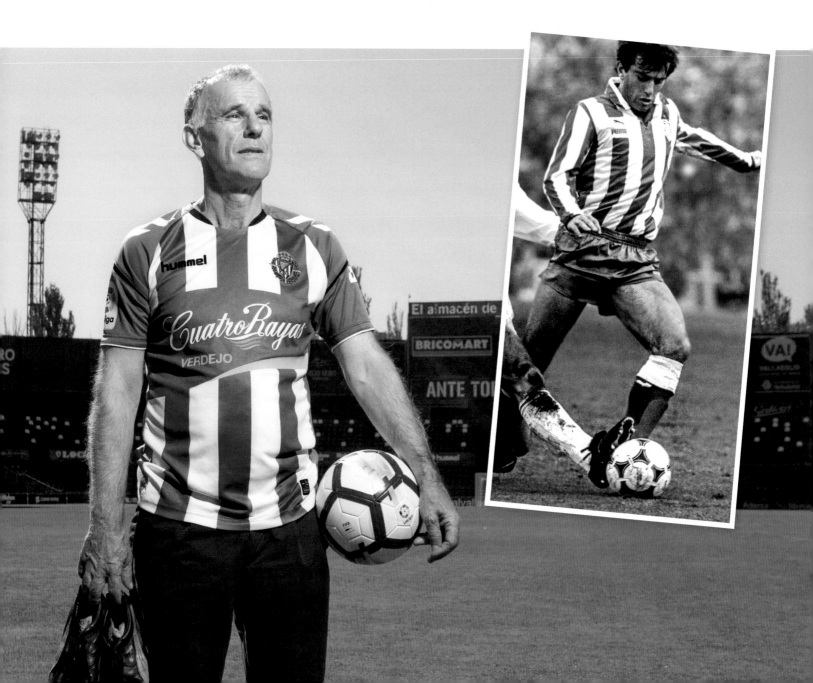

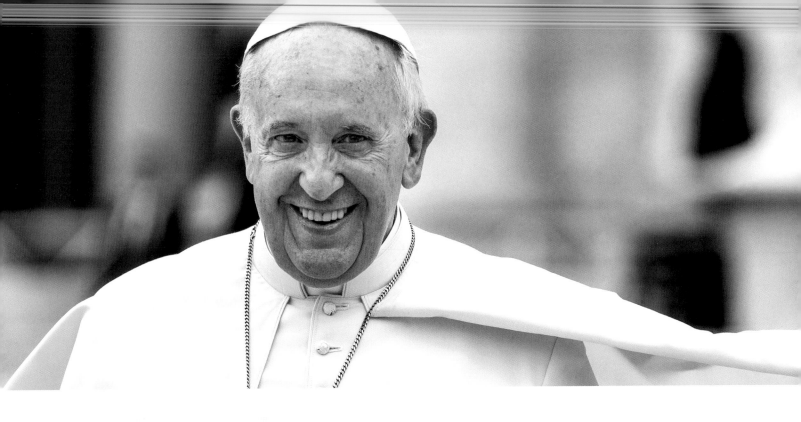

POPE FRANCIS RESPONDS

Jesús Sagüillo's story is a truly human story. Like our own, it is made of successes and failures. Many older people are good examples of how to face failures with strength. When they face their failures with wisdom, they show how wise they are. Failure is the source of much wisdom. Some people facing failures get angry and complain. No complaining allowed! It does not help. It does us more harm than good. The elder's wise vision of things is actually rooted in knowing how to accept failures. You have to play like Jesús. This is what it means to live! You need to take life as it is. It is like the goalkeeper in soccer, catching the ball from where another player kicks it: it can come from here or from there . . . But you do not have to be afraid of life, of getting in the game. Jesús was a promising soccer player when he experienced failure. And what did he do? He trained more. He fought hard. He practiced kicking the ball, and he got better at it, better than ever before.

Without failure, there would be no story of our salvation. I like Chapter 2 of the Letter to the Philippians: the story of salvation begins in failure. Jesus poured himself out. He humbled himself. And yet the "failure" of the cross, brought to its completion, is the root of our salvation. There is always a hidden wisdom in failures.

"Without failure, there would be no story of our salvation."

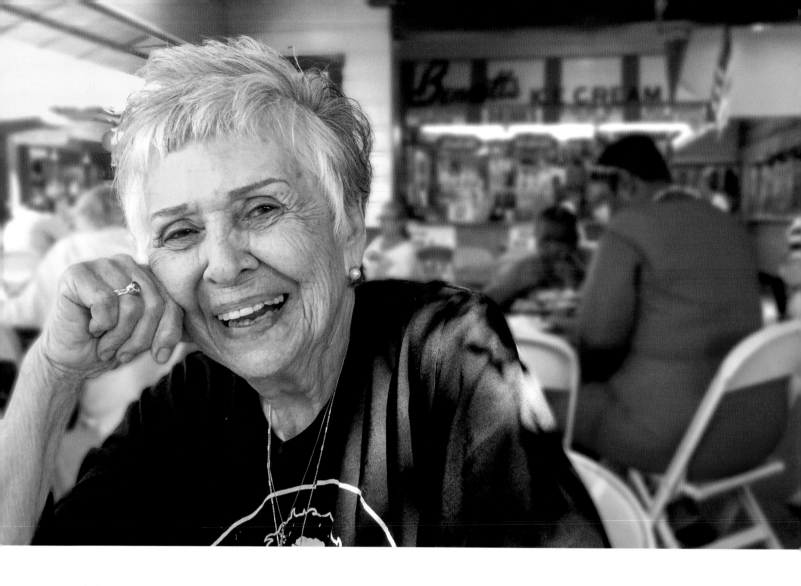

CONSTANCE CARUSO

86 | Homeboy Industries Volunteer and Former Talk Show Host, USA

INTERVIEWED BY ROSEMARY LANE

RL: I want to talk to you about the George Eliot quote you mentioned: "It's never too late to become who you might have been."

Conny: That's my theme. It is never too late to become who you might have been. I was tomorrow's woman in the 1950s, and I didn't fit. I was in a job that didn't fit me because they wouldn't pay attention that there was somebody in here. I had no sense of my capability. So I lived each day in agony, but that pain was good—it's the fire that turns us into something we could become. We grow by fire.

RL: How did you figure out that you had something to give?

Conny: I did not figure it out. I didn't figure out I'd get a television talk show. I was just being Conny. I said, "Why are you hiring me? I don't even have the talent." They said, "Well, you are funny, you

are smart, and you are a little bit crazy." Those were the requirements. They wanted to see me just being me.

RL: How did you deal with the uncertainty? In my own life, I feel like sometimes I'm waiting for the next big thing to happen.

Conny: Here's my magic. Whatever I do, I'm never looking to see if something has changed. I just keep moving. The danger is in watching. But you have to put it into practice. You don't have any proof of the future. But to be a human being is to know that things are in motion that we do not see. You're being taken care of. Know that.

The miracle is, things keep happening, even in old age. You live literally until you die, if that's what you choose to do, and that's what I chose. I think I'm 86 going on 35.

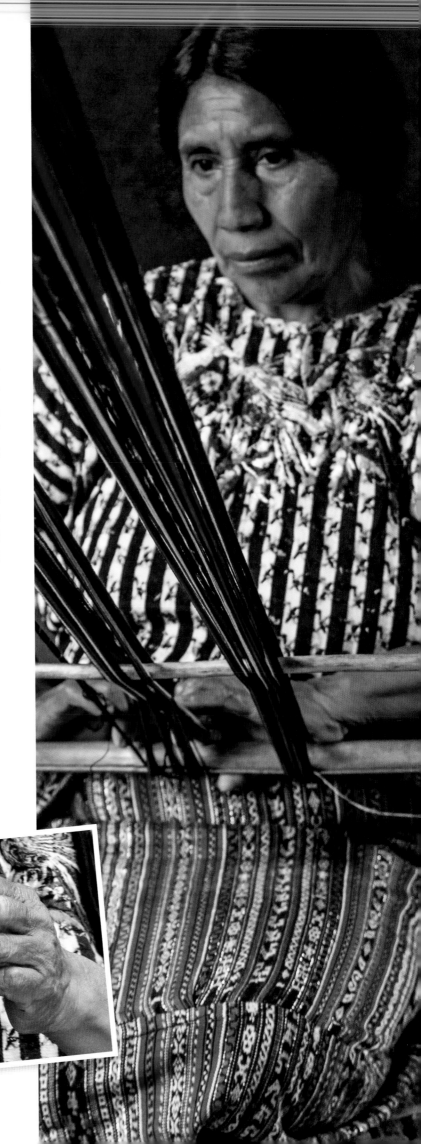

ANDREA MENDOZA CHIVILIÚ

63 | Fabric Maker, Guatemala

INTERVIEWED BY OSCAR VENTURA TUCH

I create traditional fabrics that I sell to tourists who visit the town I live in. My mother taught me how to work with fabrics. She used to tell me I should learn to work so that I could cover the family expenses when I got married. My work did help my husband and me cover our many needs.

Today, being alone, I realize that I can rely on myself. My children are already married and have their own needs. If I need to buy any medicine when I get sick, I don't have to bother my children because, like me, they also live with many shortages. Learning to work for myself helps me live with a clear goal in life: if I don't work, I cannot eat.

I believe that God has been very patient and merciful because I still have the energy and the capacity to work. I see people at my age and can sense that they can no longer live as I do; I owe all that to God.

> "I believe that God has been very patient and merciful because I still have the energy and the capacity to work."

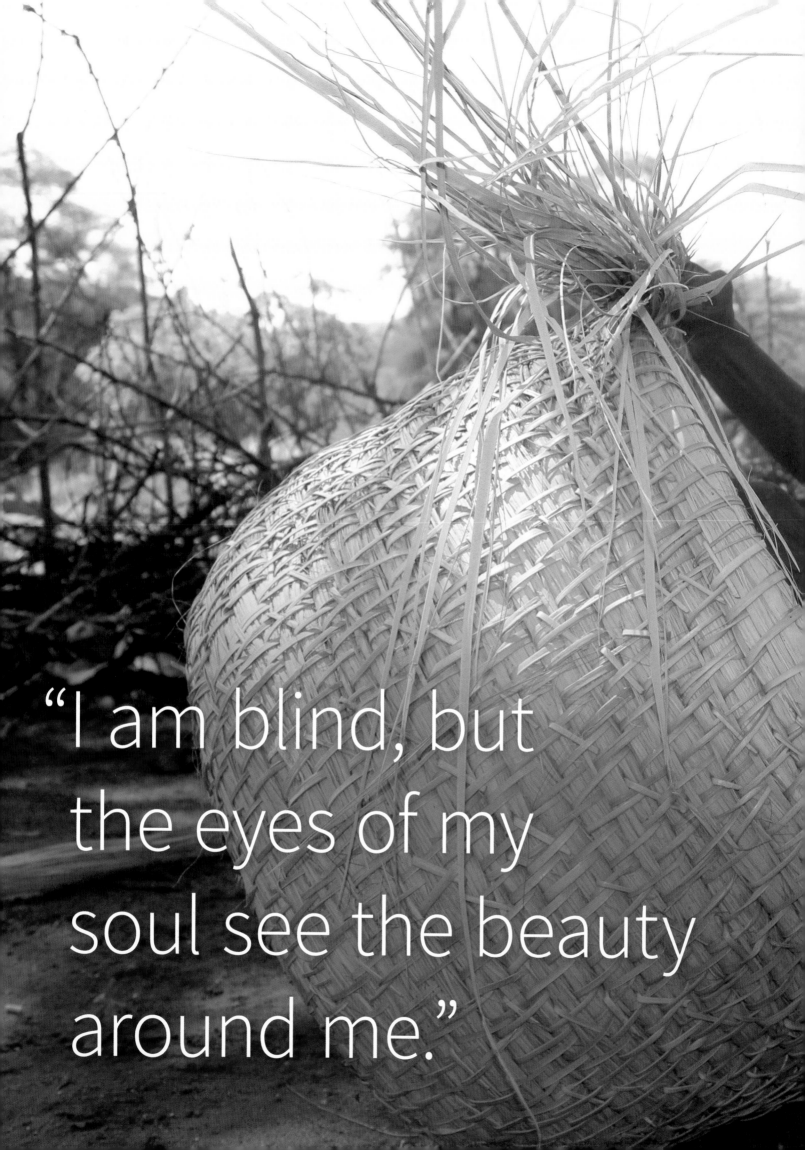

"I am blind, but the eyes of my soul see the beauty around me."

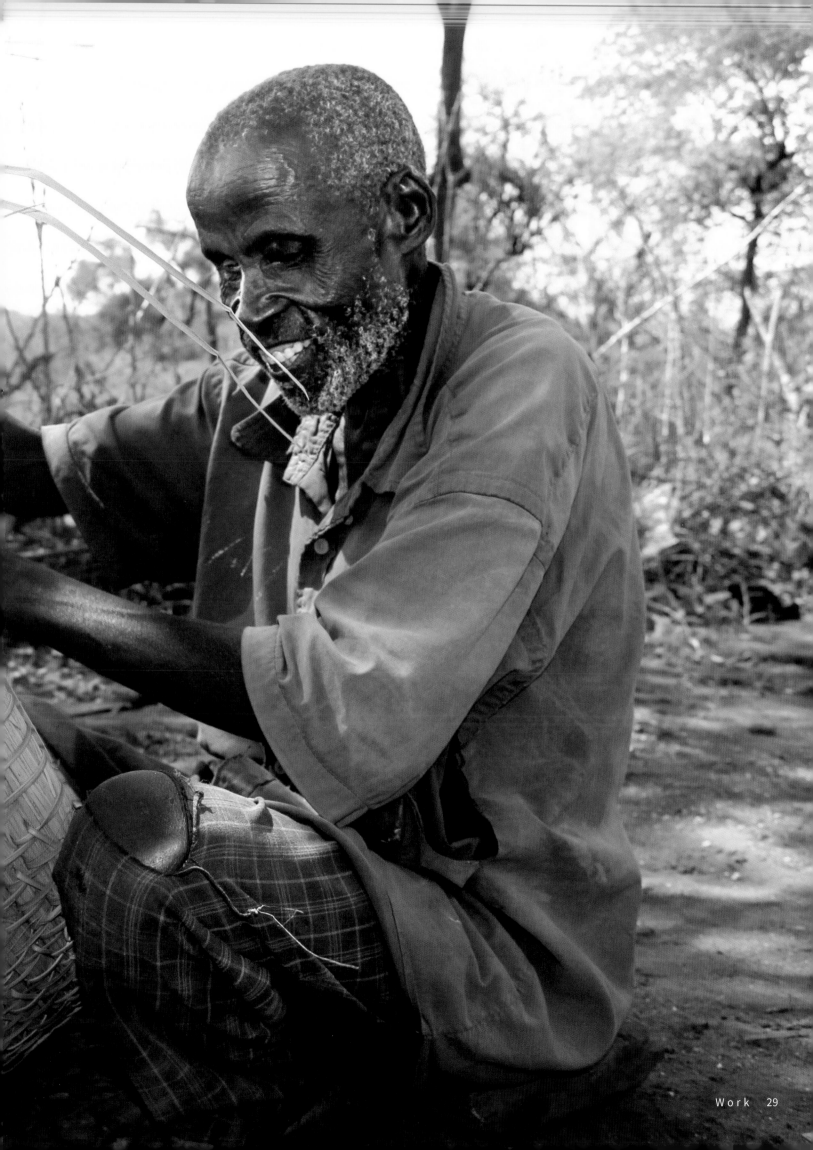

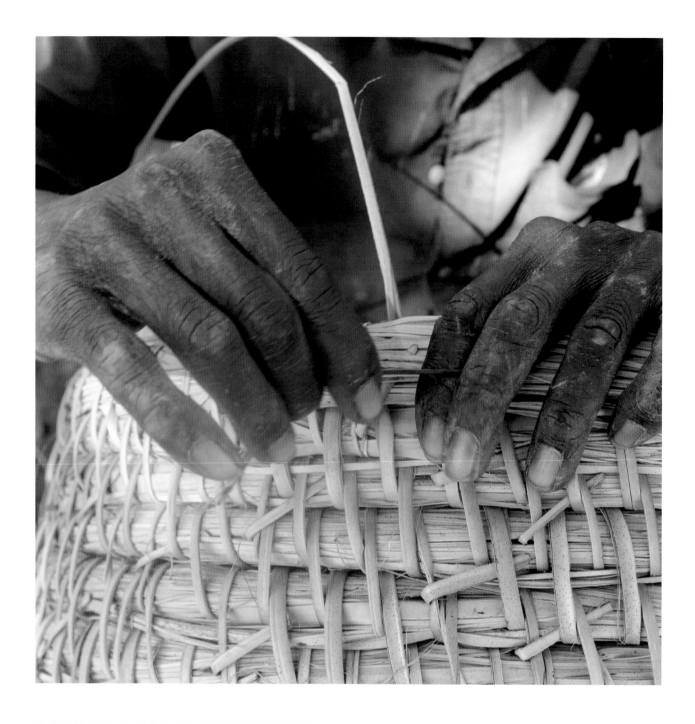

BERNARD NJAGI MUGWETWA

77 | Basket Weaver, Kenya INTERVIEWED BY REGINA MBURU

Do you want to hear an interesting story? Once upon a time there was a bat. He was so wise. He attended an animal meeting on earth, and he got some teeth. He later attended an animal meeting in the skies, and he got some feathers. When he died, he was taken to the skies, but the animals there said they did not know him because he had teeth. He was brought back to earth, but the animals there said they did not know him because he had feathers. In the end, he was buried on top of the mountains, because he did not belong anywhere. You might lose everything as you try to belong.

I am blind, but the eyes of my soul see the beauty around me. As I weave my baskets, I smile. Unlike the bat, I am happy where I belong and have accepted myself just as I am.

POPE FRANCIS RESPONDS

I think about the mystery of everyone's identity. We are who we are, and everyone has their own story. Some people do not accept their identity. They want to change it. They want to be someone or something else. But wisdom means bearing your own identity, accepting yourself through and through, being proud of yourself no matter what. Elders with many years behind them have lived into their own identities over a long time. They have to reckon with their lives and how they have lived. Elders carry this wisdom in their dreams: it is their history, their very own story.

Bernard is blind but he sees us clearly! How can that be? It is because he can see himself and behold the beauty all around himself. For him this means making beautiful baskets. I have met several older blind people. I realized that many of them are able to see better than those with physical sight. Sometimes it is not easy to accept yourself the way you are, but those who live long can come to peace with themselves and with their story, even if it takes many years. Some people, like Bernard, look at their story with pride. We all should do that.

"Wisdom means bearing your own identity, accepting yourself through and through."

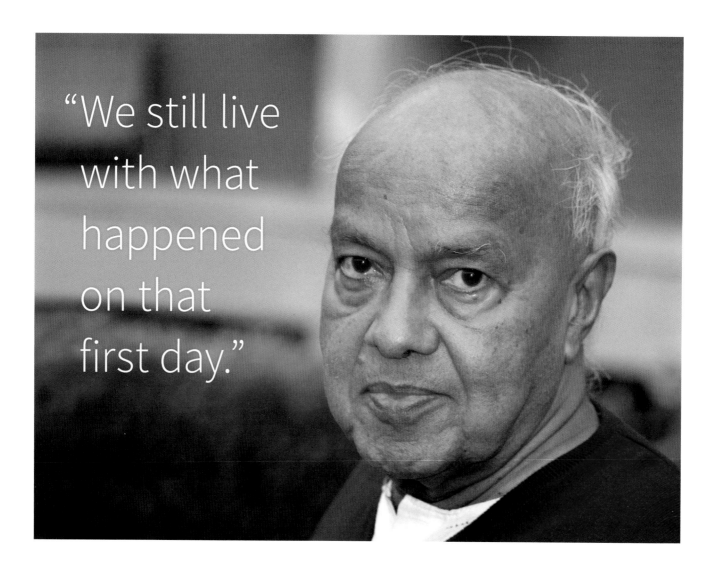

"We still live with what happened on that first day."

T.K. JOHN, SJ

80 | Theologian and Professor Emeritus, India

Years ago, a group of Jesuit seminarians and I spent a week in a slum. It was shock therapy. We still live with what happened on that first day.

Four students and I were given a newly made shack for the night. We spread out the mat, turned off the light, and began to sleep. But a foul stench woke us up. It was unbearable. Dawn came at last, and we discovered there was a small stream of sewage flowing under our hut. The contrast between our rooms in the seminary and here in the slums began to haunt us. A sense of guilt and shame invaded our bones.

We spent the rest of that week visiting the people and listening to their stories: how they became landless and homeless. We were with people who were not counted, yet they welcomed us and shared what little food they had with us.

A professor who had introduced us to the slum also introduced us to a way to respond. He would buy vegetables at wholesale and sell them at that same price to people in the slums, bringing vital nutrients to ill-nourished children and helping people save money. After delivering the vegetables, he'd sit for a brief reflection with the buyers on how they could do what he did through their own cooperative. "Stand and work united in this hard life," he said.

This principle was operative in what became our slum work. When the vegetables we bought reached the slum, we handed over the distribution to a group of youths from different, often conflicting communities. After that, we organized a game of football, uniting the different groups.

Religion should encourage us to work together for some local common good. A divisive force can be turned into a unifying one.

OLGA DOLORES TAVERA ALVA

68 | Former Street Vendor and Restaurant Owner, Peru

INTERVIEWED BY HENRY FLORES

I worked in a flower factory for seven years until my grandmother died. Then my mother and I started to work on the streets, selling breakfast to the workers when the Cayetano Heredia Hospital was being built.

The workers began asking us for lunch. At the time, we were living far from the hospital. We walked back and forth so much that my mother got kidney problems. We decided not to do all that walking and slept on the street instead.

In the same area, some houses were being built. We talked to the engineer, and he gave us a small piece of land to live on until the project was completed. The police came to remove us. We asked for an audience with the mayor. He welcomed us and told us he would let us stay if we built a kiosk. So we built our kiosk and slept in it. We worked like that for about four years.

Young girls usually go out with their friends and have fun, but I stayed because of the love I felt for my mother. We had no help from any other person; my dad abandoned her. He never helped me, so I had to work, and I did so faithfully next to my mother.

It was difficult. Temptation was always close. I was 20. At that age, women are pretty. One day, a man told me, "You are young. You and your mother are sleeping on the streets. I can take you to a place where you will make money easy without working so hard." See how temptation is? I said, "No! I wasn't born to do that."

I know that many people will sleep on the streets tonight as I did so many years ago. I hope that businessmen will be touched by God. There are so many of them, so many factory owners who have the means. I'd want to touch their hearts to collaborate with those brothers and sisters because nobody is immune from tragedy, like a fire or earthquake. All human beings can go through something like that, but if we all are in solidarity and united and we think about the needs of our brothers and sisters, we can collaborate a little bit and make our country move forward.

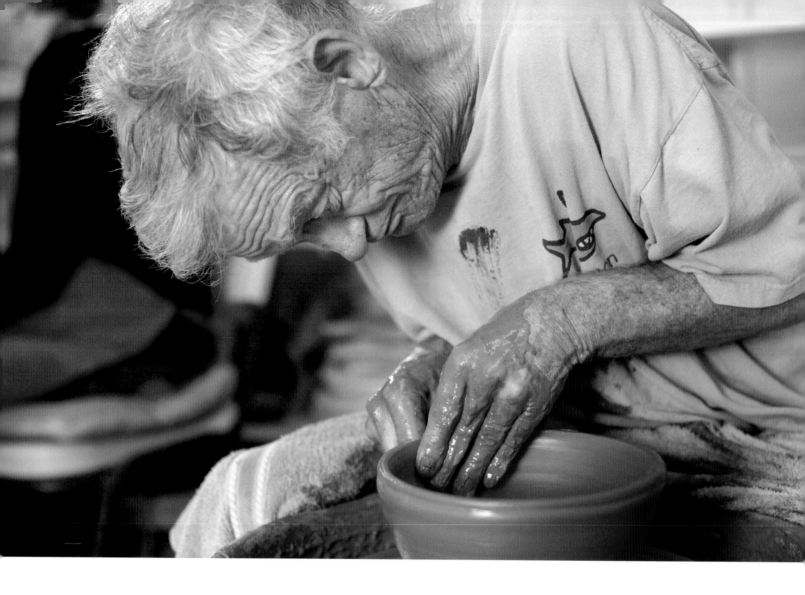

MARTIN BENTON

69 | Potter and Retired Attorney, USA INTERVIEWED BY TOM MCGRATH

Martin: I have been making pottery for many years. When I was much younger, a very good friend of mine loved and collected art. I mentioned to him that I would like to try pottery. He knew a potter, Jill Hinckley, who had a gallery in the Watergate Hotel—this was in the late '70s. Jill had a good reputation. One of her works is in the Renwick Gallery at the Smithsonian. So my friend went to Jill and said, "I've got a deal for you. I've got this friend who has cerebral palsy, and if you can teach him how to turn clay into a pot, I'll buy 10 lessons for him." [*laughs*] And that's how I got started.

TM: What have you learned about work from making pottery?

Martin: Before I started making pottery, I had the idea that you had to make a perfect pot. Over time I have come to realize there is no such thing as a perfect pot. There is a relationship between the potter and the clay, and the clay has a mind of its own. You can shape it and bend it to a certain extent. But if you try to mold the clay in a way it doesn't want to go, it will end up in your lap. [*laughs*] Pottery is a good teacher. It teaches you patience and how to get centered and not think about anything but doing pottery. If you start thinking about something else, you'll end up with the clay flying across the room. It just keeps me in the moment. It took me years and years to learn that you don't try to create a certain number of pots in a given period of time. You just have to concentrate on what you're doing right now and hope that you get something that somebody will like. A lot of times I will work on a pot that I don't think is all that good, but then somebody comes by the table and really enjoys it and pays money for it. Evidently somebody liked it. [*smiles*]

"Peace is a work of art, and today there is a great need for this kind of art."

POPE FRANCIS RESPONDS

Martin was a lawyer. He has left his books and the courtroom behind in his life . . . because now he works as God does! He works as a craftsman with ceramics. The first craftsman who worked with his hands was God. The hands of a craftsman are the ones that best communicate God's way of working, by giving shape with loving hands. But God does not just love the perfect things that are without defects. He does not make things to discard them. He loves them just as they are. He shapes and molds them, the clay of his hands. Craftwork is God's work. Peace, I often say, is a work of art, and today there is a great need for this kind of art. Craftwork is the opposite of abstract, theoretical, ideological work. Abstract work stands apart from ordinary living in that nothing is touched, shaped, or bruised in the process.

Clay requires patience. I am moved by Martin's patience. In his patience I sense a profound wisdom that takes a dream and gives it shape. An elder, at work modeling clay, offers us a beautiful image. Martin's own life was a vase shaped by the hands of God. Indeed, the craftsman who has patience can avoid the waste of mass production. The industrial mindset makes and then wastes and then discards. The patience of the artisan, however, requires care and dreams.

MARY O'CONNELL

71 | Writer and Editor, USA INTERVIEWED BY TOM MCGRATH

A question I've always found interesting is: how do young people find the work they're supposed to do?

For some people there's a family business, and for others, it's, "My father was a doctor. I always wanted to be a doctor, so I became a doctor." But what about those kids who have no one to look to as a model or those who want to do something different with their lives? How do they find what the path is for them?

I live in Chicago, and we have this terrible problem of youth violence, which I find very, very distressing. I attended a panel on this issue that included a former gang member who had spent time in prison and is now working to help young people stay out of trouble. He said something shocking: "What you don't realize is the *power* that comes when you have a gun in your hand. If you are somebody who feels powerless and feels disrespected, there is so much power in having a gun in your hand."

Afterward, I thought about my father. He was a construction worker, and the power he had in his hands was his tools and the skills that went with them. He had the ability to make things and fix things. In our family and community, he was the guy people called when there was something wrong with their heating or when a step was missing on the back porch.

The work he did wasn't highly prestigious; it was a solid working-class job. And because of the unions, it was reasonably well paid. However, it was work that he felt was worth doing. He told me once, "When I die and I go up before St. Peter, and he asks what I did in life, I can say I built buildings. I helped build the steel mills. I built people's homes."

How can we help young people in our city put something else in their hands besides guns? Tools, or stethoscopes, or musical instruments? For years, I was on the board of a free music school for poor kids, which does just that.

With my grandchildren, I watch for the thing that makes their eyes light up, and I let them know, "If this is something you want to do, there are people who do it for a living. There are ways *you* can do it too." And I think we need to do that for all our children.

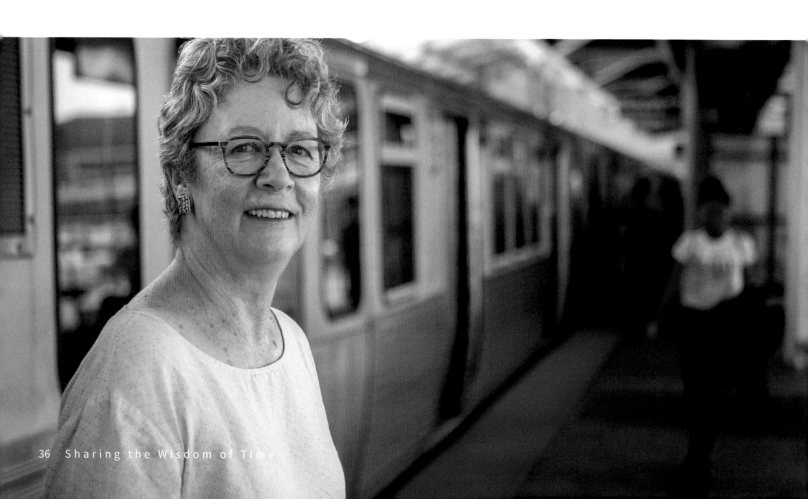

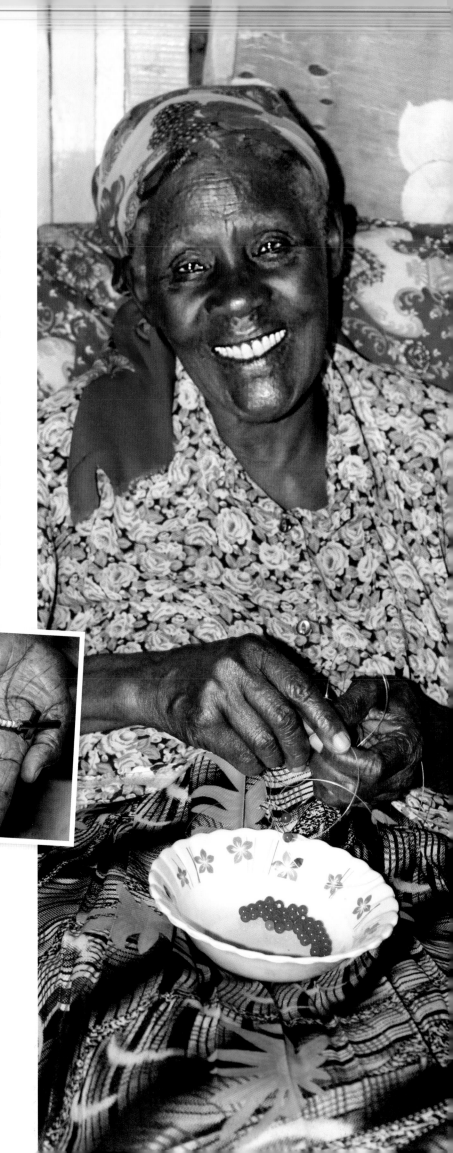

ALICE WAYUA MWOLOLO

67 | Bead Worker and Rosary Maker, Kenya

INTERVIEWED BY REGINA MBURU

My passion is making baskets out of beads and jewelry. I also make rosaries. I work from my house. I cannot afford to rent a shop. My clients come to the house to buy what they want. However, during the day, I hawk my wares around the area I live in. People love beaded jewelry, so I am able to make a few coins.

My work keeps me occupied. I have no time to worry about life issues. I am sure that keeps diseases such as high blood pressure at bay. I often feel God's presence when I am busy putting the rosary beads together. I am not able to pray when making one, because I am busy concentrating on the work. However, every day at 3 a.m. or 4 a.m., I wake up to pray the rosary. I feel so calm. I feel very happy when I am using my hands to do something worthwhile.

"I feel very happy when I am using my hands to do something worthwhile."

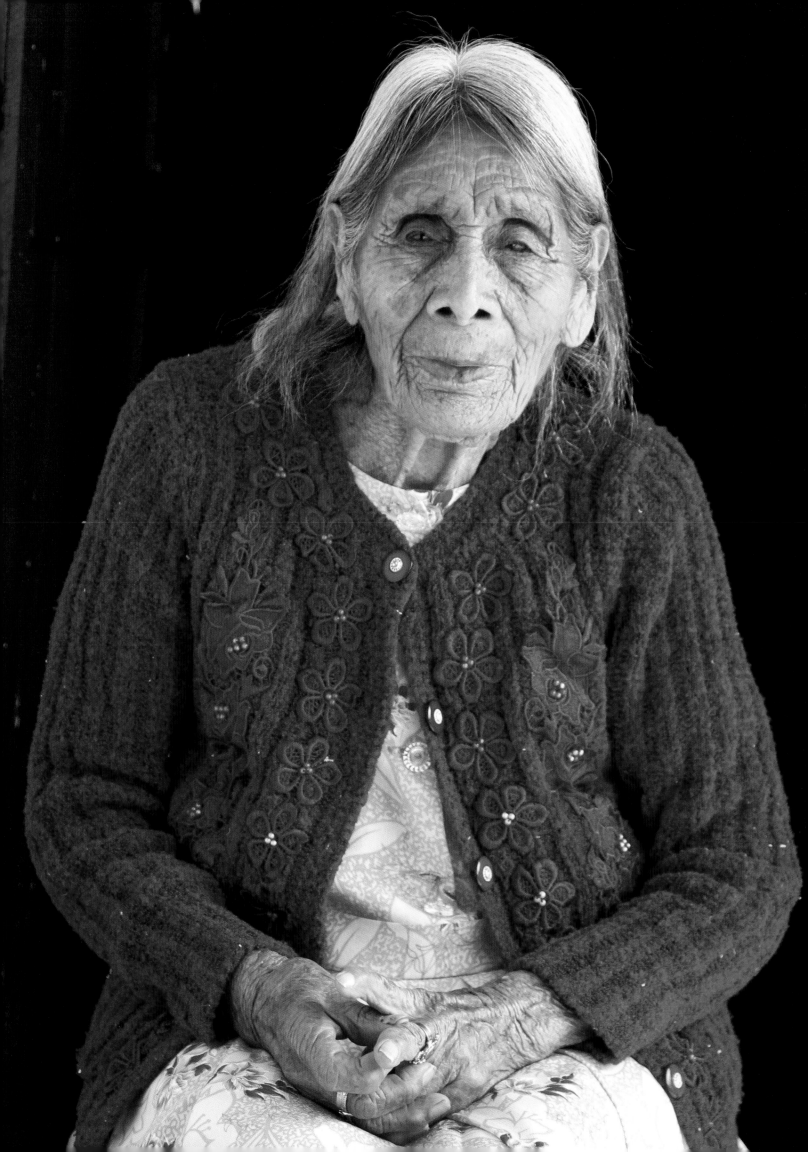

"The people of our community know me as 'mamita.'"

ELISA MARGARITA QUIROA LÓPEZ

100 | Retired Midwife, Guatemala INTERVIEWED BY LUIS COCON

I became a midwife at age 14. My first delivery was triplets right here in town. This is how I earned a living for my children. I continue to care for the women of my community. I can't deliver babies anymore, but I follow women through their pregnancies. I was still strong enough for deliveries up to about age 83.

The people of our community know me as "mamita" because I've delivered a whole lot of babies. [laughs] Even the mayor calls me mamita because I delivered him, too. I don't know how many babies I delivered but probably more than 10,000! Now I have taught my granddaughter this gift of delivering God's children. I hope my family will continue doing it for many generations.

Sometimes I delivered babies for free because people could not pay, and sometimes they would pay with a few pounds of corn or beans. I am grateful for what the Lord provides.

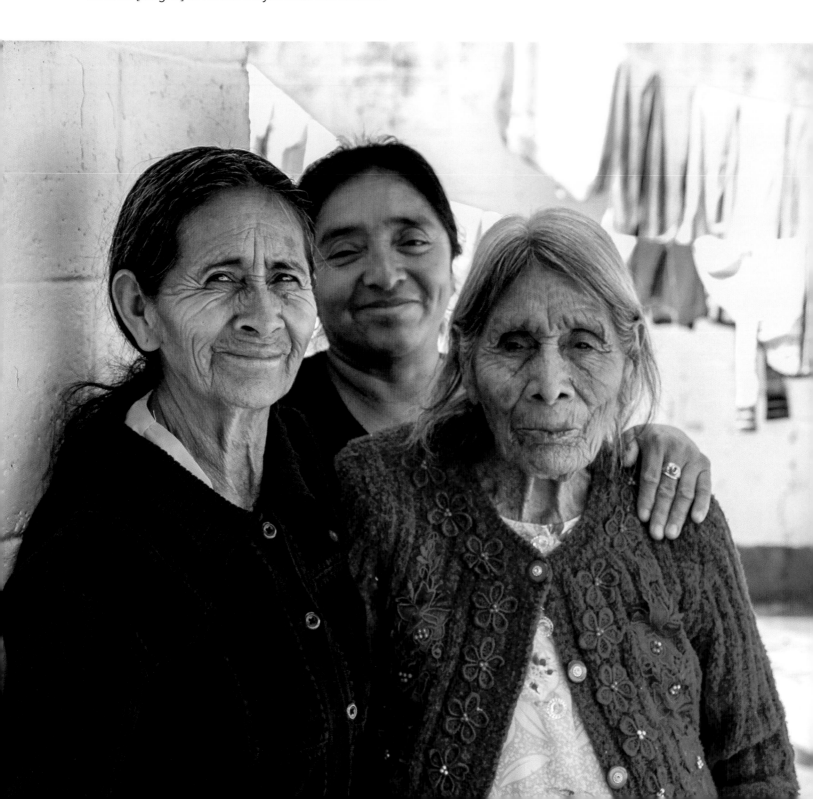

POPE FRANCIS RESPONDS

Midwives and nurses have a special place in my heart. I always bless the hands of those who helped bring children to birth. Elisa has helped more than 10,000 babies to be born. I hold in my heart the midwife who delivered me; my two brothers, Alberto Horacio and Oscar Adrián; and my two sisters, Marta Regina and María Elena. Her name was Mrs. Palanconi. We were all born at home. She delivered babies using a tin birth pan that would be kept in the bedroom. My mom kept that birth pan as a precious souvenir.

This is the way I was born. As soon as we arrived, Mrs. Palanconi put us in that pan, and then she took care of us and of our mother. When Mrs. Palanconi showed up with her suitcase, it meant that a little brother or sister was about to arrive, and we all waited expectantly. I was the oldest, and I saw all of my siblings born. Mom went to Mrs. Palanconi's party when they celebrated her 5,000th birth. And even after that, she kept on working.

What a great joy to give life, to deliver babies, to contribute to the beautiful relationship of mother and newborn child. Elisa Margarita's glance must contain a dream, the simple dream of giving life and birthing the future. I think of her hands. How much they worked! How beautiful they are. Nurses cure wounds one by one with those hands, just as God does.

"Nurses cure wounds one by one with those hands, just as God does."

MARTIN SCORSESE

75 | Film Director, Producer, and Screenwriter, USA

When you're young, you imagine that there's an ideal state called "success." You'd struggle, you'd be recognized, you'd finally "arrive," and . . . The End.

But arrive where? To do what? Take it easy?

The saying goes that success is fleeting. It comes and goes, and comes again and then goes again.

To be acclaimed, validated—sheer euphoria. But it can be a trap because it might lead you to believe that you're permanently safe from further failure and rejection. And then, when you make something that isn't greeted as warmly or that's even hated, you'll feel like the bottom has dropped out.

What can you learn from it? What can you learn from failure, which is finally just as fleeting? I think I've learned more from failure, rejection, and outright hostility than I have from success. Actually, what I learned from failure prepared me to learn from success.

When I was a student in the 1960s, Elia Kazan came to give a talk. Kazan was someone I revered. We'd had documentary filmmakers come to speak, but this was the man who made *On the Waterfront* and *East of Eden.* Later, I got up the nerve to write him and ask him for an appointment at his office on Broadway. Much to my amazement, he agreed. On the day, I took the subway to Times Square, got off with the address memorized, and then proceeded to get lost. This meant I showed up late, just as he was putting on his coat and getting ready to leave. But I steeled myself and asked him if he would hire me as his on-set assistant for his next picture. He didn't even blink. "We don't do that," he said curtly. Then I gave him a script I'd been working on and asked him if he would read it. Again, his reaction was instantaneous: "I don't read while I'm writing my own script." He shook my hand, wished me luck, and that was that.

Later, I came to understand how toughening that experience was for me. Because when that kind of rejection happens, if you choose to learn from it, it can be alchemized into an experience of renewal. It focuses you back on yourself and your responsibility to give everything of yourself to your work, just as Kazan did by refusing to read anything while he was writing or to spend precious time on set taking a young person under his wing. To me, Kazan was a hero. But in the end, I had to learn that he was just another human being who, just like me, had been sparked to express himself in moving images. He was implicitly telling me: I can't do any of the work for you; only you can do that.

A few years later, I was looking for money to make a picture. I'd made a couple of short films that got some attention, and my producer arranged a screening for a certain gentleman who was devoted to the art of cinema and occasionally wrote checks to finance pictures. We waited outside the screening room to meet him. The

> "I think I've learned more from failure, rejection, and outright hostility than I have from success."

door opened and out he came. He was dressed immaculately—bespoke suit, handmade shoes, a topcoat with a velvet collar, and a bowler hat. I'd never seen anything like it. And he was smiling, which seemed like a good sign. My producer introduced us and asked him what he thought. And without any hesitation, he said, "I didn't like it." We were stunned into silence. He kept smiling.

My producer pressed him. The man leaned in close, came face-to-face with me, smiled again, and said, "If I saw one thread of talent in there, I would tell you." And with that, he walked away. Smiling.

Now, I grew up in a very tough neighborhood, so I'd seen and experienced real cruelty. I'd experienced it in school, too, among my fellow students. But I'd never encountered cruelty like *that.* My producer and I looked at each other, shocked.

Now, I could have said to myself: maybe my work just doesn't appeal to the people who really *make* movies, the ones who *know,* so I guess I should call it a day. But I didn't. I started laughing, and so did my producer, and we couldn't stop. Because, in the end, what else was there to do but keep going forward? I'd made the work, I stood by it.

I wasn't going to abandon it just because one cruel man didn't like it. All I could do was stand by it, protect it, and nurture it.

Cinema was not a career choice for me. It was my vocation: I *had* to make movies. I knew that to make the ones I wanted and needed to make, I had to give everything of myself. I had to approach moviemaking with devotion, rigor, and humility. Flannery O'Connor was fond of quoting St. Thomas Aquinas to the effect that art is a good in and of itself because it reflects the glory of God. I certainly didn't articulate anything like this to myself when I picked up a camera for the first time, but I believe that it's true. It's never about us, the ones who make movies or write poetry or compose music—it's about doing justice to the life around us and to the question of what it is to be human.

When you give everything to what you love, whether it's filmmaking or woodworking or cooking or poetry, you realize over time that there is no final destination. And you also come to realize that it's *always* the first time. There are no shortcuts. You acquire technical knowledge, skills, confidence, but every step is a first step into the unknown, and every shot is a test—of the material, of your belief in it, of your talent and your instincts, of you. For me, every shot, every scene, every edit, and every interaction with every collaborator is a school. You never stop learning.

You're keeping the flame in your heart protected and alive. That's precious work.

"It's about doing justice to the life around us and to the question of what it is to be human."

> "Failures cannot stop us if we feel the fire in our heart."

POPE FRANCIS RESPONDS

I cannot accept the saying, "Everyone is born with their fate already written." It's just not true. Our life is not given to us as an already-scripted opera libretto. Our life does not play out like a movie where the scenes are all predetermined. A movie director may know this better than anyone else. We must let ourselves freely encounter life and God. And sometimes life will surprise us like a sudden and unexpected insight. Failures cannot stop us if we feel the fire in our heart. And the one who says, "You are worth nothing" cannot stop us. There are opportunities and inspirations that bring you forward in your vocation. There are opportunities, of course, and there are some mistakes. With all of this mixed together, you create your life. Life is a mixture that the elder knows well. Hiding mistakes is useless. You learn from your mistakes and failures, as

Martin says. To say, "My life is already written" is a meaningless excuse, a useless abstraction. Your life is not determined. You need to take what comes to you. Use what you have in your mind and in your heart. Use it on your journey to discern and discover what you most desire. What really leads you forward is the sense of vocation. It is a call, which is far more than a choice. And this brings you to give yourself, without holding back. You have to take everything in your life, mix it all together, and, with this mixture, move forward.

The success of life is not glory but patience. Sometimes you need a lot of it. The wise elder has so much patience. And this is the wisdom that leads you to dream.

EUGENIE CARMEL GAZAL

89 | Retired Travel Agent, Australia

INTERVIEWED BY ROSEMARY LANE

I've always tried to reinvent myself with each new experience, especially the difficult ones.

In 1987, my daughter Julianne purchased a travel agency franchise. Within a year, I was her right-hand woman, having retrained as a travel agent at age 60. My family and I still chuckle that I was the only 60-year-old student while my peers were only 18. But really, age was no obstacle in my belief that I could achieve.

I did find it humbling, but my travels have taken me to nearly every continent in the world. They have taught me to respect all people and their cultures. Geography doesn't count when it comes to meeting good people.

I am now approaching 90, and I still work alongside Julianne. I wouldn't swap my life for anything. After my quadruple heart bypass in 2011, I can say with confidence that it is being active, having a positive outlook, and staying close to people that heals pain, lessens our self-doubt, and gives us the power to remain ourselves—whatever our so-called age is!

I've got to get to 90. You think I'll make it?

DOMINIC LAI

70 | Insurance Agent, USA

INTERVIEWED BY THOMAS HOWARD

If I were to give advice to younger generations, I would share this Chinese proverb: 敬业乐群 (pronounced *Jing Ye Le Quen*). It means, "If you are dedicated, respectful, and joyful at your work, the whole group wins." If someone at work is unhappy, why not try to cheer them up? Win-win is the fruit of following this Chinese proverb.

It all boils down to attitude. If climbing the corporate ladder makes you miserable, then stop it!

ENRIQUE MOLÍNA CALICHO

69 | Woodworker, Bolivia INTERVIEWED BY ROXANA PANIAGUA MONTAÑO

Many years ago, I worked as a farmer. I was doing well. But one day I was bitten by a rattlesnake. I got medical assistance right away. I thought I was good, but after some months, the pain was more intense. I was in shock when doctors informed me that my leg had to be amputated.

This was very hard for me. How could I work and survive? I got depressed, and I thought of taking my life, but thank God for my wife and little kids. They provided strength and courage. One day I thought, why don't I do woodworking? I borrowed tools from my neighbor, and I started making a few things. My wife spread the word, and that's how I got into woodworking. If I did not have anything to do, I would die of boredom. I want to be useful and provide for myself. My work keeps me alive.

What I Learned from an Elder

YENIFER TATIANA VALENCIA MORALES

20 | Coordinator for Unbound, Colombia

INTERVIEWED BY ROSEMARY LANE

Editor's Note: Unbound, a nonprofit organization, sponsors children and the elderly.

RL: What motivated you to work with the elderly?

Yenifer: To know their stories. They trust their lives to me. I listen to them and understand them. Despite my young age, I try to help them, encourage them to better themselves, to continue with their faith. That motivates me to keep going.

This week, I asked an elderly woman, "Where do you sleep?" She started crying. I asked, "Why are you crying?" She said, "It is just that I am embarrassed because you have the look of a very rich girl." I told her, "Of course. I am rich. Rich in the smiles you show me, in the hugs you give me, in the stories you tell me. As far as the rest, I am just like you. Come on, tell me what is in your mind." She started to smile and said, "It's just that my bed is in really bad shape, and my house has many leaks. I sleep with my daughter because at home I get drenched."

Along with some friends from the community who are well-off economically, I am helping her fix her roof and buy a bed. Now, every time the woman sees me, she smiles. That delights me.

RL: How do you feel when you discover that someone lives under those conditions?

Yenifer: I did not cry with that woman because I needed to encourage her. But the heart gets wrinkled. Sometimes you feel powerless because you cannot say, "Here, Grandma, take this and go and fix your roof, buy food, buy yourself a bed, buy yourself a dress." But you can say, "Come on. Take my hand, and let's look for a solution together. Let's tell each other jokes so that the heart can get unwrinkled, at least a bit."

RL: Why do you think it is important for young adults to have a relationship with the elderly?

Yenifer: The elderly are the ones with the experience. They have already lived; they may have stumbled but got up and kept going. We don't yet have a history. They are the ones to guide us. I feel that I have listened and shared so much with the elderly that my life is in the path of what they have taught me.

Working with the elderly has been good for me in every aspect. I did not have the chance to live with my mother or father; I was raised by a far-removed aunt who was already an elder.

My mom never gave me a lot. But I will never leave her because the stories you hear from the elderly who are left alone are heartbreaking. So I will never do that.

RL: Do you feel like you are an old soul?

Yenifer: My sisters have told me that I am. [*laughs*] That I'm like a grandmother who sits and talks to them. I haven't noticed it, but many people have seen it in me.

RL: Why are you devoted to serving the elderly at age 20 when so many other young people are doing other things?

Yenifer: I have time to have fun, to go out, to take a walk. I have time for everything. I also have time to listen to the elderly. I love it. Grandparents will always be willing to tell you a story.

> "When Yenifer meets older people, she listens to their dreams, and this fuels her vision of the future."

POPE FRANCIS RESPONDS

I like what Yenifer says: "We don't yet have a history"! Those words belong to a person who is waiting in anticipation. Young men and women who are able to listen to older people are humble; they face life with their eyes open, ready to build something significant. Young people who have no time for their elders or disregard them do so because they have no sense of history.

Making history is not the same thing as surviving! Human beings were created by God to make history, not just to survive in the jungle of life. God says to Adam and Eve: "Go ahead, grow, multiply, make history . . ." To Abram he says, "Go ahead, get up, walk, look at the sky, look at the horizon, walk, go, make history!"

Our God wants to join us in our history. He mixes himself into our sins and into our failures. Just read the genealogy of Jesus in the Gospel of Matthew: God walks in the personal story of so many people, so many sinners. God is not ashamed to enter the story of so many sinners; he is not ashamed of his people.

Not wanting to make history is a parasitic attitude. Watching life from the balcony is wanting everything brought to you like a Christmas gift; perhaps a nice though useless gift that you quickly set aside. Yenifer understands that she is called to make history. This is why she listens to and understands the older people she works with. She learns from them. She learns by helping them. In fact, when she meets older people, she listens to their dreams, and this fuels her vision of the future. Go forward!

"An elder who has fought
for the future has a vision,
and it is a hymn to human
possibilities."

—*Pope Francis*

STRUGGLE

Pope Francis

I carry a medal of the Sacred Heart with me. It was a gift I received from a woman in Sicily who came to our house in Argentina to help my mom a couple of times a week. She was a single mother with two children, a daughter and a son. She had come to Argentina to work. This lady told us about the struggles in her life. She told me about the night she realized that her baby was about to be born. She was home alone, but she did not lose her presence of mind. She walked along the railroad tracks to the hospital, where she gave birth. What strength she had! I never saw her sad. After a while we lost touch with each other. She came to visit me when I was rector at San Miguel, but I was busy and had to let her know I was not available. How sorry I was! I felt horrible about it for years. Fortunately, I met her again. When I was Archbishop of Buenos Aires, a person who came to visit me was brought there by a taxi driver who happened to be this lady's son. I was able to reach her this time, which made me happy, and we met regularly for a few years. She came to visit me in the bishop's house, and one day she gave me this medal. I wear it every day, next to my chest, inside the white cassock.

I have it on my heart. It helps me face my daily struggles just as she did. Her medal of the Sacred Heart of Jesus helps me through struggles to this day. She taught me to fight! She died when she was 92 years old, leaving behind her children and grandchildren.

I also remember a nun I met in Bangui, Central African Republic. She was an Italian from Brescia who was over 80 years old. She had been living in Africa since she was just over 20—all her adult life! She was accompanied by a little girl, who called her "*Nonna*" (Grandma). The sister told me: "I came by canoe with this little girl. I was a nurse, and then I studied a bit and became a midwife. I have helped 3,280 children to be born."

"And this little girl?" I asked. She told me the little girl's dad had left and her mom was dead. She grew fond of the little girl, and after asking permission from her superiors, she adopted her. What courage! That woman is a fighter! She never surrendered to fatigue.

"She never surrendered to fatigue."

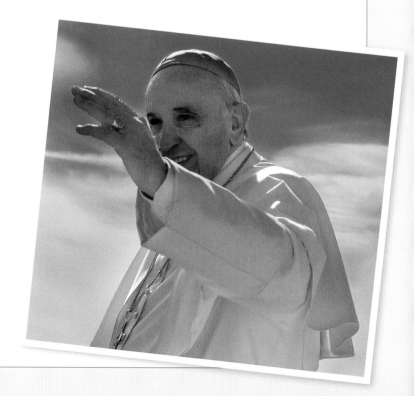

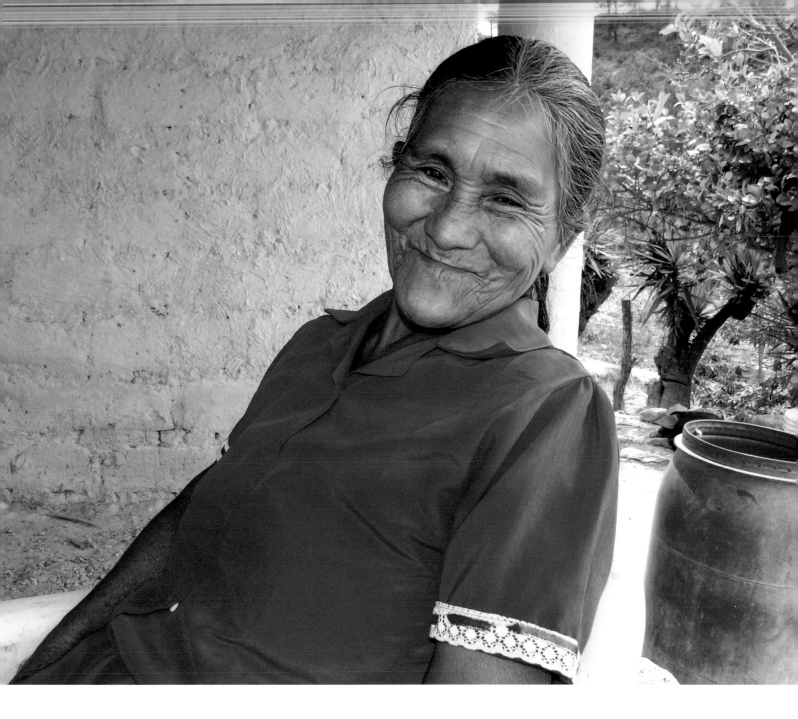

ROSA MARÍA GÓMEZ PADILLA

62 | Former Farmer and Potter, Nicaragua INTERVIEWED BY ENOC MARTINEZ

Our struggle is food, the production of food, because if we don't harvest corn or beans, we don't eat and we cannot buy it. I say to my husband, "Martin, to do our work, near or far, we have to get up early. If we start at 6 a.m., we have to be on our way at 3 a.m." We fight for our daughter. She is handicapped, and that is not easy. She cannot walk, and she's deaf and mute. I have to bring food to her mouth so she can eat.

There are times when I run out of everything and am without food. I don't complain. All we can do is work very hard. I was telling my oldest son, "Study so you can feed me later."

What matters most is that I have my children close to me. I have my sick little daughter, and I want her to always be around, but that can't be. When the day that she dies comes, it will be a long time for me to heal. I tell my girls, "I don't know what I will do when she leaves me; I can't know in this case." They tell me, "No, Mama. If God is in charge of her, it will be God's will, but you have fought so much for her."

That is the last fight we have, to keep fighting.

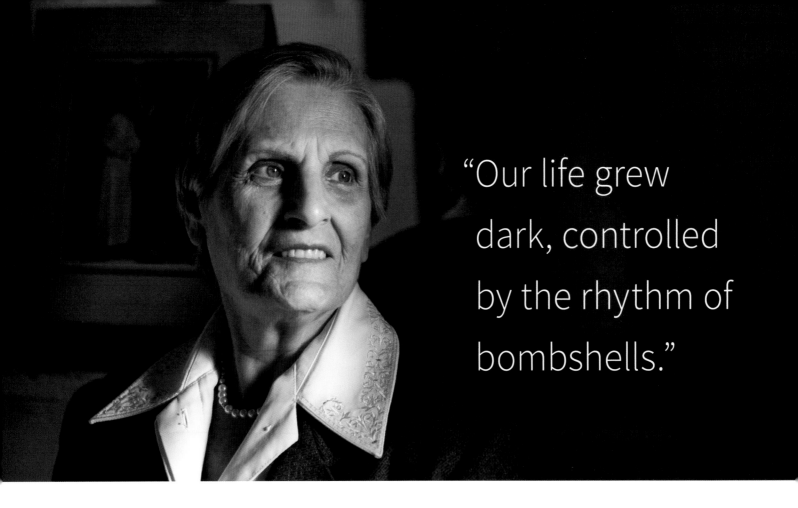

"Our life grew dark, controlled by the rhythm of bombshells."

JANET SHAABO MARDELLI

77 | Grandmother, Syria INTERVIEWED BY TONY HOMSY, SJ

I have lived in Aleppo my whole life. My family knew a carefree and comfortable life. But since the conflict in Syria began several years ago, everything has changed.

The first mortar bomb fell in our neighborhood on the day my older sister died, though she died peacefully minutes before the bomb exploded a few meters from her house. Then the losses began to mount: my friend lost an arm in a blast. Two buildings in the next street over were flattened by missiles. Two young relatives were killed, along with many, many others around us. Our life grew dark, controlled by the rhythm of the bombshells. We became prisoners of our fears in our homes. The price of everything doubled, if not tripled. The economic situation became a burden.

The biggest loss was the death of my husband. I am thankful I was able to bury him in dignity, just two days before the road to the graveyard was blocked. I could only visit him there once.

I feel like I lost all support when I lost this piece of my heart. Our relationship lasted 52 years. People who knew us called us "Romeo and Juliet."

I feel desperate at times. But after four years of his absence, I feel his love for me through our children. And sometimes I feel him touching my cheek or hear him calling my name.

I find myself at a new turning point. I am moving to Italy as a refugee. It is an uncertain adventure; I don't know where it is leading me. Feeling alienation is hard, and I don't know how to cope with it. At the same time, I know that any decision to stay will cause my whole family to be stuck in Aleppo, where there is no realistic chance to make a life.

The power to make this sacrifice rises first from my husband's love, which continues through the family. It also flows from the wisdom I learned from him: "Be decisive in your life. Don't cry for the present moment while standing confused between the yeses and the noes. Make a courageous decision, no matter what aspect of life you discern."

POPE FRANCIS RESPONDS

Janet's story is very current as we struggle with yet another global war, only this time the conflict is scattered in pieces around the world. Her story of struggle speaks to us of people compelled to leave their country, to migrate, and to flee from hunger or war. Janet has to flee because of war. She is moving to Italy from Syria. I talked to so many refugees in Lampedusa and in Lesbos . . . sometimes just for a few moments. I looked into their eyes, touched their hands, exchanged words, and saw their tears. These are courageous men and women who will not let themselves be overcome by difficulties. They struggle on despite everything. In the confusion of war there are people like Janet who have learned to be decisive. They may be in fragile circumstances, but they have not allowed themselves to be paralyzed by uncertainty or by swinging back and forth between "yes" and "no." Some are even willing to give up everything to save life, family, and memories. I came to know the wisdom of elders who had to flee from their roots. They spoke a "yes" to life. Their struggle is a "yes." It is the fight for life that arises from an inner wisdom. After so many setbacks, people can weaken in the struggle. They can grow tired and say, "All right. Enough, it's over!"

When people say that, they accept defeat. Unfortunately, I have seen that attitude many times. But, when I listen to Janet and her story, it confirms my faith in the inner strength that humans have to overcome the negative. That strength is a grace of God. An elder who has fought for the future has a vision, and it is a hymn to human possibilities.

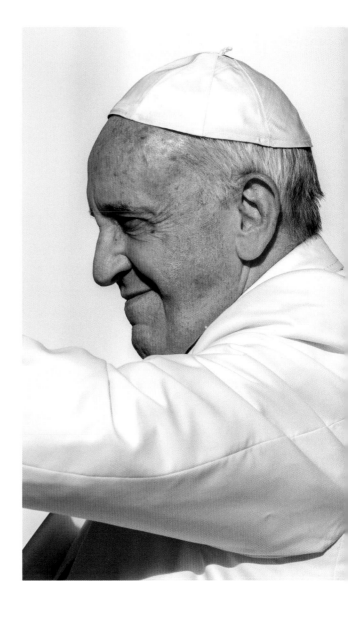

"An elder who has fought for the future has a vision, and it is a hymn to human possibilities."

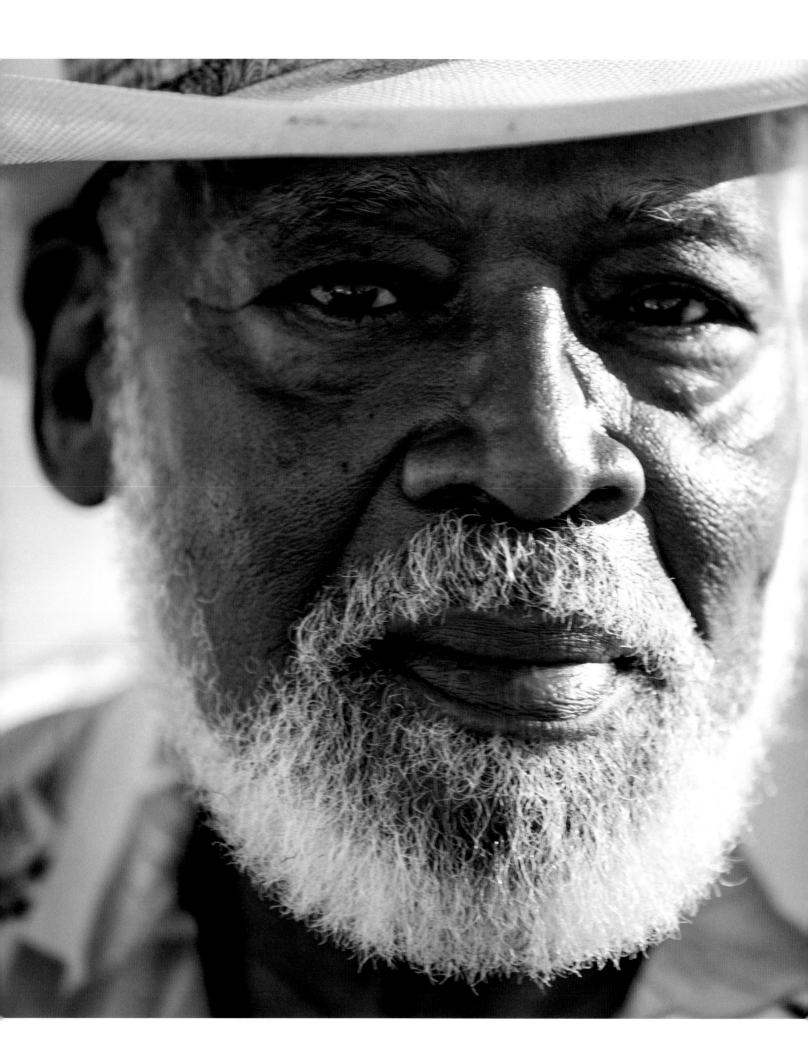

CASSUIS PAXTON

77 | Former Counselor, USA

INTERVIEWED BY EDDIE SIEBERT, SJ

Cassuis: We moved to the San Gabriel Valley in 1981, and kids threw rocks at my daughter for riding her bike down the street. Little white kids. [*motions throwing rocks*] The parents were inside those homes. The mothers, the fathers—they saw their kids throwing rocks at my daughter. Now I hadn't been that furious in a long time when that happened. My daughter is a very smart little girl. And you don't throw rocks at my daughter.

I walked up and down the block shouting at the top of my voice, "My name is Cassuis Paxton, and this is my daughter. We're gonna be here." That's all I said. We're gonna be here. So if you don't wanna see her, you got a problem. After that, the principal came to my house; the mayor came to my house; I had no more problems. Because I tell my kids: be here, live, do well.

ES: What can we do today to overcome such problems?

Cassuis: Go visit a church. Go visit a black restaurant. Go to a park. Have seminars and talk to people. You got black neighbors somewhere in your neighborhood, go meet them! You got Chinese neighbors, you got Muslims, go meet them, say hello. And I do—to strangers, all of 'em—I say "Hello, hi!" I feel better for doing it. And believe it or not, I get some great reactions, too.

DAMIJANA KRAVCAR

66 | Slovenia

INTERVIEWED BY JAN CELAREC

I have been an invalid since birth. I suffer from cerebral palsy. I have not taken even one step independently. That is why I was very sad in my youth. If I would not have been an invalid, I could have gone to the theater to work. I would have liked to dance, too. I could have danced so long that no one could stop me. But this is just a dream. Since the age of 10, I considered committing suicide several times. I still suffered very much as an adolescent. I could not reconcile myself to the fact that I was an invalid.

When I was 20 years old, I made a pilgrimage to Lourdes. At first I was against it, but some people made me go in spite of that. Being there changed me a lot. I met many people, both healthy and ill, but this alone did not make the difference. What did change things was how everyone helped one another if they could.

After I was back home for a week, my mother said that my face had somehow changed, that I looked happier than I had before. I was indeed, for I recognized what true life is all about. It means to love your own life and to live it no matter what it is like. It does not matter if you are ill or healthy. There is no greater happiness than when you feel that there are people close to you whose hearts are open to life.

Four years ago, I met the members of the Slovenian music group Nemir (in English, "restlessness"). I was so moved and inspired by their music that I began to write poems. I became aware of some of my qualities that I never realized I had. Today I know that life is worth living. I have to accept what I have and continue walking on my way with the help of my friends, who I always keep in mind, and with the help of our common Friend.

"Having confidence is a form of passive struggle."

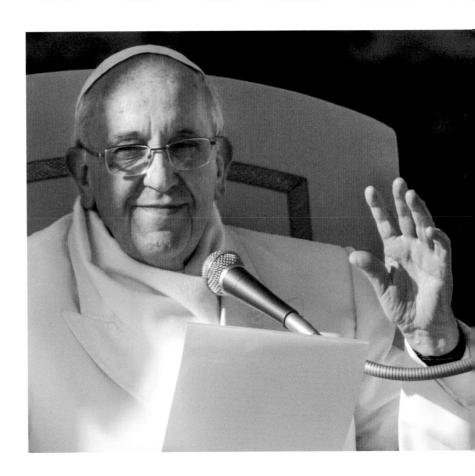

POPE FRANCIS RESPONDS

Damijana experienced a childhood illness so serious that it could have entirely prevented her from having a happy life. She seemed to face insurmountable obstacles. As she grew older, she dreamt. But all her dreams were dashed: wanting to walk, to run, to dance. As a young person, how could she give up her dreams? There is no wisdom in just giving up. Now, at a certain point something changed: she went to Lourdes, where she witnessed the real miracle of people selflessly helping one another. This experience opened her eyes. She found she was not alone. What really strikes me is that she did not go in search of salvation. She let other people bring her. She did not realize that after her trip to Lourdes, her face had changed. Her mother told her. She allowed this change to happen and grow. She did not fight it. And then she opened, she blossomed, and she discovered talents and abilities. She discovered poetry. Now, after many years, she cherishes this wisdom.

Sometimes one's struggle is like that. It begins in a passive way. You accept the struggle by overcoming your resistance to change. Having confidence is a form of passive struggle. Passive struggle means accepting what happens to me. I accept, and then I discern the future. I learn to understand how to go forward in life.

YVAN BOQUET

84 | Parish Coordinator, Belgium

INTERVIEWED BY CHARLES DELHEZ, SJ

A few years ago, I was close to leaving this world. My doctor gave me a frightening diagnosis, and I could feel all life leaving my body.

I remember well the white wall in front of my hospital bed. There was a crucifix, a television set, and a clock ticking time away slowly. My gaze always returned to the cross. Jesus accompanied me in my suffering. I felt his presence beside me.

Thanks to the support of my relatives and community and the medical team who cared for me, I survived. I'm a medical miracle, doctors say. My illness was an "experience of life" rather than an ordeal. I perceived things I did not see before, and I now see God's presence in everything. I cannot live without him. My faith is much stronger than before I was sick. As St. Paul said, "For when I am weak, then I am strong."

Is suffering necessary in the experience of faith? Did not Christ himself undergo suffering to save us all? Our suffering puts us in tune with him. I do not wish suffering on others, but it can lead to an awakening of faith. It must be accepted as such.

From this adventure through illness, I received new ardor. Every day that God gives me, I feel devoted to serve others as God and others have served me.

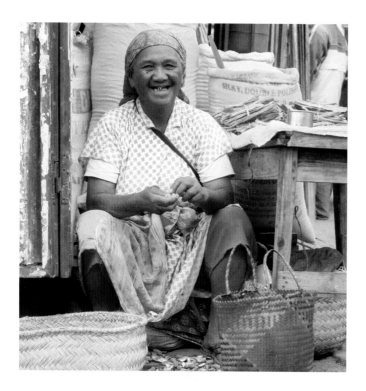

FLORINE RAZAFINDRABEZA

74 | Peanut and Firewood Seller, Madagascar

INTERVIEWED BY ROVAH RAMANANJANAHARY JAQUIE ARMAND LALAINA & ONJATAFIKA RANDRIAMALALANOMENJANAHARY

Editor's Note: *Florine had seven children who all passed away, as did her first and second husbands.*

I remember every ordeal that the prophet Job had to face during his life. Compared to him, every test that God gave me was nothing. But the most important lesson for me was that when God makes us pass through difficult trials, he is already preparing a solution. And behind a "no" coming from him is always a bigger "yes." Trust in the guidance of our Lord.

MARGARET O'REILLY

77 | Retired Teaching Assistant, Northern Ireland INTERVIEWED BY PAT COYLE

Margaret: When I was about 9 or 10, I came home from playing with a friend to find my mother quite distracted. She had gone to the shop next door—where she rarely shopped—and they asked her to pay for the oranges I had bought. She was mortified to be asked for the money because the people at the store didn't know her all that well.

My mom asked me, "Did you buy those oranges?" I told her, "No." My mother slapped me for lying. She asked me again, and I thought maybe I could get out of this by admitting to taking the oranges—which I hadn't. I lied, and then I got another slap. This went on, with me saying that I *did* buy the oranges and then that I *didn't* buy them. Each time I got a slap. No matter what I said, she wouldn't believe me.

There was a loud knock at the door, and the shopkeeper who had asked my mother for the money was standing there crying because, being next door, she had heard all the goings-on. She was devastated that I had been blamed in the wrong. A woman who had sent her daughter for the oranges had come in to pay for them, and the shopkeeper realized the injustice she had done.

She said how sorry she was and gave me a huge bag of sweets.

The thing I regret the most was that I should have stuck to the truth. If I had stuck to it, eventually my mother might have believed me. Because the truth will set you free. Lies are like a rock in a big chain around you, and it just gets tighter and tighter. It's very easy to lie, but it's also destructive. When we're lying, we don't realize just how far the lie is going to go.

PC: You grew up in the North of Ireland, and your city was a war zone during the thirty years of the Troubles. There were many lies told that got people thrown in jail. It can become endemic in society.

Margaret: Absolutely. Once it starts, there is no end to it. It's like throwing a stone into a pond. The ripple just goes on and on and on. I always tell children the story about the oranges, how it affected me, and how they need to think about what they are saying. And that even a small lie is not a good lie.

PC: And the truth will set you free.

Margaret: And the truth will set us *all* free.

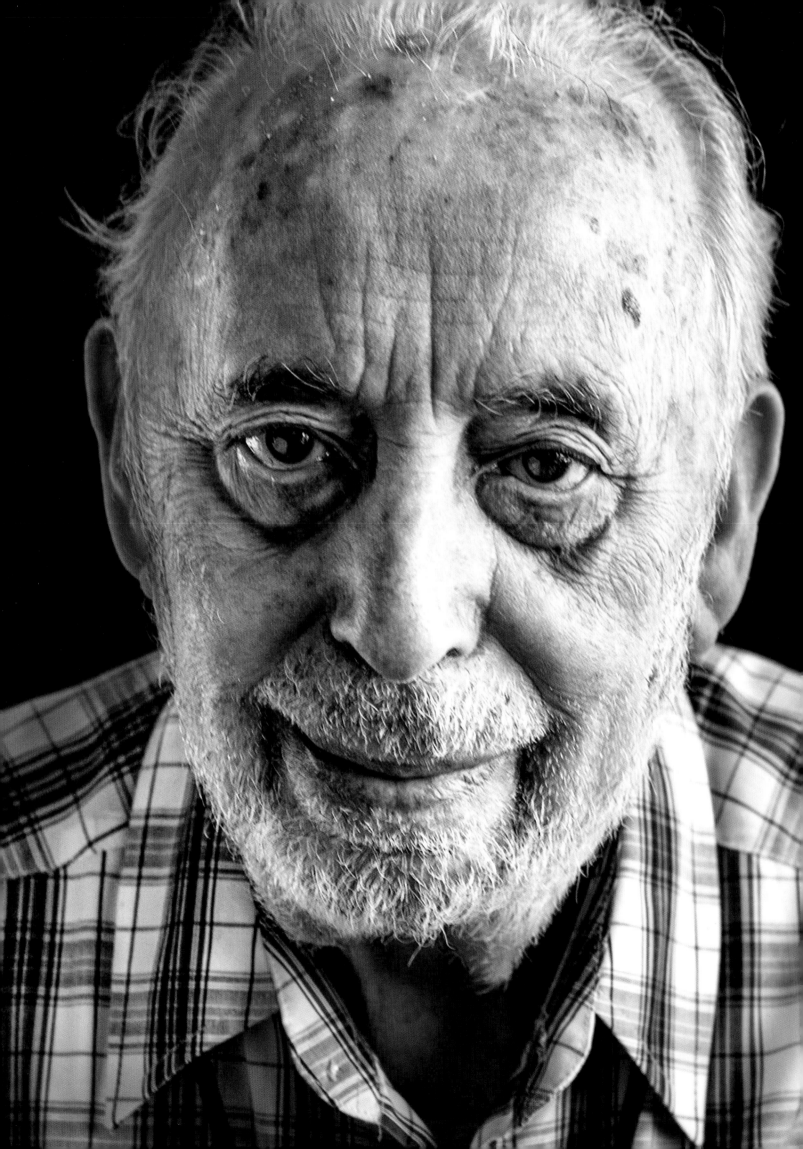

"I can still feel my father's hand leaving mine."

ERWIN FROMAN

89 | Former Grocery Store Owner, USA INTERVIEWED BY MAURA ZAGRANS

In 1944, Gestapo soldiers came into my village in Romania, rounded us up, and put us on trains that took us to a ghetto and then to Auschwitz. It was chaos getting off the train. We were in a daze after traveling three days in the car, and we got out to the inmates yelling, "Out! Out!" and German shepherds barking. I never saw my mother or my sisters getting off the train. But me and my father walked hand in hand to where they selected if you go to the right or the left.

My father approached a Nazi soldier and told him he was a first-class tailor and that he was willing to work. The soldier asked how old he was. "Fifty-six." The soldier told my father to go to the left. When I tried to go with him, the soldier hit me in the shoulder with the butt of his rifle to separate us. I can still feel my father's hand leaving mine. I never saw my father or mother again.

So when I watch the world news every night and I see refugees from Syria, I see myself in them. Like them, I left home carrying everything I had on my back. And just like in the mid-1940s, the world is not responding. They're killing their own people in Iraq, Pakistan, Afghanistan, and Syria. Right here in this country, more than 700 people were murdered in Chicago just last year.

We cannot solve these problems. But we can pray. And we can be kind to one another.

I speak to students in high schools and hope that my story will have meaning for them and they will learn from my experience that we are all created equal. There should be no hatred. Will that happen? I hope it does.

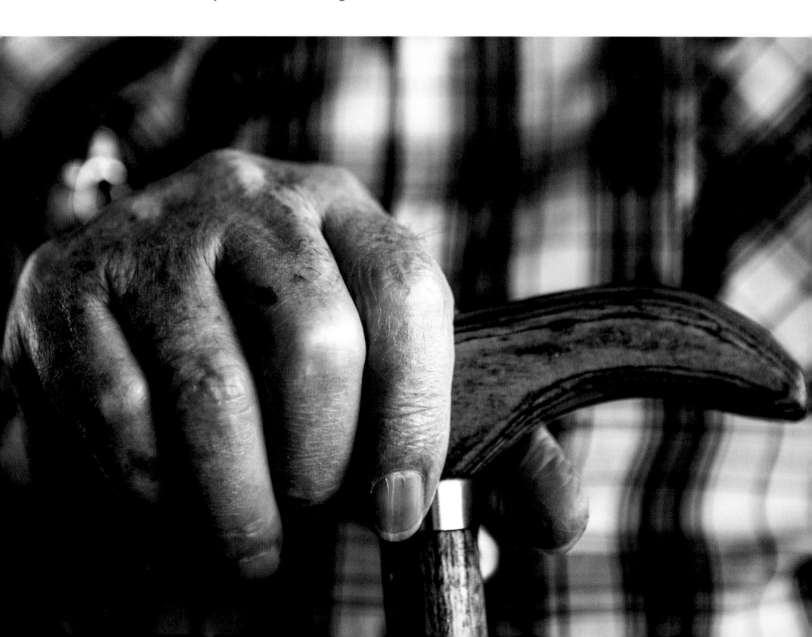

"You can fight with the smile and with the readiness to be kind to others."

POPE FRANCIS RESPONDS

I feel so much pain in Erwin's experience. This man who experienced the tragedy of World War II. Today he has the eyes to see the tragedies of the present. And the wisdom of his 89 years causes him to ask the question, *What can I do for the future?* His dream is for a world that no longer has the marks and scars of what he experienced as a young man.

As an older man, Erwin reminds us of one simple thing: you can fight with the smile and with the readiness to be kind to others. Readiness is a form of struggle that conquers the cruelty of indifference and the tragedies that TV news and other media bring to our eyes. Sowing goodness, then, can mean looking each other directly in the eyes, not being afraid to shake others' hands, and offering our presence and the gift of empathy and understanding. Each

one of us can recognize we are sinners. We all suffer. If we can discover the solidarity that connects us all, then we can learn to look at ourselves with an accurate understanding and realize that we are all people in need.

A priest once told me that when his mother sent him to the market, she always made him buy some extra groceries. Once she told him, "Bring it to that family over there." And another time she told him, "Bring it to that other family over there." A society in which selfless love disappears is a twisted society. No, we cannot solve all the problems of the world, but we can treat ourselves with goodness and care for one another. That is our dream for a better world.

LENA PHUA

72 | Wife, Mother, Grandmother, Singapore

As we approach our 50th wedding anniversary, I have to admit that, despite countless attempts to keep it afloat, our marriage has been for the most part a failure. From the beginning it was a struggle—two very different people with very different values. To the unsuspecting public, we presented an enviable façade. But for years, my marriage had been getting worse.

At one point, God intervened. My wise daughter brought me to a Benedictine monastery for a three-day stay. I made the journey reluctantly. But the silence spoke to me. At the end of the second day, I wept my heart out in the chapel. I realized that I needed to find my God if I was to survive the struggles in my marriage.

It hit me like a sledgehammer that my practice of religion was just that—practice. I was not living my faith. I plunged into despair. I prayed for an end to the struggles in my marriage. I longed for peace, which seemed unattainable until a wise old French priest shared that peace is not a cessation of conflict; real peace lies within me. And so I persevered.

Along this journey, the Gospel of John convinced me that despite my faults—and they are many—God loves me unconditionally. All my life I felt that I had to perform to the best of my ability if I were to be loved—by parents, husband, children, friends. The Gospel debunked that belief. For the first time in my life I felt loved. Period.

Now, at age 72, I soldier on, but now I do not soldier alone. In my faith I have found contentment.

REV. PATRICK RENDER, CSV

75 | Pastor, USA INTERVIEWED BY TOM MCGRATH

When I finished my term as provincial after 25 years in the priesthood, I was given time for a sabbatical.

That year put a lot of things in my path, some that were temptations and some that were frightening. Some were invitations. Someone asked, "Are there other things you might be called to be or to do?" I did a lot of soul searching, going to spiritual direction and psychotherapy. I also took a class from an artist who taught us how to draw and paint like children, who can spontaneously pour out what they're feeling on the canvas.

A lot of my early paintings were full of turmoil, full of fire and destructive things. I did a painting of rats crawling all over me and tearing away at my flesh. This all came out of *me*! Toward the end of the sabbatical, however, I painted myself coming out of the water onto dry land, with flowers growing out of my body, signs of new life emerging from within me.

I witnessed the patience of God during that year of searching. It wasn't like God was sitting there impatiently tapping his foot, waiting for me to come to this point. It was God working patiently within me, bringing me to the place where I could be comfortable in myself, with myself.

I meet with a lot of people approaching death, and some of them worry about mistakes they made earlier in life. They wonder, *Did I really confess this? Did I tell the whole truth? Did I really change, or did I keep doing the same thing in new ways?* They have anxiety about facing God with the possibility that they haven't yet "got it right." And that's where the patience of God comes in.

You may make stupid choices. You may fall on your face. But the parent who never gives up on the child is the God who never gives up on us.

MARÍA TERESA VALDÉS

84 | Former Catechist, Mexico INTERVIEWED BY IGNACIO GUZMÁN BURBANO

I have had many experiences in which I've felt God's presence. One of them was when my third child, Javier, was born very ill. They had to give him several blood transfusions. After that, a nurse told me, "The blood that was given to your child was infected with hepatitis." There was no doctor, no pediatrician. My husband was not there. I was desperate and felt a profound sadness.

My mother shook me and said, "Don't you believe in God?" I told her, "Yes, I do. I do believe! So much that I give him my son." In that moment I felt a peace come to me. In the midst of my sadness and anguish, a peaceful presence was there.

My son got well, thank God, but years later he had another serious illness and the story began again. This time, my daughters were 10 and 8 years old. They grew jealous of my son because my focus was just on him. He couldn't move, and we didn't have any idea what would happen to him.

Every night I would tell my daughters, "Let's pray for Javier to get well." One day my two daughters told me, "We don't want to pray because Javier is not getting better."

It was in this moment that I realized I was wrong. I shouldn't pray for Javier to get better. I should pray to God to make the union in my family stronger, to get closer and stay together to help Javier come out the best possible way.

From that moment on, our prayer was to give thanks to God because he was allowing us to be together, helping Javier in his illness. And the dynamic in the family changed completely. This was God's way of telling me, "This is not the right way. You're wrong, my little one."

POPE FRANCIS RESPONDS

María Teresa's is a story of solidarity that strikes me very deeply. She faced many medical disasters but did not heap abuse upon the doctors or lay blame on them. She fought with prayer, and did so hand in hand with the Lord. A battle of the people of Israel comes to mind. Moses lifted his hands and held them up for a long time in prayer to encourage his struggling people. María Teresa struggled for her son's health. She also fought for her family's unity. She sought to convince her daughters to fight as well. She learned how to involve the whole family and to find the right ways to do that.

I am thinking of a family from Buenos Aires. The couple had a nine-year-old daughter who suffered a serious infection. The septicemia was so serious that there was little hope she would survive. At six o'clock in the evening, her father decided, "I will go to Lujan." Lujan is an important shrine dedicated to Our Lady about 70 kilometers away from Buenos Aires. The night came. The church was closed. This man clung to the shrine's gates and, in his struggle, prayed that the Madonna would see that his daughter was healed. He returned to the hospital at six the following morning. He saw his wife in the waiting room and not in the daughter's room. He thought his daughter was dead, but instead, the fever had broken. The doctors did not know why. That man went back to Lujan and went to confession.

Think about it: you? me? Would we have the courage to spend the night as he did? Prayer can mean engaging in a heartfelt struggle with God.

> "Prayer can mean engaging in a heartfelt struggle with God."

ROBERT HAMILTON

67 | Attorney, USA INTERVIEWED BY TOM MCGRATH

Times of struggle challenge us to be honest with ourselves. They help us recognize when we are trying to rationalize something we want or want to avoid instead of concentrating on what is the right or just thing to do. The hardest lesson can be overcoming fear—fear of failure, fear of personal loss, fear of embarrassment—because decisions informed by fear almost always lead to the worst results. Faith in what is right and true and just must be the guiding principle.

JOSEPH GICHERU CHEGE

83 | Former Artist, Kenya INTERVIEWED BY REGINA MBURU

I remember seeing soldiers coming home after the war in 1945 when I was a young boy. We were scared. We were told that Hitler and the French and British would be coming to Nairobi to have some tea and that we should put out our lamps. The French ended up settling in Isiolo, the Germans in Kilimanjaro, and the British Empire took over our country. That was a big deal—it shocked us all. We used to eat our food in the dark because we were afraid of getting bombed.

Later, there was war between the Mau Mau and the British. I was arrested in April 1954 by the British Air Force because I was a Mau Mau soldier. I was detained for almost four years.

It was hard labor. We used to carry stones in buckets, bury people who died in the camp, and wash toilets. It was mostly unpleasant work. We were supervised by soldiers carrying guns in military trucks. I was in Manyani camp. There were so many of us—almost three or four hundred thousand—at Manyani. I saw many people die. There was no tea, just dead bodies to bury. It was such grief and endless tears. I cried so much, my stomach would cramp and I would just wait for my death.

Death can shake you and leave you in deep sadness. Your blood loses its strength for a while. But God gave me strength, and I was able to bear it. That experience taught me that there is nothing too big to handle. Anything can happen at any time. You have to find the strength in you.

"I had lost hope, but now it has been restored due to the love of others."

CHRISTINE NAMPANDE

70 | Gardener, Uganda INTERVIEWED BY JANE BUTANSIRA

After my husband died in 1989, his relatives attempted to evict me from our family house and land. I decided to rent land for cultivation. I had to travel four miles from home to that land every day with a child on my back. But I thank God that I reported the case and the judge was true and fair. Both properties were returned to me, and it's where I am now.

I have tried my best to look for money to put up a strong house because the one my late husband left behind is not strong and might fall any time. However, I thank God because I went 10 years without sleeping on a mattress and a bed, and now I have them and sleep well.

If it wasn't for the love people showed me after the death of my husband, I don't think I'd be alive now. My children are unable to support me, but it's the support of others that has made me survive. Before, I had lost hope, but now it has been restored due to the love of others.

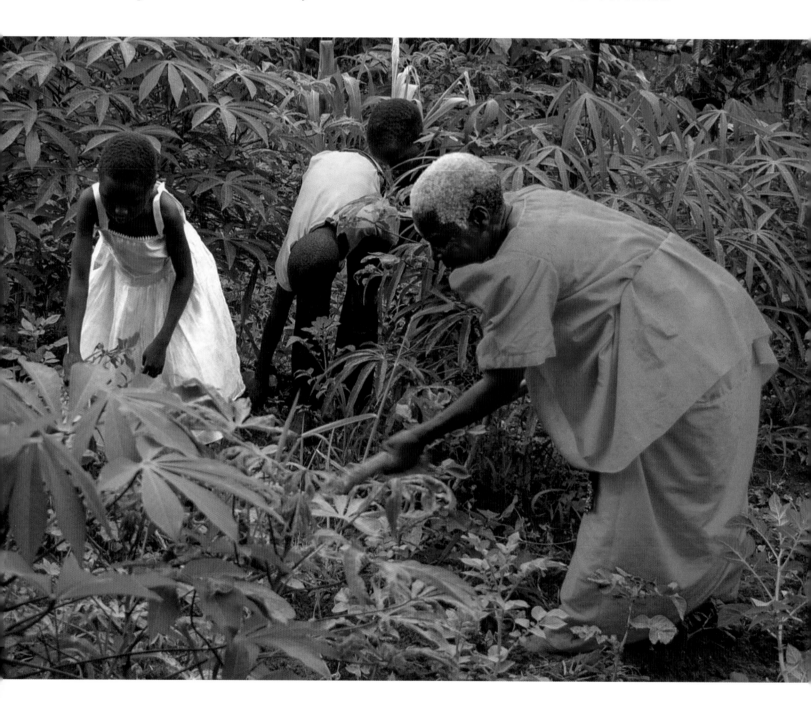

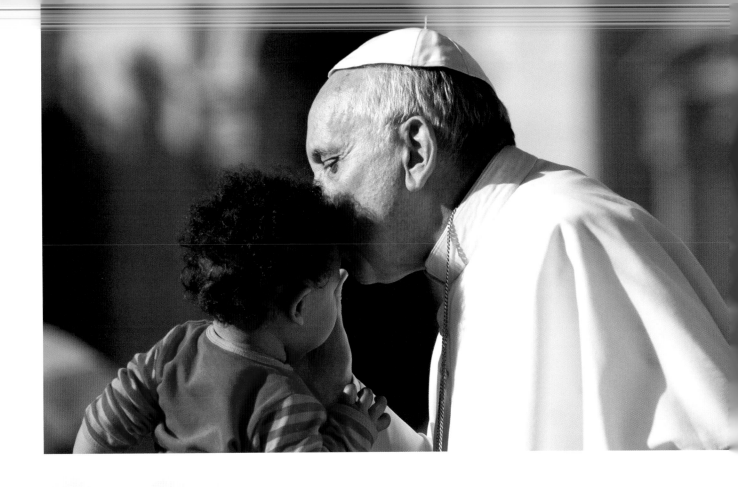

POPE FRANCIS RESPONDS

Christine's words make us pause and think: before, I lost hope. And now I find it again thanks to the love of others. She lost her husband and had to face so many difficulties and injustices. But taking the next step toward what is important is how you get back on your feet. I once heard a motto that I liked: "A man must never look at another from above, except to help him lift himself up." Christine met people who helped her lift herself up.

"Get up" is a word that launches new beginnings. It is the command that God speaks to Abram: "Arise!" God says to him, "Look at the sky! Get up and see! Try counting the stars!" There are people who fall and stay down because they cannot find someone to help them stand up. Once you have experienced what Christine did, you learn the wisdom of getting help. You experience the solidarity that allows your heart to dream. Now Christine is helping others rise up. Her children are unable to help her now, but with her dreams for them they can envision a brighter future.

Franciscus

"Once you have experienced what Christine did, you learn the wisdom of getting help."

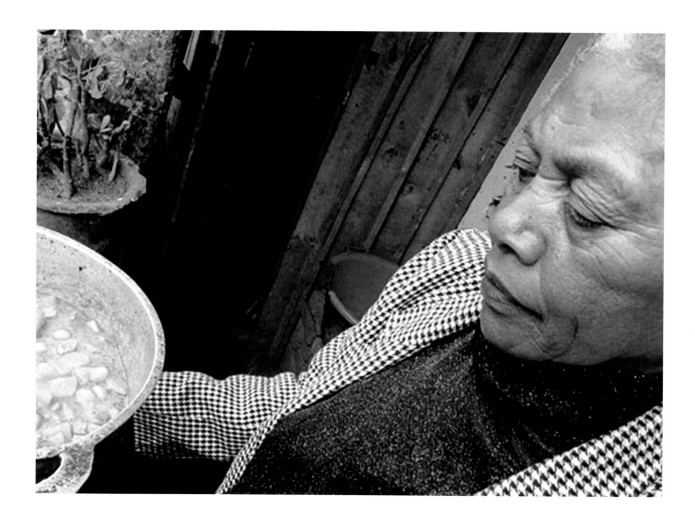

RAZANAMIALY SIMONE

65 | Flower and Squash Seller and Launderer, Madagascar

INTERVIEWED BY VONJY RAZAFINDRANDRETSA-SOA NINA RUPHINE AND ONJATAFIKA RANDRIAMALALANOMENJANAHARY

The last of my sons died in 2003. I could not accept his loss, so I became an alcoholic. I was like a slave to alcohol. I worked by washing people's clothes, and as soon as I received my salary, I would drink. My daughters stopped helping me financially. I stopped going to church. I felt very alone. Eleven years later, I got sick. My feet and knees began to give out. In this condition, I realized that alcohol could not resolve my problems. I had caused a lot of damage around me. My community saw me as a kind of parasite.

But with the grace of God I changed. I continue to work as a laundrywoman and now have some savings. My community does not see me as a parasite anymore. I have a good relationship with my daughters. They give me pocket money that

I use to buy yogurt. I even managed to improve my house; there had been holes in the roof for years. And I was blessed in another way: caring people took me to the doctor and helped me get better. My feet and knees feel better.

It was God who took me out of the darkness. God was patient. He gave me a long time to change and tested me, so now I know how deep my faith is. God showed me love. I was a very big sinner, and he received me in his heart when I started to change. Now I go to church every Sunday. I feel more freedom in my life.

Temptation will never disappear in this world. So, my dear, put your life in the hand of God because, trust me, there can be miracles when you believe.

CELSO EMILIO LOPERA JARAMILLO

76 | Former Farmer and Day Worker, Colombia

INTERVIEWED BY ANDREW KLING AND SOL ROBLEDO

After living in my town for 40 years, I had to leave because of the disappearance of my 16-year-old son. I had to save my other children. We walked for three days to reach the town where other family members lived.

Two years later, the situation got worse with the guerrillas and the paramilitary. We moved around looking for a safe place, doing farm work for a daily salary. There were days when I didn't have enough to eat, but I wouldn't let my family go hungry.

The strength to keep going came from God. I still don't have much, but I feel grateful for God's mercy. The Lord helped me keep my other 10 children safe.

I never wanted revenge for my son's death. I have had very bitter days, days when I was so angry at the people who took my son's life, but I had to be strong for my family. You don't pay back people who have hurt you. You should never look for revenge. It is hard. But you have to keep living. You have to forgive from your heart. This is very difficult, but you have to do it.

I have always lived kneeling before God. Now, I ask God to help me buy some land. I am starting to see a beginning again. God has not abandoned me.

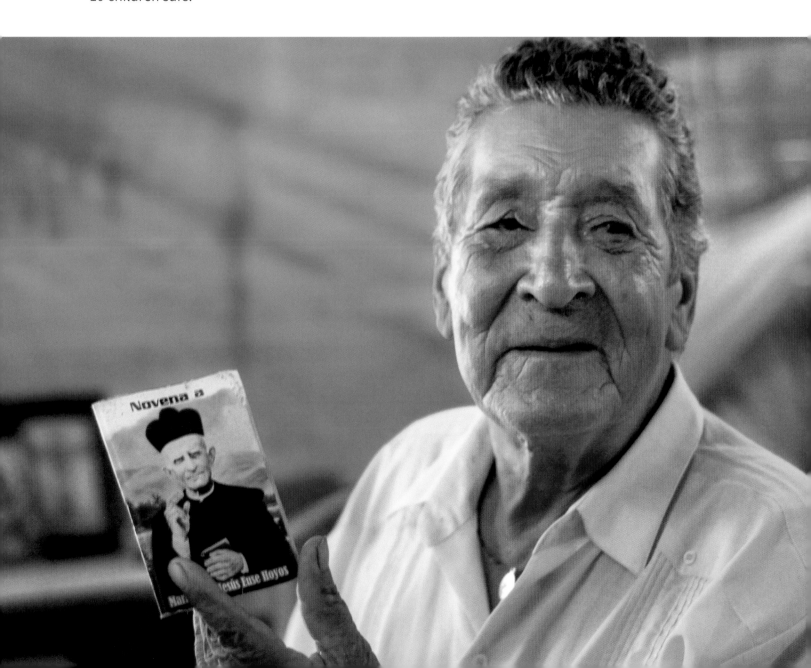

TONY AND GRACE NAUDI

71 & 65 | Retired Company Director, Former Assistant at a Planning Authority, Malta

INTERVIEWED BY ROSEMARY LANE

Tony: We had a period of troubles in our marriage. I used to work in the conference management business, so I had a lot of meetings and events.

Grace: Long hours.

Tony: Especially on the weekends.

Grace: Overseas trips.

Tony: It was quite an exciting job. That was at the peak of my career, and it was also when our marriage was suffering the most. We had some issues, and they were the result of me following my ambitions instead of paying attention to my family and my commitment to marriage. But the Lord had different ways of dealing with this matter. I lost my job, which was a big blow for me. That started putting things into place, and I began to understand why it happened. In fact, I had to change my career completely.

I started from scratch by being a receptionist in a hotel at night. In the morning, I was a freelance salesman. I started moving from one hotel to another until I became sales manager in one of the hotels.

When you reflect back on your own path, you can recognize, "Oh, this is why it happened. That just saved my marriage." Everything is intermingled, and it's a plan that you don't figure out and you cannot put on paper. When it happens to you, you will understand that there is somebody who is actually playing the game of chess and you are not the player.

Grace: You want to get on in the world, you want to be a success, and you think that's really important. But in the end, that's not what's most important. The important thing is to find yourself, to know yourself, and to be grateful for what you have. You tend to exclude the frivolous things when you come face-to-face with hard facts. Then you know what is important.

Tony: Very often when we talk about discernment, we're choosing between two options: this or that, A or B, B or A. I once heard a priest say that there is only one choice to make: do you want to go with God's plan for you or not? Because if you decide to go with God's plan for you, you'll then ask yourself, *What mission has he got for me? What is my call in life?*

Grace: It happened to us. We were trying to follow the Lord, and he showed us the way.

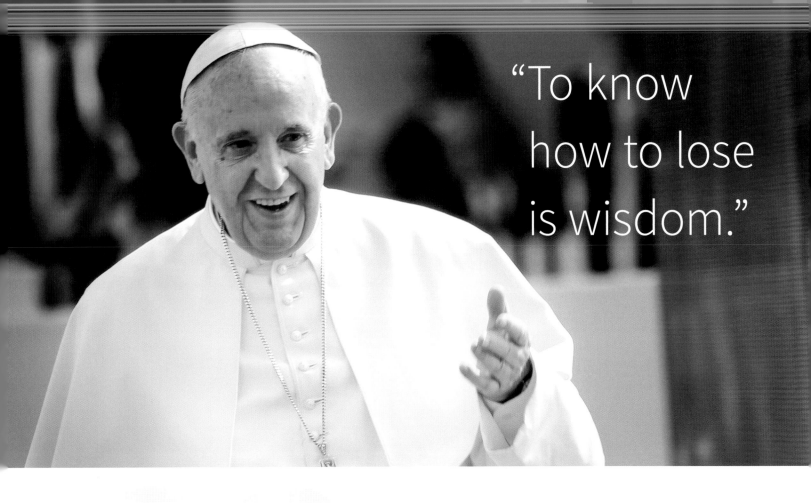

"To know how to lose is wisdom."

POPE FRANCIS RESPONDS

Tony and Grace had everything and lost everything . . . But no! It is not true—they had each other! That was enough to start over. A poem by the Argentine Jesuit poet Osvaldo Pol comes to mind. He concludes with the words *saber perder es la sabiduría*: "to know how to lose is wisdom." Such wisdom enables us to start over again. It is the ability to know how to lose.

I know this from experience. My dad was an accountant. He worked in the family business. It was an asphalt company. But in the economic crisis of the 1930s my family lost everything— even the family chapel at the cemetery! My grandparents and dad took out a loan, and they bought a grocery store. They started all over again. They had the wisdom to know how to lose. They had a dream that rose out of their failure. My dad, the accountant, went around delivering food home to home with a basket in his hand. This lasted until he found a new position as an accountant. To begin again—this is the dream! I like recalling a song of the Alpine troops: "What is important is not the falling, but to not keep lying there on the ground." You can say, "I've lost everything, I fell down!" Yes, but do not stay there on the ground! Get up and go forward. I love those brave families who struggle to go on, even though they may have to ration out bread so that there will be enough for later. They go forward. These families know how to fight. They also know how to make good decisions. They know how to discern and feel within them the courage that comes from God.

PAULA SALGADO PONCE

75 | Former Tortilla Maker and
House Cleaner, Honduras

INTERVIEWED BY FRANSIS
GARMENDIA

My husband got sick and never got better. I tried for five years to help him heal, but it was in vain. He passed away when he was 42. I was alone with my kids and without my parents, but I never gave up.

I said to myself, *I'll keep fighting for my kids!* There were times when I only had a few tortillas to feed them. I would bite a small piece of a tortilla to save the rest for them; there wasn't enough for me to eat the whole thing.

But all those bad times finally passed. I feel like the light has come to me. I can't say that my life was always bad because God was always there lighting my path. I never lost my faith in him.

"All those bad times finally passed. I feel like the light has come to me."

"My parents would make everything stretch like a piece of gum."

MARÍA DOLORES DE GUEVARA RIBADAS

80 | Spain

I was born in the middle of an air raid during the Spanish Civil War. A year later, my father, who was a pacifist, was arrested and sent to Valencia to serve in the Civil Service unit. My mother was left alone with me. This was a very precarious time. We relied on government food distribution that took place from time to time. We had a neighbor who would give my mother an egg every day for my nourishment. This neighbor took the egg from the house where she lived—the Commissioner's home—where, paradoxically, there was an abundance of food.

The war ended in October 1939. We were all reunited, but more hardships followed. Food was scarce. Rationing continued. My grandfather came to live with us, as did one aunt and her two-year-old daughter. My brother and I shared the same bedroom with our parents. My grandfather slept in the living room and my aunt in the space under the stairs that led to the apartment above.

My parents would make everything stretch like a piece of gum. I remember my parents having only

bread soup for dinner from the leftover ration bread. Even in this situation, my mother would share with an old lady who often came to beg. Despite what this might look like, there was always happiness at home. We sang and looked at life with optimism. Overcoming challenges was a constant in my parents' life.

My parents taught us how to pray, how to trust God. They showed charity and mercy toward many people who crossed our path. They lived with an attitude of service, clearly seen in their actions—their arms and hands always ready to embrace and support others. Years later, when my mother got sick with Alzheimer's, both of my parents came to live with my family. She passed at the age of 79. My father lived 16 years longer. He was 95 when he passed away.

My parents and their perseverance have left a deep mark, and I give thanks to God for having been able to look after them until the end of their lives.

ANN GARNETT

72 | United Kingdom

It had been just a few months since the ending of my 43-year marriage. I was feeling emotionally bruised and battered as I went for a long walk in the Welsh hills with an old Jesuit friend. This friend had accompanied me through all the years of struggle.

He asked me, "How are you feeling?"

My responses, all confused and contradictory, tumbled out: "Angry, fearful, relieved, stunned, resentful . . ."

He stopped right there in the path and turned to face me. He cupped his hands, as if holding something precious. "Nurse your resentment," he said. "Nurse it like a candle flame, and when you are ready, you blow it out."

I was shocked. How could it be right to "nurse resentment"? And how would I know how and when to blow it out?

Three years passed. I often thought back to that moment and that strange but wise advice. Then a series of unexpected events happened. It began with a time of prayer during a retreat that opened up areas of the hurt I had not, until then, even recognized in myself. There followed the certainty that sometimes comes in prayer that I needed to have a conversation with my ex—and I realized that I was very uneasy about initiating it. Then came the opportunity—and I missed it because of my fears. Then came the second chance, the very same day. We held the conversation. We moved on. Something shifted.

A few days later I was startled to realize that I had blown out the flame of my resentment without even noticing I was doing it. The timing and the moment were God's. All that was asked of me was that I should respond to the moment.

After that, it was a great deal easier to walk on into an unpredictable yet much more amicable future, freed of a burden my heart was never created to carry.

POPE FRANCIS RESPONDS

There are times in life that invite us to stop, to look at the horizon, and, as Ann did, to take a walk. There are times when we really need to break away and take a breath of fresh air and go out for a stroll. This helps us get out of the grip of pain and away from the harsh slap of fate. Ann's fate is a marriage that came apart after 43 years. "What will I do for the rest of my life?" she would ask herself.

Life sometimes gets us in a tough spot. We can react to a failed marriage with bitterness. But I must say that even behind a broken marriage there is always a caress of God. Failure is not the last word. Failure always has a door that opens: woe to you if you turn it into a wall. You will never be able to get free. It can be quite difficult to find that door! And yet it is the only door that opens up a future for you and gives you a larger horizon.

Bitterness traps you in a lump of resentment. There is a good Argentine tango called *Rencor* [Rancor, in English], and it describes a "vile hatred that runs through my veins" that renders "life bitter as a condemnation." "The evil they have done to me," the song continues, "is a running wound that fills the chest with anger and bitterness." But in the end, maybe rancor is another name of love. You have to dig in these depths. Failures are messages. They tell us something about our weakness, human misery, our egoism, our contradictions. These messages present you with a choice: either you choose your life or you choose death. Praise and petitions brought to God prevent the heart from hardening with resentment and selfishness. Ann began a journey to find the Lord, and now she helps others in their spiritual journey. The goal of the spiritual struggle is to choose life. In this struggle there is great wisdom.

"Failure always has a door that opens."

What I Learned from an Elder

SHEMAIAH GONZALEZ

42 | Writer, USA

Dr. Weinstock was my Victorian Lit professor. He was known for being a tough grader, so I started going to his office hours. Every time I went, we'd end up talking.

Relationships mattered to him. I felt that he was really interested in me, cared about me, and had all the time in the world just to talk. When our class got out late, he'd walk me to my car and wipe the windows off with newspaper from his briefcase while I waited for my ancient defroster to work. He'd stand on the curb waving as I pulled out into the dark.

I'd always struggled with depression, which he knew from reading my poetry journals for one of his courses, but that last year of college, it debilitated me. He didn't have me for a class that semester, or I think he would have noticed the signs. I'd missed classes. I was behind on coursework. I'd sleep too much or not enough. Everything overwhelmed me.

One night I felt so alone. I couldn't turn to my parents. My boyfriend and I had broken up. I had confided in an aunt that day who told me I should just pretend I was happy and the rest would fall into place. I was so close to graduation, but I was terrified to move forward and complete the work. I didn't know if I could. I felt paralyzed. So I called Dr. Weinstock.

As soon as he picked up the phone, I started sobbing. I finally got my name out, and he wasn't irritated by my calling. He was concerned. He talked me through my anxiety and then got a plan in action at school, which included being able to take my exams through student services.

I don't know what would have happened that night if he hadn't answered the phone—or had been annoyed. Even after that night, I was embarrassed to see or talk to him. But he'd call to check on me until I was back on my feet. I knew he cared.

Dr. Weinstock was open to being real with me and wasn't frightened when I was vulnerable with him. There have been a couple times since that night that I've had the opportunity to be there for someone in a moment like mine. It's an honor to have someone trust you like that. I'm still learning to be like Dr. Weinstock. If we say people matter, we should treat them as if they do. After that night, I knew I mattered.

"I don't know what would have happened that night if he hadn't answered the phone."

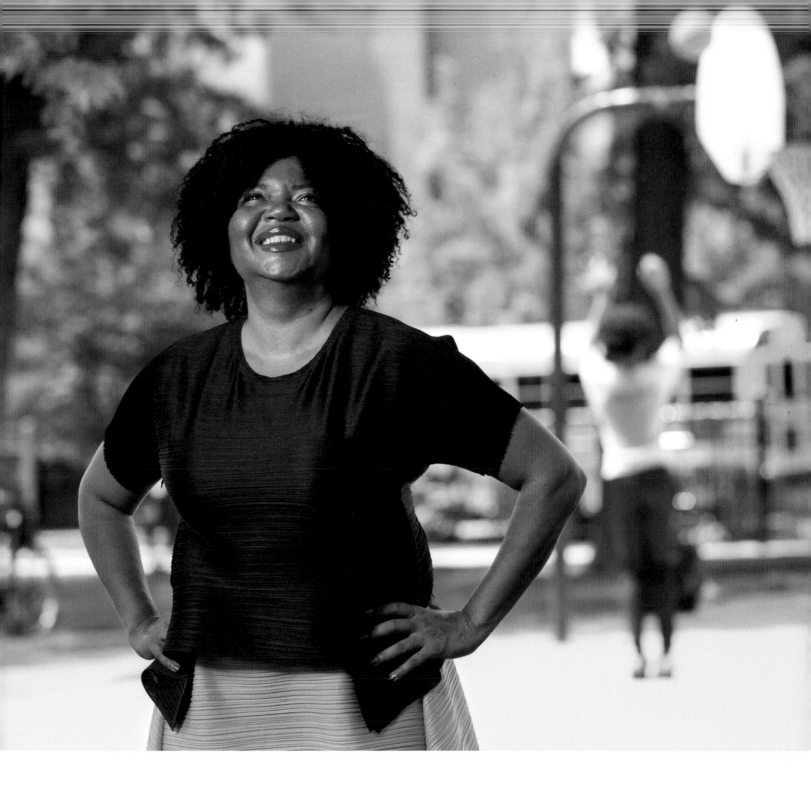

CHANDRA GREER

60 | Stationery Retailer, USA INTERVIEWED BY ROSEMARY LANE

I think I was nine. I was put in a summer camp for gifted children, which was a big deal because my family didn't have any money. I was the only African American kid in the whole camp. And I befriended this girl, she was Jewish. She was really cool; we got along well.

One day, these little boys started calling me a nigger. The little girl walked over and told them to shut up. I have never forgotten that she had the courage and was willing to risk her standing in the group to say that. Just feeling what that feels like made me want to be like her. I decided that if I was in the same position as her, I would be that person. And I have never in my life let someone be berated or abused in my presence without saying something.

I think it gave me this worldview that, if no one else is going to do something, you have to do it. Just as that little girl did.

LOV

"Love is creative, and it will not be overcome by the disasters and pitfalls of life."

—*Pope Francis*

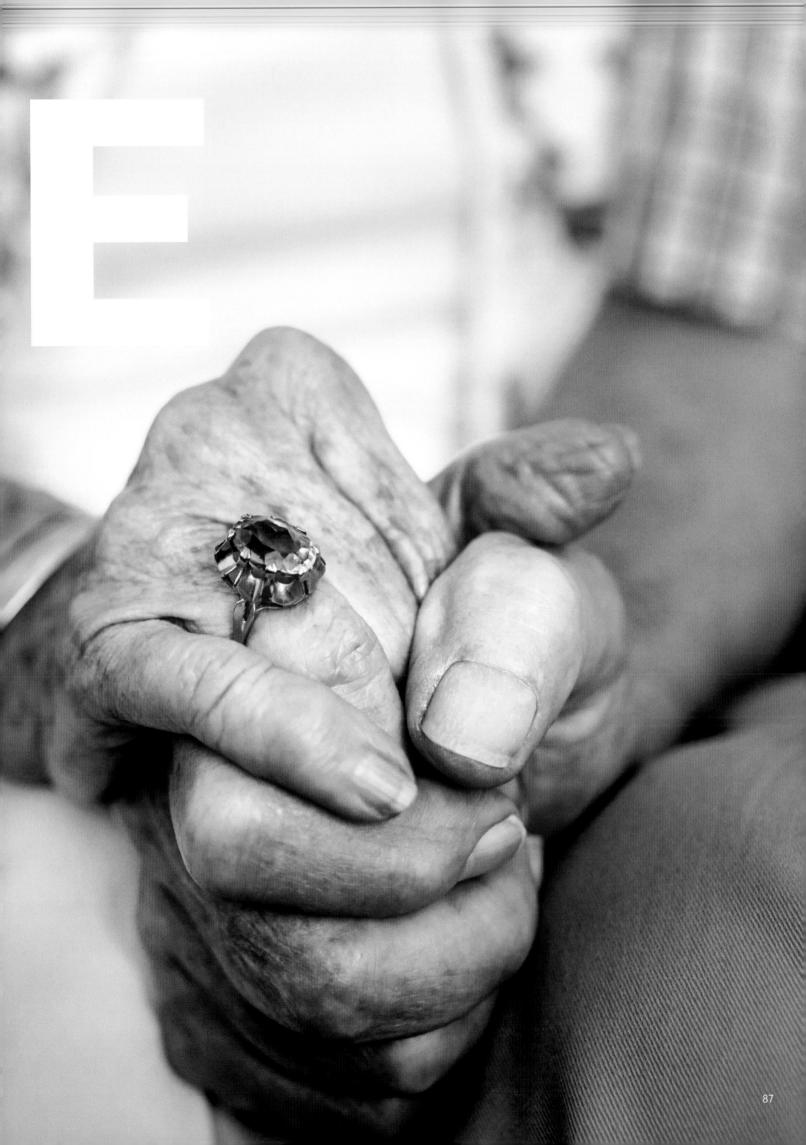

LOVE

Pope Francis

I like to linger during meetings with older couples, some of whom are celebrating 50 years of marriage. Once I met a couple celebrating their 60th anniversary. They got married young—before they were 20. They were doing well, and we were talking. At one point I asked, "Which of you has had more patience with the other?" They did not answer. They just looked each other in the eyes. When they looked back at me, their eyes had changed, transfigured. They simply told me: "We are in love."

It's nice to see older spouses who are still looking out for each other and who are still looking at each other like this. They never stop loving and choosing the other, day after day. It's encouraging to find grandparents who show in their lined faces the joy of having made a good choice *of* love and *for* love.

The beauty of love is also gentleness. The language of gentleness is expressing love with your hands, with your eyes. This is the tenderness that remains through time. To see couples who, after 60 years, after a life of struggles, can say, "We are in love" is beautiful. It's truly beautiful.

"The beauty of love is gentleness."

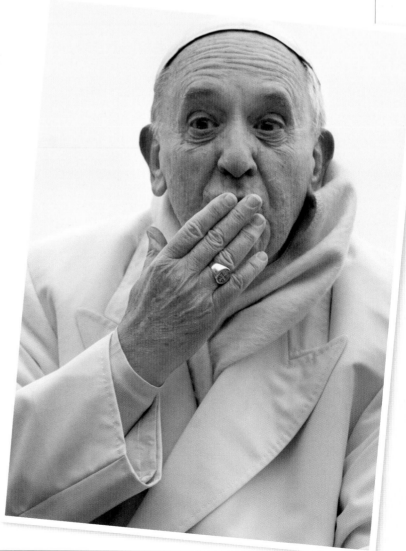

RAPHAEL NYAGA KABETE AND CORONERIA KANYUA

70 and 65 | Kenya INTERVIEWED BY REBECCA FINDLEY

Editor's Note: *Raphael has been working as a carpenter since retiring as a security guard because he "doesn't want to go idle with age." He hopes to help his wife start her own corner store one day. They have been married more than 50 years and have two great-grandchildren.*

RF: What is the secret to your long and loving marriage?

Coroneria: He takes care of all my needs.

Raphael: I call her nice names like "sweetheart" and "lovely."

CEDRIC PRAKASH, SJ

66 | Human Rights Activist, Lebanon INTERVIEWED BY ROSEMARY LANE

The other day I was writing a document. Somebody was standing by my side and spilled his whole cup of coffee on it. I had done a lot of work. I had made all my markings. And it was all blotched. At first, I did not know how to react. But now he will never forget the way I decided to react. I just asked him, "Shall I make you another cup of coffee?"

These are small, simple, daily things by which we can make a person's day or break a person. If I'm experiencing God's mercy for my sins, how do I communicate this mercy—this unconditional love—to the people around me? By being present with them, by listening, by holding a hand, by a touch? I am trying to do it in the small, ordinary things of daily life. It's not about the extraordinary.

When the Lord's mercy touches me, it influences my attitude and behavior. I become a spark, a way of proceeding. I become a new approach. That is mercy to me. It's not just "Don't worry about what you've done. I forgive you." Mercy is not lip service. Mercy is about a tangible, living, vibrant act that forever grows, that deepens.

POPE FRANCIS RESPONDS

Father Cedric's story is wonderful. Sometimes, we turn our little misadventures into epic dramas. The frantic pace of life and the exaggerated importance we give to our tasks prevent us from keeping a good sense of proportion. That's when the humorous side of things disappears, along with the ability to put them in their proper perspective.

The story of Father Cedric helps us understand that we must go beyond the inconveniences of life . . . maybe with a sense of humor, and certainly with the conviction that all things can be resolved. The wisdom of age, accompanied by a sense of humor and a touch of irony, can help us to see our daily challenges in a positive way and avoid dramatization. We have to take a fresh and creative look at things. Love is creative, and it will not be overcome by the disasters and pitfalls of life. That's the way love sees things.

> "Love is creative, and it will not be overcome by the disasters and pitfalls of life."

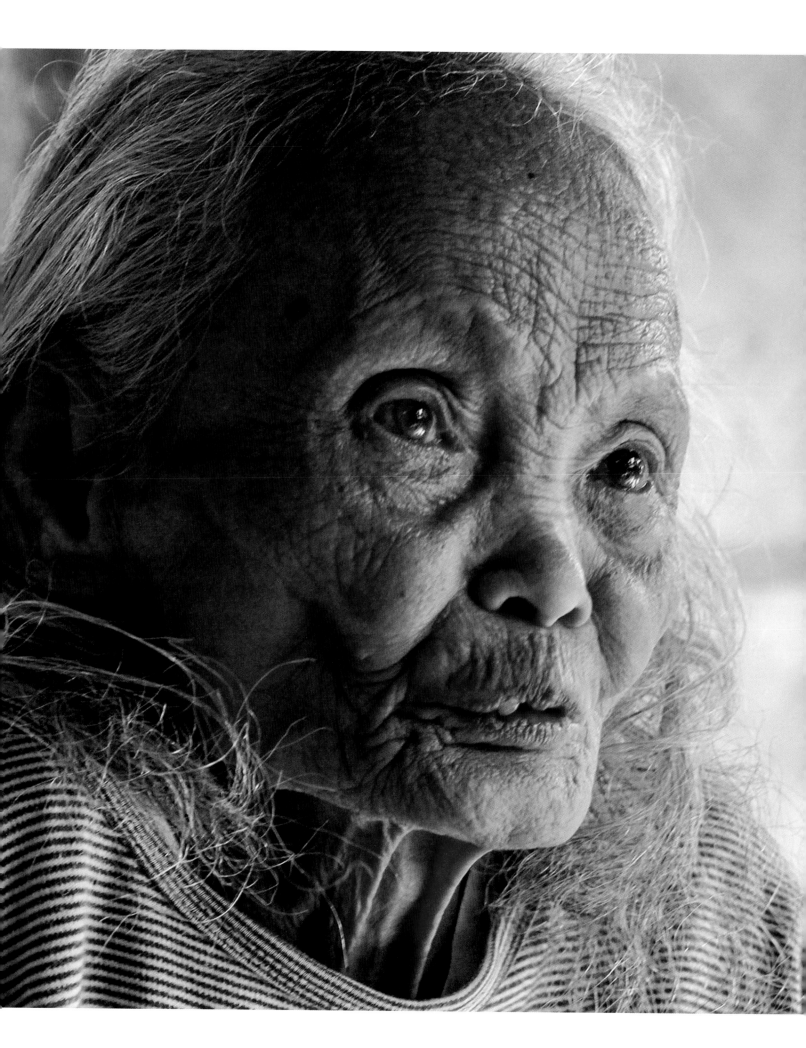

JOLITA DELA SADA DELA CRUZ

90 | Farmer and Midwife, Philippines

INTERVIEWED BY TRISTAN JOHN CABRERA
AND MALOU NAVIO

Editor's Note: *Jolita is a member of the Dumagats, an indigenous cultural community who live in a rural area of the Philippines.*

For us Dumagats, if our parents said marry that man, we didn't have a choice. We had to marry the person our parents liked the most. That's what happened to me. I married the person whom, at the beginning, I didn't know how to love. I was 15 years old then.

I always think that the day I got married was the happiest day of my life. He was the first and last man I loved. I treasure the love we had. Though it had its ups and downs, we were much stronger together. When my husband died, I did not marry again. I told myself that my love for my husband will last for a lifetime.

[*She sings* Ang Tangi Kong Pag-Ibig, *which means "My only love."*]

He is my one and only love.

CARLOS E. OBANDO

67 | Program Director, Loyola Institute for Spirituality, USA

INTERVIEWED BY ROSEMARY LANE

I used to pretend a lot—that I knew the world, that I was king of the world—always pretending to impress the person. With Margie, I learned not to pretend. Just sitting on the sidewalk with her and having a hamburger and a Coca-Cola was more than enough. And that was a relief, because I was accustomed to being somebody I wasn't. I was not a Latin lover. I was just a man looking for the right soul mate. It was meant to be.

I grew up without a dad. We went through a lot with my parents' divorce. When I came to the United States, I was bleeding all over the place. But I didn't want to recognize it. It was very easy for me to love somebody, but it was extremely difficult to be loved by somebody. Because I was

so hurt, I was not able to pull down all the fences that were protecting my heart.

When you love and are loved by somebody, you have to be vulnerable all the time. You have to be yourself. You cannot sugarcoat your love. If I go home tonight and pretend that I'm too tired, that I need my space, no. You are my space. You are my holy ground. But being in the presence of that holy ground is risky. You have to take the risk.

Margie is my resting place. When I get home, I don't have to do or say anything. The mere fact that I can be in her arms is enough. Marriage has to be a place of hospitality where you come and rest with me and I come and rest with you.

"True love disarms. And being disarmed means living with confidence."

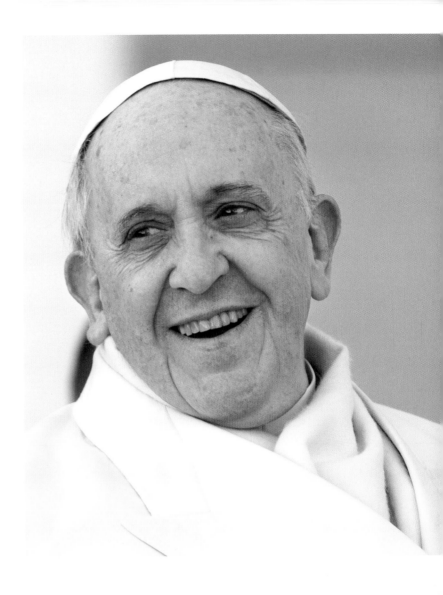

POPE FRANCIS RESPONDS

A favorite verse of mine (Psalm 131) says: "I'm like a weaning baby in his mother's arms." Up to a certain age, children do not know what pretending means. Eventually they learn. But early on, they don't know how to pretend. They know the scent of their dad and mom, and they surrender themselves to them. Love has this capacity to disarm us. Love can remove all our defenses. We are left just as we really are. We can often experience this with the Lord: it is the experience of faith as trust. If you truly feel loved, you are free to be vulnerable. Whoever experiences true love lets go of the self or ego and lowers their usual defenses. There is a kind of spiritual nakedness that reflects a deep wisdom. For someone who is really loved, there is no artifice and there are no deceptive maneuvers. True love disarms. And being disarmed means living with confidence. Two mature people who have loved each other for a long time know that love has brought them into a completely comfortable place to live.

MARIA ŚMIAŁOWSKA

74 | Neurobiology Professor, Poland

INTERVIEWED BY JULIA PŁANETA, HER GRANDDAUGHTER

JP: What is life all about? What is the most important thing?

Maria: To love and be loved. To feel loved and accepted. I have to reproach myself for certain moments in life when I was tactless, when, for example, I hurt my father because I did not like his comments and rebuked him.

It is only since I have grown older and experienced similar situations myself that I can see how wrong I was not to show love or to not let somebody feel how deeply I loved him. You should not be ashamed of love, hide it, or pretend that you are indifferent.

JP: What if someone rejects this love? In our families we often hurt each other.

Maria: I can only say how I try to cope with it: forgive. Love despite everything, even if you don't have a chance to show it. In prayer, imagine how God loves us.

When God waited for the prodigal son, he did not follow him around, rebuke him, or try to rescue him. He just waited. He waited and loved. He was not inclined to criticize or condemn. When the son returned, the father welcomed him without any reproach.

When we get hurt, we want justice. We want life to somehow take revenge on the person who has harmed us. Instead, we should be genuinely glad if we can see even a bit of good in the person who has hurt us, even if this good is given to someone else, not us. We can at least pray for some good for the person who has harmed us. I know it is easy to speak theoretically but not so easy to do. There have been altruistic situations when someone has forgiven, for example, the murder of his own child, but more often, we want justice. People want justice too much, instead of mercy.

JACQUES PÉPIN

82 | Chef, Cooking Show Host, and Author, USA

INTERVIEWED BY ROSEMARY LANE

I have cooked for people for nearly 70 years. It was always to express love. From when I was a kid and my mother was cooking—for my First Communion or any type of big occasion—the family would get together, and the table became the grounds at which we communicated and loved one another.

Now, after 50 years of marriage, my wife and I still sit down for dinner every night and share a bottle of wine. That kind of ritual is very important to us. It completes the day. Without it, we would be lost. The table becomes the canvas in which we discuss the day; we discuss life.

Cooking may be the purest expression of love and of giving. Because it's always for someone else—for your spouse, child, parents, or friends. You cannot cook well indifferently. You have to cook with love.

"The poorer and the most powerful in this world, the youngest and the oldest, we all need to be loved."

FATHER ÁNGEL GARCÍA RODRÍGUEZ

80 | Founder of Mensajeros de la Paz and a Free Restaurant for the Homeless, Spain

INTERVIEWED BY JOSÉ MANUEL VIDAL

JMV: You are a rare case within the clergy because you have a son. An adopted son, but a son.

Fr. Ángel: As the father of an adopted child, who spent so many days and months in the hospital when he was in critical condition, I learned how much a father's love hurts. I understood the piety and fear of Mary under the cross.

The experience that disarmed me the most was when I showed my son a photograph of the day I met him in El Salvador. He was about one year old in the photo, and I was holding him. His body was extensively burned; he had just survived a terrible domestic accident. His skull was not closed yet, which made it difficult for him to survive. My son, then 11, pointed at the photograph and asked, "Why didn't you save me from getting burned?" That hurt so much. I realized that his love for me was like how I used to view the priest in my town—that a parent is supposed to be some sort of superhero for his or her children. But I told him the truth: "I didn't save you because I didn't get there in time. And that hurts me deep inside, in my soul."

But on second thought, I think I did save him, just as he saved me. Because love always saves.

With the scars of the disability, and with all I would like to have avoided for him, I believe my son is a happy 13-year-old now.

I know he will have problems like all young people. But I know he has a father who has learned that, when you have a son, the least important thing is that he finishes college. The most important thing is that, when he has a fever, you are there to take him to the doctor; when he suffers from a broken heart, you are there to give him your support. And when you are not there anymore, you have left him an inheritance—an education—that will give him opportunities. I think being a parent is the most dangerous and, at the same time, the most wonderful thing.

The poorer and the most powerful in this world, the youngest and the oldest, we all need to be loved. We are more alike than we think. Love makes you suffer, but it always gives you a result more valuable than the suffering. It's like having surgery: you endure pain to be well. Sometimes you have to suffer to be able to experience joy. You have to value love with all its pain and suffering. Because love is all that matters.

POPE FRANCIS RESPONDS

The experience of Father Ángel tells us that the love for a child saves both the father and the child. *Love consists more in giving than in receiving,* says St. Ignatius. *And we show love more with actions than with words.* To be a father means to give intense and hardworking love to a child. And children, just by their presence, are salvation for their fathers. Children "force" their fathers to love them, to move beyond themselves, and to take care of them. With their many needs, children "draw out" care from their fathers, especially when they are young. Every relationship between father and child is a sign of humanity's survival in history.

A father is not a superhero. He cannot protect his children from every suffering. It would be unfair if he wanted to do so, because he would be shielding them from real life. Still, his love stands firm, ready to give support, strength, hope, and care. A father's heart beats with wisdom. A father's radically generative disposition of mind and heart leads him to think about his children's future and their welfare. So speeches or ideas or ideals are just not enough. What fathers must provide is a living example.

"What fathers must provide is a living example."

C. RADHAKRISHNAN

75 | Writer, India

"Share" was the lesson my mother repeated often. "Share with love, and you will be loved," she would say. Miss Hilda, who taught the alphabet at primary school, gave us, for want of anything else, portions of her lunch when we wrote anything right. She spent the lunch hour pretending to knit because her lunch box was already empty.

Sharing leaves lingering happiness. You may forget the toffee you ate immediately after you swallow it. But you'll forever remember the happiness on the face of a friend when you've shared the sweetness.

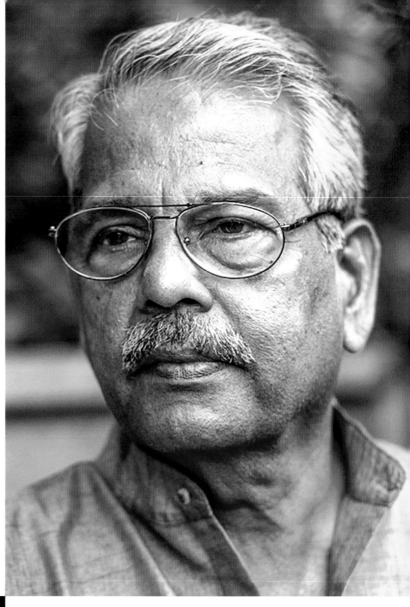

SYLVIA CAPELLAN ATABAY

76 | Store Owner, Philippines

INTERVIEWED BY TRISTAN JOHN CABRERA

Marriage is not just for one day or even for one year or 10 years. It is forever, 'til death do you part. I always remember what my grandmother told me: "If one is fire, the other one must be water." Don't both be fire when there is a misunderstanding. You need to understand each other's weaknesses. There must be balance. There is no perfect marriage, but there is a perfect love like what Jesus has done for us.

JOE SCHNEIDER

98 | WWII Veteran and Retired President of a Manufacturing Company, USA

INTERVIEWED BY ROSEMARY LANE

I met her on a blind date. One blind date, and we just walked in for life!

They talk about love at first sight. Well I'll tell ya—that was it! She was the girl I didn't even know I was looking for until I saw her. It was God's gift. A lot of people say, "It was luck." But you know, God operates in different ways. I think God sent two people he wanted to keep together because he knew we'd have the glue to stay together. It was a very, very wonderful life.

I lie in bed at night and talk to my wife, who's deceased only three years today. People would say I'm a little off in the woods, but I just talk to her as if she is still there.

You have to recognize when you've met someone exceptional. Make sure that the glue that holds you together is a grace that comes from heaven. And thank God for what he gives you. Ask him to help you every day of your life. My daughter is standing here, and she says, "Amen!" [laughs]

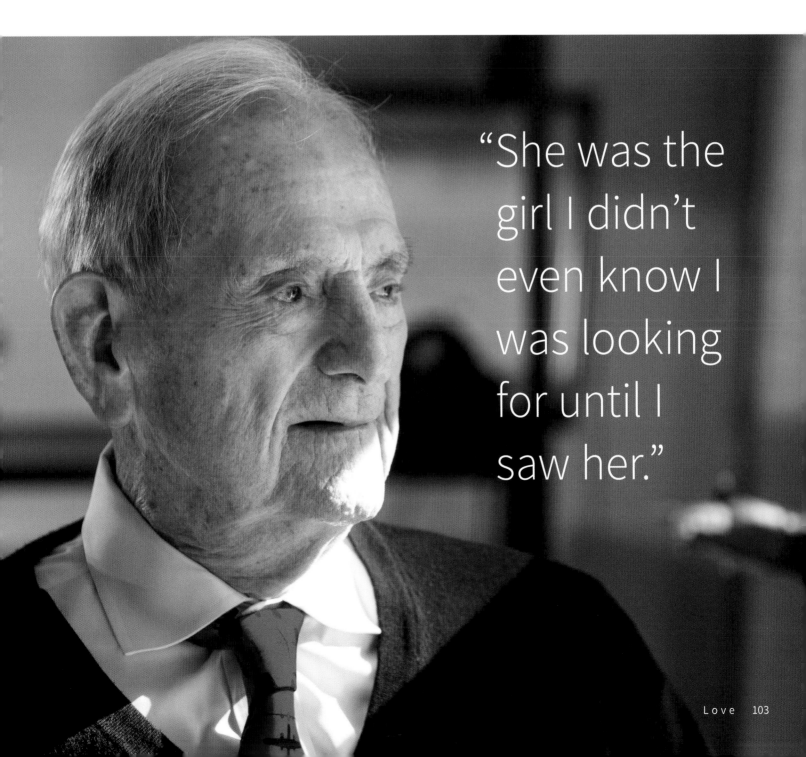

"She was the girl I didn't even know I was looking for until I saw her."

BERTA GOLOB

85 | Writer and Retired Teacher, Slovenia

For years, I taught teenagers at a behavioral institute for children and adolescents. They had many harmful traits, such as stealing and verbal and physical violence.

It was the worst when someone insulted their mother—who was often a prisoner, a prostitute, or an alcoholic. Their response was a slap in the face or a punch in the stomach. All they wanted was to disfigure the offender's face and knock him or her down. At that moment, I understood why it is important for educators in such institutes to be like guardian angels at every step those teenagers take. For somewhere deep down in their misery, there was a burning fire of love denied in every possible way.

Many people don't know that in the heart of every single person, even in the most dangerous criminals, there is a bit of generosity, even if he or she doesn't know how to express it in any other way than with wild rudeness. Those troubled adolescents taught me to recognize the bright light behind all the shadows.

Love does not exist in boasting or showing off. On the contrary, love is silent and often hurts in silence. I think that the face of love, although bruised, cannot be anything other than the holy face of God.

"Those troubled adolescents taught me to recognize the bright light behind all the shadows."

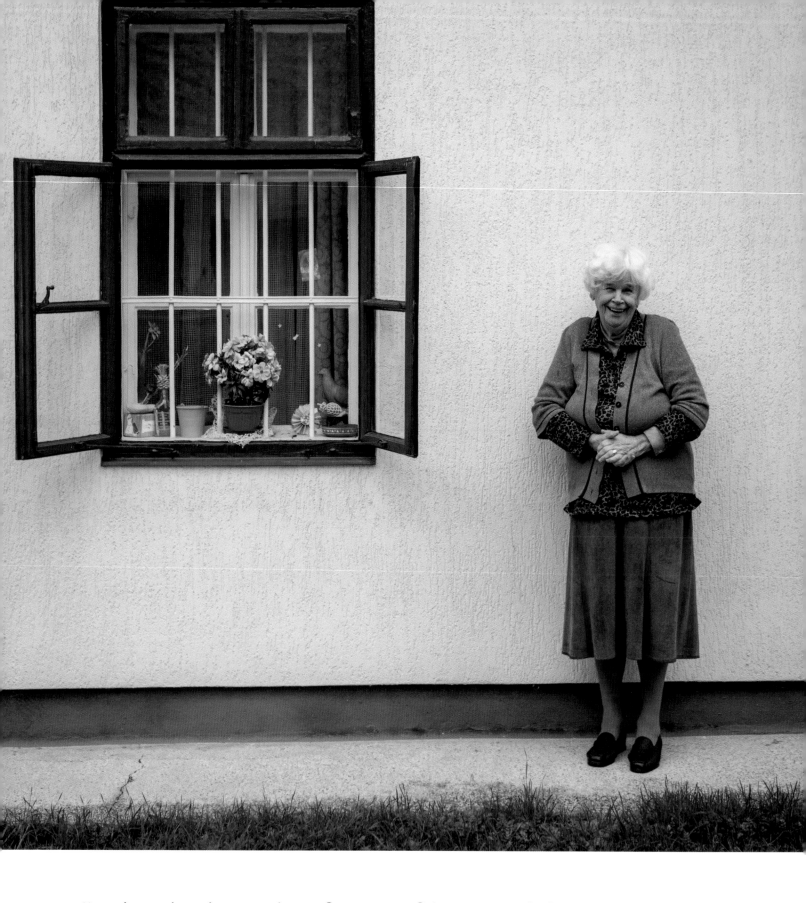

"I think that the face of love, although bruised, cannot be anything other than the holy face of God."

> "Do not let appearances fool you; look under the ashes for the fire, the ember, the coals, and the flame."

POPE FRANCIS RESPONDS

Berta's story illustrates one of love's basic stances: do not let appearances fool you; look under the ashes and look there for the fire, the ember, the coals, and the flame. This is a great piece of wisdom. An 85-year-old woman like Berta has learned it well. She can dream of a better world and help the children develop a vision of a different world. The young people she took care of were tortured souls and also violent. The time she spent with them taught her to go beyond their appearances and not to look at them superficially. A branch may be broken and not completely broken off. It can still bring sap to the fruit. You have to observe carefully to discern the sap that is passing through to the fruit.

When you stand in front of the ashes of human misery, do not be discouraged and say that the fire has totally burnt itself out. The wisdom derived from life's experiences teaches us to look beyond the present moment. When talking about human beings, never voice a lack of confidence. That would be a serious temptation. To overcome mistrust, you have to have much love and the ability to be silent, to wait, and not to react instinctively. You should not be impulsive. This is a grace. Under the ashes, there is often a coal that shouldn't be put out but actually deserves to be fanned into flame.

MÉLANIE NBOG NYOBE

64 | President of a Nonprofit for Refugees, Cameroon

Married some 40 years ago, my husband and I led an ordinary family life, raising our three children.

Eight years ago, I discovered that my husband was living a double life. He had an affair with a young woman. His behavior after my discovery was so arrogant that I was thunderstruck. I thought I'd lose my mind.

My husband devoted himself to this other relationship, asking that I accept his behavior. I was advised by a family friend not to lean toward divorce, which adds wounds, but to turn to God time and time again to get out of this situation.

I lived through all the trials and tribulations. Thank God, the Lord placed generous souls around me for this eight-year-long crossing of the desert that recently ended. A year ago, my husband returned to our home, barely able to walk, struck by disease. I hesitated to welcome him, my heart weighed down by suffering and resentment. But a short while ago, I experienced relief. It was as if Jesus himself had come to bear my sufferings and lighten my heart. From that day on, our relationship resumed; I stayed beside him through his irreversible illness for 10 months. Before he died, he said to me: "I have spent my life hurting you. I will never rest in peace unless you forgive me." I had already given him my forgiveness—otherwise, how could I have taken on a palliative care patient night and day? The Lord had worked a miracle.

My husband passed away a few months ago in my arms, surrounded by his family and friends in praise and prayer, having received the last rites. May the Lord Jesus keep him in his light.

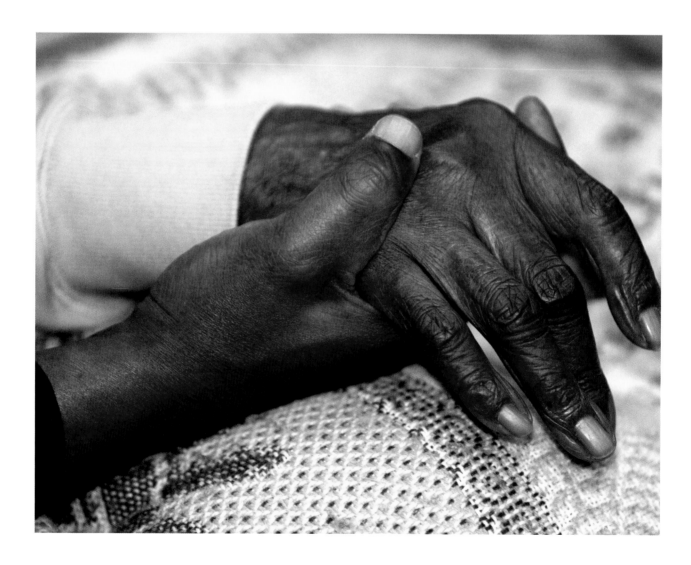

DAVE MCNULTY

68 | Provincial Assistant for Operations
of the Midwest Jesuits and Board
Member of the Jesuit Refugee Service, USA

INTERVIEWED BY TOM MCGRATH

TM: What advice would you offer to young people just starting out?

Dave: I would repeat what I told my daughters and their new husbands on their wedding days: "If you want to be happy in this life and in your marriage, in every difficult situation simply ask yourself, 'What does love require?'"

TM: Where did you learn that?

Dave: I was on retreat with men from my parish, and one of the guys, Steve, told the priest, "I'm going through a hard time in my marriage. I'm not sure it can survive. How do I know what direction I should go? What should I do?" The priest told him, "Ask yourself this one question: 'What does love require?' If you do that, you can be sure you are on the right path."

That question just lit a light bulb for me. I think I had always made spiritual discernment too complicated. I had read a lot, made retreats, etc. Finding God's will is important for me. Then all of a sudden—kaboom!—a light went on. God was telling me, "Hey, it's not so complicated, Dave. It's a simple question: 'What does love require?' That's discernment in a nugget."

That question is the North Star for me—always there, always true.

TM: Did it help Steve?

Dave: It helped him tremendously. He and his wife ended up staying together, and their marriage was much stronger as a result. They honestly didn't think there was any hope of staying together. But they did. And Steve became a much gentler man.

Love always makes you vulnerable. Deep love places you in a position of deep vulnerability. You've got to be willing to live with that, and ultimately, for me in my life, to give the results to God. I say, "Y'know, Lord, I'm trying to do your will, whatever the consequences may be. And I know I have to live with them, but I'm going to push them over to you [*laughs*] because you're stronger than I am."

"In every difficult situation, ask yourself, 'What does love require?'"

DOROTHY ANDRIES

80 | Journalist, USA INTERVIEWED BY ROSEMARY LANE

My husband had a stroke, and I couldn't keep him at home anymore. I visited him every day.

Our song was "Our Love Is Here to Stay." I would sing it and say, "We sure did that, honey—57 years!" Then I would sing "Goodnight, Sweetheart." They used to play that at the end of dances when all the sweethearts would have to part. Back then I would think, *Goodnight, sweetheart. Although I am not beside you, tears in parting will make us forlorn, but a new day is born. Goodnight, sweetheart, till we meet tomorrow.* Now I think, *This is for old sweethearts too.* I should write that and send it to AARP—maybe I'll get $50 or something!

But as I was taking care of him, I felt a lot of peace. It was just this conviction that this is what I should do. We didn't always get along well. I was very disappointed when I realized it wasn't going to be easy. I thought [marriage] was just my pretty white dress and flowers. But I think we expect more of our spouses—that they should be more understanding of us. I mean, we're just people. We're just human beings. Even though we think we're absolutely adorable and perfect, we're really not. So be kind and jump in with both feet and mean it and stay. Ride out the hard times and ride out the bumps. Because nothing could replace that feeling of peace that I had in taking care of him at the end.

BERNARDA DE JESUS ZAPATA DE PARDO AND RAMÓN ANTONIO PARDO GARCÍA

79 and 84 | Colombia INTERVIEWED BY ANDREW KLING

We have been married for 60 years. Love hasn't changed throughout the years. Our love is the same. We respect each other. Never fight. We don't call each other names. We pray the rosary together. We love each other like we are told at church: until God sets us apart.

We have been poor, but we have had enough.

What I Learned from an Elder

KLAARTJE MERRIGAN

28 | Doctoral Candidate, Belgium

When my grandmother was 89 years old, she had been living in a home for the elderly for years. She had survived my grandfather, whom she had loved dearly her entire adult life. Many days she struggled with his absence, seeming unable to remember that he had passed away.

"It felt as if he was there. I talked to him, just yesterday," she'd say. I realized that her sense of time was different from mine. The two years my grandfather had been dead felt like a day to her, compared to the 62 years they had lived together and loved each other.

I had been without a partner for three years and saw many of my peers getting married, having children, and settling down. I was scared and felt like I was running out of time. I confided my fears to my grandmother on one of the many Sunday afternoons I spent with her. When I told her that it felt as if it was too late for me to settle down, she laughed out loud, joyfully, kindly. "You have all the time in the world, my dear. You are so young. What do you want in a partner? Look for that, and don't settle for less. You have all the time in the world."

Again, her different sense of time and lack of urgency moved me, but so did the realization that she spoke with authority because she had known true love. I realized I had been trying to impose a time line onto my life that was not my own. I was not honoring the natural rhythm of things because I was scared, because I felt rushed, because I felt I was growing old, because I was forgetting the freedom that was still mine. I decided to not make choices out of fear or out of a false sense of urgency but to have faith that things would work out in time.

POPE FRANCIS RESPONDS

Because of their great range of experience, grandmothers are able to give perspective to the anxieties of their grandchildren. Young people today are frightened. They are afraid of running out of time. Opportunities seem to be passing them by. They are under pressure to have everything and to have it right away. A grandmother's patient look gives peace and balance. And this is true for a granddaughter who is afraid of ending up on her own. Love should not be sold off as if it were a commodity. True love is free. When you feel that you have to settle to get love, that is not love. And a grandmother knows this, and she knows that there is always time for true love, just as Klaartje's grandmother told her. Being open to love diminishes the fears and anxieties that close our hearts. Fears lock us inside ourselves. So many times the fear of not finding love leads us to lock ourselves up from the love we are looking for. You won't see it even if it passes you right by. You need to learn the wisdom of time, which only grandparents—not even parents!—can teach their grandchildren.

This is true for many young people today. Anxiety is one of the great markers of our fluid society. Today, young people are born into this fluid and shifting situation. And anxiety leads them to cast aside what is solid and definitive and then to choose something passing. For young people to have a vision of the future, they need the wisdom of grandparents who know what is transitory and what has lasting value. And they know this because they have experienced it firsthand, in their own story.

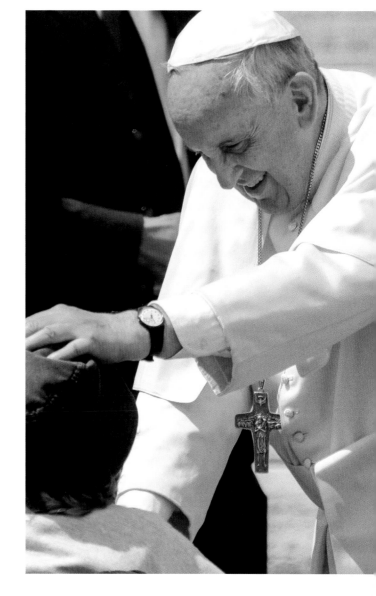

"There is always time for true love, just as Klaartje's grandmother told her."

DEA

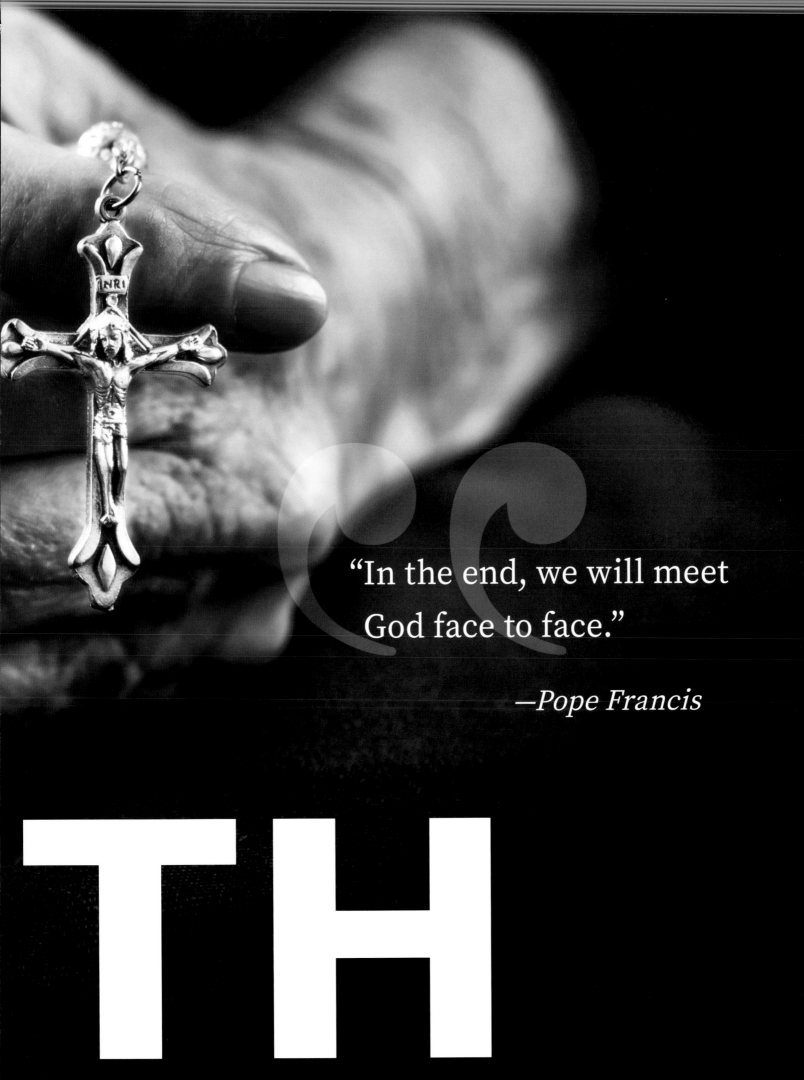

"In the end, we will meet God face to face."

—*Pope Francis*

TH

DEATH

Pope Francis

Older people know that they are nearing death. Many of them struggle yet live joyfully until the end. I had the chance to know my four grandparents. The first one died when I was 16 years old. The last one died when I was 38 years old. So the connections with my grandparents were frequent. And—except for one grandparent—I was with all of them when they died. They were all prepared. I cannot forget the witness of my grandparents, how they prepared themselves and consciously moved toward death.

When I think of the experience of death, I also think of an old neighbor. She was an educated woman named Mari, and her husband had a good job in southern Argentina. She also had a daughter and a son who were both married. But one day her life changed. Her husband died and she had to work as a maid. She did so with such wisdom that she became the "lady" of the house. She was a great friend of my mother. I knew her well. The woman's level of culture impressed me. I would see her reading Nietzsche, and she liked the opera. I felt a kinship with that woman. My parents allowed me to go alone to the opera when I was 16 years old. I went to the Colón Theater, standing in the "peanut gallery," that is, in the economy seats way up high. Often Mari accompanied me, and afterward we would talk about the performance.

I remember that once her daughter called me. I was a Jesuit at Universidad del Salvador. She told me her mother was seriously ill and asked me to pray for her. I asked a Jesuit companion to go with me to the hospital. There, Mari and I said our goodbyes. I had the chance to say farewell to her, just as I did with my grandparents. Experiences like these with seniors approaching death did me so much good. These esteemed elders stand now before God. I cannot forget these people who watched me grow. To forget them would be an injustice to the beauty of life.

"I cannot forget these people who watched me grow."

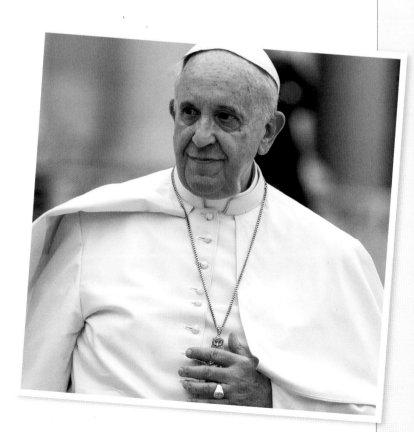

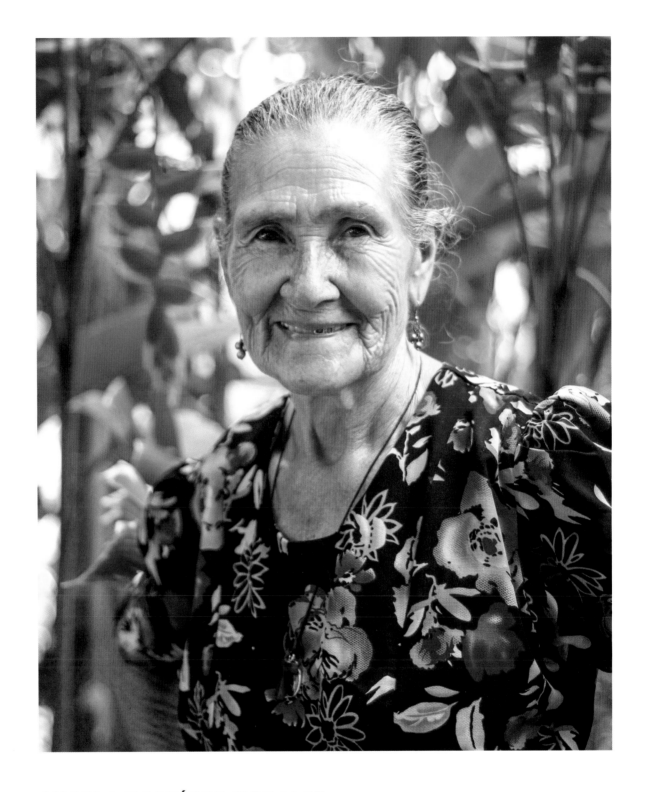

ANGELA MARTÍNEZ MORALES

72 | Lay Franciscan, El Salvador INTERVIEWED BY DANIEL PEREZ

In my 72 years, I've learned to live a life of tranquility and love. God has given me plenty of life. He has given me life to do something for others, to serve in all that I can, because God gives us all gifts that we discover through understanding and discernment. Yes, serving others is God's reward.

I am old now, and I think my walk is coming to its end. I've heard a voice in my dreams say, "It's time to come." I'm not afraid because I know I'll have eternal life with God.

DANILO MENA HERNÁNDEZ

73 | Planter, Costa Rica

INTERVIEWED BY RAFAEL VILLALOBOS

Our oldest son Gerardo passed away. He was 47. He died of acute hepatitis. I still haven't recovered from his death. I always dream of him. It's just little things that bring you down, but you also have to recognize that you have to go through it. We come from dust, and to dust we shall return.

Death is very sad because we have to leave our loved ones. I think about Audelino and Uriel [his twins, who are blind] and about Hilda [his partner], who is very sick. She has had Parkinson's for 11 years. I am not sure if it is the heat or what, but she is suffering day and night. She is always in so much pain, especially in her leg.

I don't like to think about the day when I will be gone, but I do know that God will take me when he wants. They are going to be left alone. Who is going to take care of them? There are many good people who would take care of the boys, but what about Hilda? No one will ever see her as I see her. I help them. I wash them. I cook for them when they are not able to cook for themselves.

My back hurts a lot, but I wake up and commend myself to God. I fix the fire so that I can make them food, and while I am doing it, I sing. I sing to bring joy to them. Hilda tells me, "You are not sick. I see you singing." But you have to be joyful so you don't live in sadness.

If we are not good with God, then we do not want to die. But if we are good with God, it won't matter if he takes us. Death is something we have to accept at any moment.

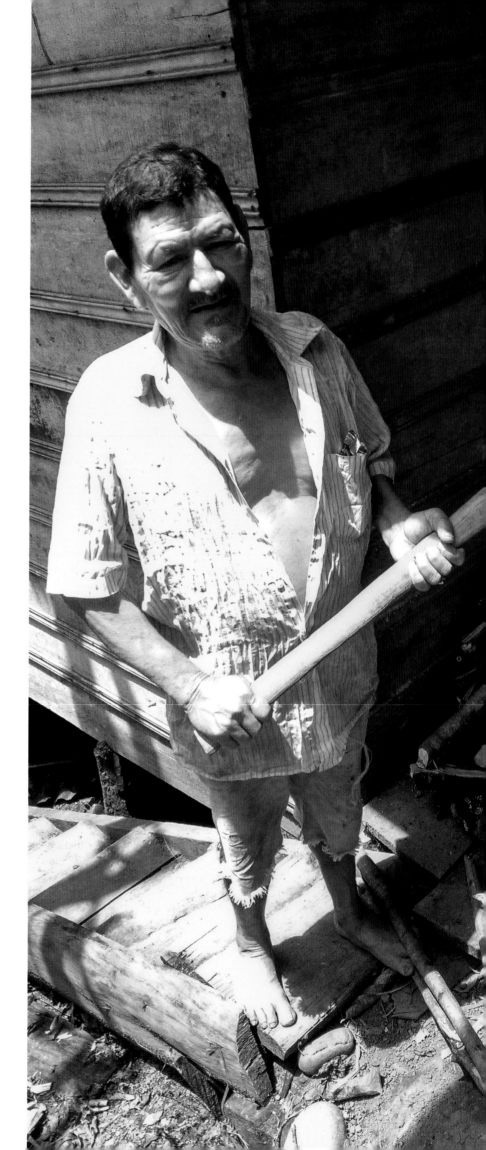

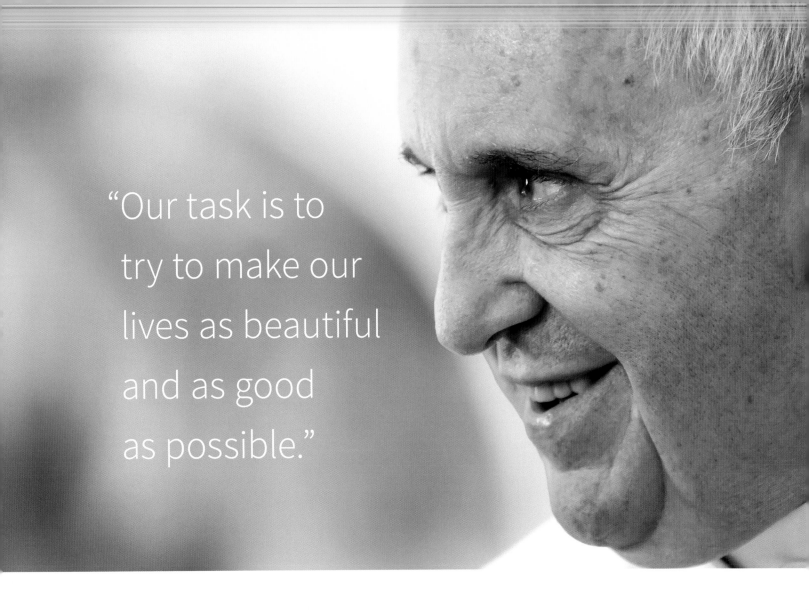

"Our task is to try to make our lives as beautiful and as good as possible."

POPE FRANCIS RESPONDS

Danilo lost a child. I know parents who have lost a child. When you lose a child, you do not know what to call yourself. Children who lose their parents are orphans, a man who loses his wife or a woman who loses her husband are widows, but there is no name for a parent who loses a child. There is no word. This is the hard reality of a life without a name.

Danilo knows this reality very well, even in the suffering of those who live so close to him. They are the people in his care. But Danilo is courageous. He is willing to fight life's battles well. Our task is to try to make our lives as beautiful and as good as possible. Our task is to bring out the joy and the smile of life. Danilo sings despite his back pain. Even if you get riled up by the pain, you can offer it up to God and then keep walking.

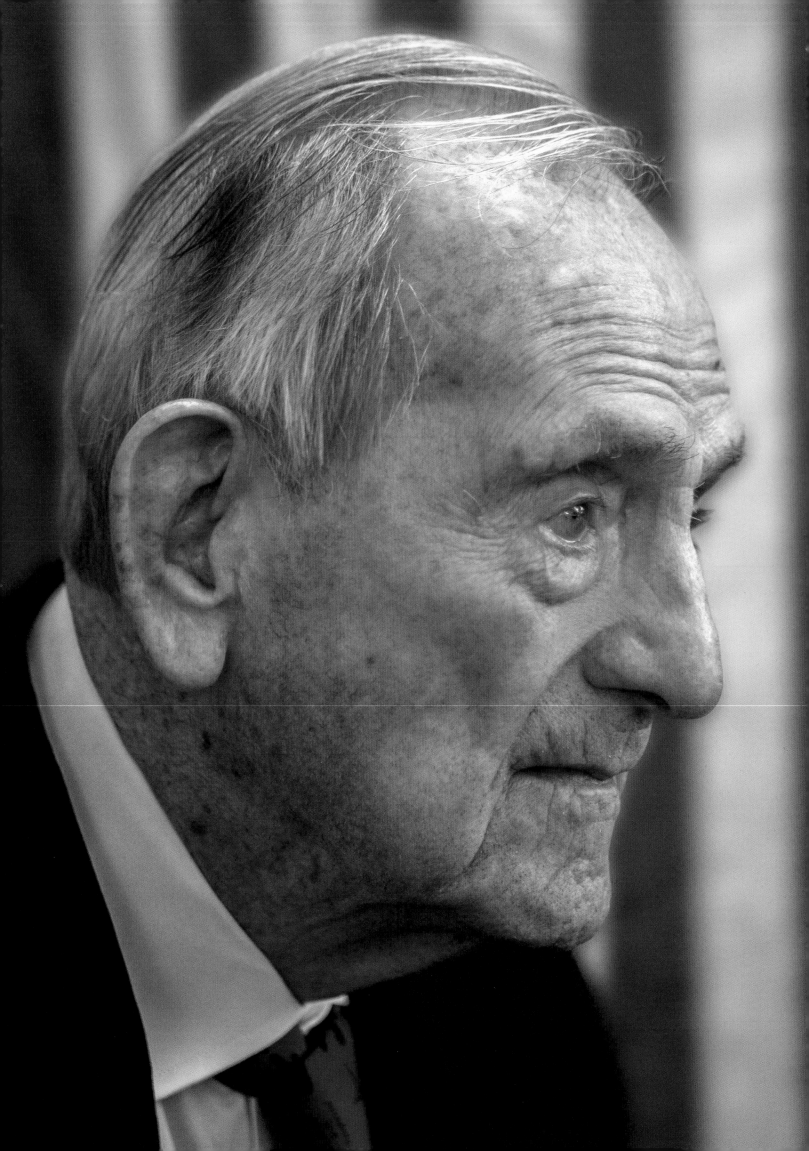

JOE SCHNEIDER

98 | WWII Veteran, USA

INTERVIEWED BY ROSEMARY LANE

Editor's Note: *In 2016, Joe received the Silver Star Medal for his role in securing the safety of his pilots in a WWII bombing mission. On December 30, 2017, Joe passed away, 10 months before the publication of this book.*

I was a bomber pilot in World War II. We were the bombers who were knocking out hundreds of bridges in Italy. We became known as the "Bridge Busters." We had to fly straight and level, otherwise we would never hit a 100-foot bridge. It was very touch and go. And we lost an awful lot of people.

I was fortunate enough to survive. All I can say is that, when I started down a bomb run, I'd pray, "Into thy hands, O Lord, I commend my spirit. Lord Jesus, receive my soul." That was my prayer every time because I didn't know if I was going to be alive in the next five minutes.

At that age, it may happen to you once or twice. It happened to me 72 times.

It's a remarkable thing to have been so close to dying at that time, and today I stand here and have another birthday. But somehow, somewhere, my God always was my savior. And he still is until this moment.

I never could have survived that war without my God. He was my copilot, my friend, and my helpmate. He was everything I needed.

MIGUEL-ÁNGEL BORONAT MARTÍN

69 | Retired Psychiatrist, Spain INTERVIEWED BY BORJA BORONAT COT, HIS SON

Growing up as the seventh of 13 siblings, it was my lot to sleep in the living room in a Murphy bed. Every night, I saw my parents adding up the expenses produced by so many offspring, and I listened to their comments.

Mama complained: "Carmelo, it is a lot of money, and I do not know how we are going to make ends meet!" Papa soothed her and always responded in the same way: "Gloria, do not worry. . . . God will provide!"

And the truth is, working at several jobs, our father (and God, too, in whom he had so much trust) managed to put food on the table and clothes on our backs and keep us growing until he left us after a painful illness in 1974. He was 62.

Two weeks before his death, I was at his side. He took my hand and said, "Miguel, today I had a strange feeling inside. . . . For the first time in my life, I felt grown up!" My face must have shown my inability to understand what he was telling me—a person whom everyone considered his or her private "adviser"!

He explained: "Yes! It is a strange sensation, inexplicable, but crystal clear. It was not a dream! I can only tell you that I felt grown up for the first time!" He went on: "So, do not be afraid, but I will die one of these days, and I am content because I have experienced the Resurrection and have seen that I will still be with you all."

POPE FRANCIS RESPONDS

"God will provide"—that's what the person of faith says, the one who has a real relationship with God's providence. I have always been amazed by the nuns who have a kindergarten or a hospital for the elderly and yet don't even have enough food available for themselves. How do they do it? Often, they tell me they are calm because they trust in providence. I remember a nun who always said, "The Lord provides." Trusting providence is a kind of stripping away. In the Divestiture of St. Francis, when he left behind the fine clothes of his father's house, there is this message that summons us to consider divine providence. If we are afraid to trust providence, let us read what Miguel says. He speaks to us about his father, who lived a difficult life in peaceful trust. This fostered his father's growth and maturation, despite the struggles of a hard life.

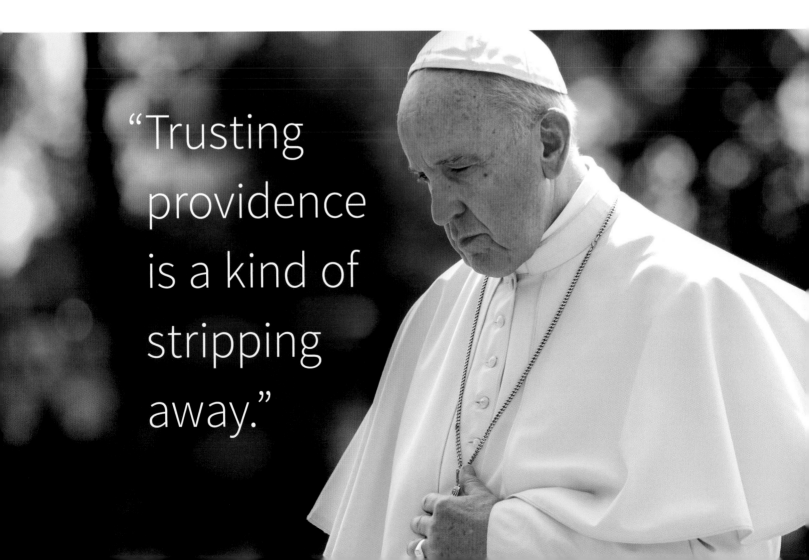

"Trusting providence is a kind of stripping away."

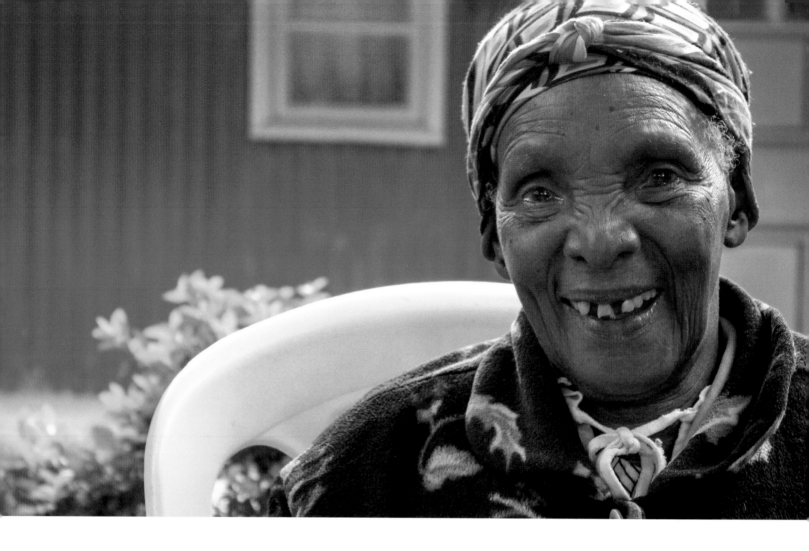

JOYCE NJOKI KAMAU

93 | Basketweaver, Kenya INTERVIEWED BY REGINA MBURU

Even though I think about death, it is God's will, not mine. I have gone through pain in my body. I used to walk and go wherever I wanted to go, but now I cannot walk. I cannot go to the road just outside here. What can I do? I wait on God. There is no one else I can wait upon, just him.

When he calls me, I will tell him, thank you. He has given me life. I have lived to see my grandchildren. I want them to have peaceful lives. I pray that God blesses them and makes their lives good.

I have been loved. I have grown old. If I was not loved, where would I be?

LUDMILA PETROVNA KOLESNIKOVA

71 | Retired Engineer, Russia

INTERVIEWED BY IGOR CHEZGANOV

I joined the Church in 1995 and was baptized in 1996. It was hard to attend Mass at first. I had a feeling like I was being swept up by a hurricane. I realized that there was no way back once I embarked on the path of faith. Never again could I live without God.

I know that God will always help me. And even if God wills that I should die in the gutter, I must make my peace with that, too. One must calmly receive everything that God gives us.

I am not afraid of death. It is only a path that leads to God.

MARGARET MCKINNON

84 | Great-Grandmother, Australia INTERVIEWED BY ROSEMARY LANE

My husband died in his mid-50s. He was an ambassador, and we had come home from a posting overseas for one of our children's weddings. He died right before the wedding. It was very hard to accept. But I had seven children, and I thought, *If I don't cope with this, they won't* *either.* So, you just keep going. I think we all have times of feeling *I can't cope with this.* But you do. Otherwise you are just a pain in the neck for everybody else.

Enjoy your life, value the time you had with your family and friends, and just get on with it.

JÓZEF WOLSKI

86 | Retired Engineer and Former Mayor, Poland

INTERVIEWED BY ŁUKASZ SZCZEPANIAK, HIS GRANDSON

ŁS: As a child, you suffered the cruelty of war. How do experiences like those affect your ability to feel happy?

Józef: They affect it a lot. They leave scars for life. When I was 12, our whole village was burned to the ground, and I became a half-orphan. I saw a Vlasov soldier about to shoot my dad. My sister, who was 16, stood in front of my dad to protect him, hoping he wouldn't kill a girl. He killed them both with one shot. I felt his loss very acutely, every day and every night. For about 20 years, I woke up in the night because I was dreaming of Daddy and the dramatic circumstances of his death. I was afraid that Mummy, who was so bravely taking care of us, would fail in her health and that I would lose her, too.

We had to beg for a year, and for a few months we lived in a shack made of branches and then in a barn next to the animals. Despite these tragic experiences and living in hunger, never for a moment did I complain about my fate. I asked God to let me survive. That situation strengthened our family bonds. We were happy to make it through another day, to have another meal.

Happiness is a spiritual, not material, joy.

ŁS: What regrets do you have toward the end of your life?

Józef: I am 86, the eldest in the family. I think my earthly life is drawing to an end, and I want to prepare myself as best I can to meet the Lord. I experienced joys and sorrows, praises and reprimands, successes and failures—all of them were an integral part of my life. Several dozen years ago, I learned from St. Thérèse that everything is grace.

"Death, too, must be faced along with a kernel of hope."

POPE FRANCIS RESPONDS

There are scars that last a lifetime. And there can be many. There are lives like that of Józef, marked by insecurity and traumatic experiences. But on life's balance sheet, Józef's experiences did not leave him in the "red" with a deficit. Quite the opposite. He may not have felt that he was a hero or a winner. However, he was a winner not by his own accounting but by the all-encompassing grace that took hold of him. Everything is a gift. There is great wisdom here. This wisdom shapes a vision that can help young people face life.

Death, too, must be faced along with a kernel of hope. To see things this way opens us to the free gift of salvation. Standing before this great, free gift makes me think of the film *Babette's Feast.* There, a joyous banquet captures the gift of faith. The lavish and free gift of salvation is a "waste" of grace. I remember the "good death" exercise the Jesuits had us do in the seminary. It was gloomy! And yet, we can look at death and feel rich, because God lavishly "wastes" his grace poured out on us. This is true despite all the weariness, failures, and tragedies that life can deal us. And this is what I carry with me.

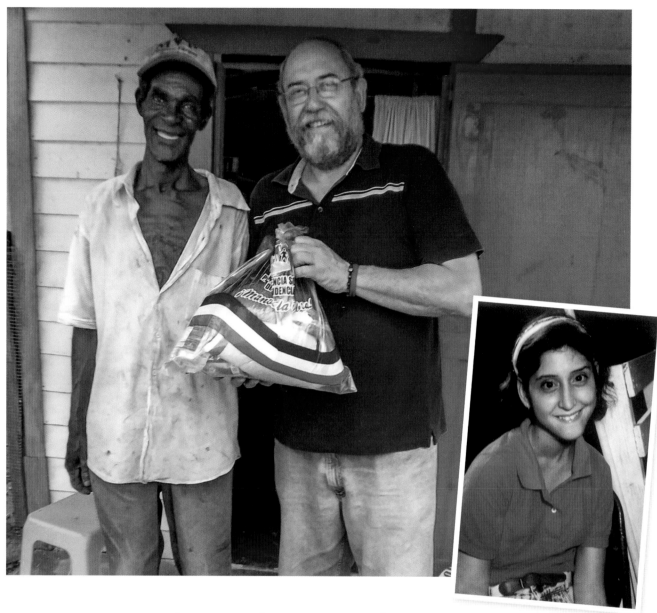

ANTONIO DE JESÚS RODRÍGUEZ HERNÁNDEZ

70 | Consultant for Nonprofits, Dominican Republic

My conversion is forever connected with the death of my daughter. The day she died, two lives were born—hers to eternal life and mine to the life of the Lord. She was born with a progressive congenital disease that affected her muscular and motor coordination and required the use of a wheelchair for most of her life. Our whole life was dedicated to her care; within our limitations, we provided everything that would make her happy—and thank God she was.

Her death 19 years ago created an existential vacuum in our lives: what could we do with all the love we had learned to give and had received from her? At that time, a Jesuit invited us to participate in a retreat. That retreat led us to a new way of seeing life, which inspired us to want to give what we had and what we could. The effects were immediate.

I started working on a social project that helps people who are poor to better their lives. The more excited I became with this work, the more bored I became with my profession. So, in November of 2003, I resigned as assistant vice president of a commercial bank in order to collaborate with nonprofit groups. These changes came about as a direct result of a close encounter with the Lord.

At the end of our retreat so many years ago, I read a sentence that fully describes these changes: "*Nothing* in the outside world had changed, but my attitude had changed, and because of that, *everything* changed." The strength of the Spirit continues to move me to do more.

CATHY HARVEY

63 | Retired Administrative Assistant at College for Students with Intellectual Disabilities, USA

INTERVIEWED BY ROSEMARY LANE

It was our daughter's birthday. She had put her girls on the bus to school. My husband drove her to class at a local community college around noon. A medical condition prevented her from driving, so she'd bike home five miles down a two-lane highway.

On her way home that day, a driver got distracted looking for a rainbow. He crossed the line onto the shoulder and hit her. She died instantly.

I had no idea. There was a knock on the door. The coroner said, "Your daughter was biking on Highway 45 and was hit by a car and killed."

The words echoed in my head. How do you respond? It took about four seconds, and my first emotion was relief for Anna. She'd had a hard life, raising her two girls as a single mom. She struggled to get around, and she was very concerned about how she was going to take care of the girls. I thought, *Her life of struggle is over.* And I knew that because she believed in Jesus, she was in heaven.

The coroner mentioned that the driver had a disability. I work with students who have disabilities. The first thing I felt for the driver was compassion because, how is he going to get over this? We were not made to handle that kind of guilt.

The day after her funeral, a still small voice said to my heart, *Call the mom.* [her voice breaks] *Call the mom of the driver and let her know you're going to be OK. Mother's Day was coming up. How must she feel? Her son killed a single mom.*

I thought, *I can't tell my husband this. He'll think I'm crazy.* But the voice was urgent. So that day, I called her. I said, "This is Cathy, Anna's mom." There was quiet. I said, "I'm not calling about the accident or the case. I just wanted to let you know that we're going to be OK. We're going to get through this."

We had a lovely conversation. They believed in Christ, so we had a beautiful connection. We decided to meet with the driver and his mom and dad, my husband and I, the two girls, our pastors, and the attorneys.

The driver was going to write an apology and read it to us. That voice in my heart said, *Write an acceptance letter so that when the meeting's over, he and his family have something concrete to take home.*

We felt that he had the bigger burden to bear because he had killed somebody. When that young man read his apology to us in the meeting, we reciprocated. "We forgive you. We accept your apology." We all signed our names and exchanged letters, and that began a beautiful friendship between our families.

I have tried to think what the ripple effect would have been had we been bitter or vengeful or asked for that young man with intellectual disabilities to go to jail. Can you imagine how that would have affected their family? And our granddaughters? If the first thing they saw was that we were vengeful? How could they have ever gotten over this? I can't say he deserves revenge. I'm the same as him. I have the same sins. I get the same distractions when I'm driving.

This was in May of 2013. When I tell the story now, a lot of people ask, "How did you get there so fast? How did you forgive the driver?" I try to explain that there were foundational things in my life already—knowing Christ, reading the Bible, going to a good church, growing in my faith. My husband summarized it in four words: "We were already there."

We grieved, but not as those without hope. That hope carried us forward. In the end, when we got over our grief, we knew that Anna made it home. We let our hearts grieve, and we rejoice for her knowing we'll see her again. It's a sad story with a very happy ending. That's the way we like to tell it.

"My childhood consisted of so many life-and-death situations that they were practically impossible to count."

WANDA SKOWRON

81 | Historian, Poland

INTERVIEWED BY KATARZYNA HUSHTA, HER NIECE

I was a wartime child. My childhood consisted of so many life-and-death situations that they were practically impossible to count.

The Warsaw Uprising broke out when I was nearly eight years old. One death—among the many we children came to see close up because of gunfire and air raids—became for me a defeat full of helplessness and a suffering that could never be forgotten. The memory comes back to me, especially on days reminiscent of that autumn in 1944.

A few hours before the Uprising surrendered, we suffered another air raid. The residents of the Stairway B unit were trapped under the rubble. Everyone rushed to clear the debris, but there was no heavy equipment. The hours went by, then the night passed. We knew the trapped people were alive, but we could not reach them. In the morning, the building was surrounded by a military unit that was supposed to escort the inhabitants out of the city. We begged them to let us carry on, but all our pleas were of no avail. We were taken away. The survivors who were left behind included my playmate Maciuś, a joyful adventurer. Nobody knows how long they spent dying.

A few days after the Uprising, we were forced into freight cars that had no roofs. The evening was cold, with an unremitting drizzle of rain. A young girl, coughing and shivering, was leaning against a doctor's knees. I was sitting next to them. The girl asked, "Am I going to die?" "Yes, you are," he answered. "But don't be sad, do not worry. Your path has simply come to an end, and you'll be with God, healthy, with no fears and troubles." He was saying this with great confidence and a smile, and added, "A lot of hardships lie ahead of us. You are already safe." When dawn broke, the girl passed away. Her face was calm, serene. I have never forgotten the lesson it taught me.

Helplessness is one of life's most difficult experiences. It takes a lot of effort to accept our helplessness in the face of irreversible events.

POPE FRANCIS RESPONDS

Telling the truth to those who are at death's doorstep is truly important. We have to find a way to help our loved ones understand that they are going to pass away. It is terrible to deceive a person who is about to die. You can say, "Come on, keep going, do not give up!" That can help. But never say, "You will be healed!" This betrays the trust the other person has in you. The experience that Wanda describes is tragic, but she tells it in a consoling way. The doctor whom she speaks about showed the right attitude toward the young girl.

My grandmother had a prayer on the nightstand that she always wanted us to say: "See that God sees you, see that he is looking at you now, realize that you have to die, and you do not know when." Then it depends on how you live your life in light of this truth. If you live it poorly, you envelop yourself in fear. All you do is scare yourself. If you live it well, then you are getting yourself ready for an important moment. Death is one more step in life. If you are sure that the Lord will not betray you, then you can go forward with courage. The Lord himself will give you the grace to see life in death. There is an expression that I do not like: "the House of the Father" or "going back to the Father's House," as if our life was a round trip. It would be better to say: "Go to meet the Lord" or "I'm going toward that meeting." There will be a meeting or encounter at the end of life. It's a meeting I may or may not have had in life and it's a meeting that I've been looking forward to or not looking forward to in my life. But in the end, we will meet God face to face.

"The Lord himself will give you the grace to see life in death."

THOMAS V. KUNNUNKAL, SJ

91 | Former Chair of Education Board, India

I worked in the school systems in India for the first stage of my life. I held many titles and prestigious positions and worked for the Central Board of Secondary Education. While serving on this committee, I started a local program that helped millions of dropouts and pushouts across India receive continuing education. It has been a lifesaver for many.

I have now entered the second stage of my life. My titles are gone, and old-age disabilities have begun to appear. How do I respond to this change of state? How do I occupy myself now? I tell myself that my best years lie ahead of me. Do I mean this? Yes! I've begun to see clearly that the *internal stuff* makes the difference and brings quality to existence much more than the externals.

I also wonder what will be written in my book of life. I do not know for sure, but I can't imagine that the petty details of the many positions and titles I held will take up much space. However, I'm certain that helping give so many people a second chance to win in life through continuing education will be recorded.

As I approach my 91st birthday, thoughts about my date with death come to mind occasionally. Am I afraid to die? Yes, a little bit, but not much. I am ready for the call, as I firmly believe that death is the third stage of my life—a new, unending life with God and with others.

"My best years lie ahead of me."

TOM MCGRATH

68 | Writer and Spiritual Director, USA

I learned a lot about death and dying from my father in the last months of his life.

One evening in particular stands out. My daughter Patti and I had come to visit, and my mother told us that Dad was having a hard day. His pain medication wasn't working, but the hospice nurse—an angel of mercy—was on her way with a medication that would provide more relief.

We walked into my father's room, and I could see Dad was agitated and in pain. He forced a smile, but it was clear he couldn't get comfortable. The hospice nurse finally arrived, and soon my father was visibly relieved. He sank back into his pillows and settled into a restful sleep. Ten minutes later he woke up. He looked at Patti and then at me, happy to see us.

Then—I'll never forget—Dad winked at us and said in all sincerity, "All in all, we're in pretty good

shape." Wait, what? Clearly my father understood his situation: he was dying and there was more pain to come. And yet here he was saying, as if he was letting us in on a secret, "All in all, we're in pretty good shape." Was this just the medicine talking?

The truth is that I had heard those words from him so many times, a frequent refrain through the years. I looked at my daughter and was deeply grateful she was there to hear this message of faith and hope and blessing from her grandfather.

Even now, years later, my family still recalls those words when we're tempted to lose heart. Someone will break the spell of despair by saying, "Remember, all in all, we're in pretty good shape." And the truth is, we are. If we truly love, nothing—not even suffering or death—can separate us from the love of God—or one another.

LUDOVINA PACHECO

87 | Former Agricultural Worker, Brazil

INTERVIEWED BY GABRIEL FRADE

In 1948, I had my first experience of death. My grandpa, whom I loved very much, died.

The day before he died, my grandpa gave me a gift and asked me to pray for his soul because he was on the way to our Father's house. We talked a lot that evening. Very lucid, he repeated once more: "My dear, pray for my soul." I went home, and at four in the morning we received the news that he had died. I remembered then what he had asked me. Before she died, eleven months later, my grandma asked me the same thing. I was 18 years old.

Keeping my promise, I pray for them and for all my loved ones. Through them I saw that life is a passage. God permits us to live, but death is the passage from a life that ends to one that goes on for eternity.

Today I am 87 years old, and I keep praying every day for their souls. I know they also pray to our Father for me and are waiting for me.

"Death is the passage from a life that ends to one that goes on for eternity."

POPE FRANCIS RESPONDS

Ludovina's experience is one of communion with our deceased relatives or friends. Her simple witness tells us how believers live their faith simply: they feel near and close to their dear ones who have died. I, too, feel the need to talk to the dear deceased ones of my own life. Often have I asked forgiveness from those I hurt and who have passed on, especially if I was not able to do so when they were alive. I often pray before the Lord for my dear departed ones whom I loved in life. And I know that they pray for me. Sometimes there are so many difficulties, and I ask for help from family members who have met the Lord. This relationship comes and goes like a wave. Including the dead in our prayers is very important. If we see the experience of death in light of the communion of saints, the truth that we are all connected in the Lord, then it is quite natural to talk with them. You begin to see the world in a totally different way.

"I, too, feel the need to talk to the dear deceased ones of my own life."

GURI RYGG

75 | Retired Farmer and Nurse, Norway

I had a very special grandmother. We talked about the strangest things. The conversation I remember best was about life and death.

I was 10 or 11, and I thought Grandma was ancient. (She was probably about 60 at the time!) I thought it was time to ask whether she was afraid of death, since she was so old. Grandma looked at me and laughed a little to herself. She sat and thought. Then she asked, "Have you been inside Nidaros Cathedral?" Of course I had been there, I said.

"Did you notice the stained-glass windows?" she asked. We agreed that they were beautiful with all their bright colors. We thought about how those windows would look if the light did not shine through them. We agreed that they would have no color. They might even look gray.

"So it is with life," said my grandmother. "If death did not shine behind it, life would lose its colors."

Ever since then, I have thought of death as the light beyond that makes life shine. Death is not darkness but light.

POPE FRANCIS RESPONDS

Death always evokes the dark, the gloomy, the terrible. Death seems to be an opaque and black reality—total darkness. Guri's grandmother, however, showed her granddaughter what she was not able to see, because Guri did not have her wisdom. Guri's grandmother led her to see death as light, hope, an opening that brings us new light from the afterlife. To see the image of a colorful stained-glass window illuminated by a light coming from beyond is a beautiful experience. This is Christian death. It helps us see today through the light that comes from hope. This experience of hope lights up our life.

I remember an elderly lady. It was 1992, and at that time I was vicar bishop of the Flores area. We had a Mass for the sick. I heard confessions all afternoon before and after Mass. When I was about to stand up, I saw a tiny lady dressed in black approaching the confessional. She was Portuguese. Her eyes were bright. I asked her if she wanted to confess. She said, "Yes." I replied, "But you don't have any sins!" She replied bluntly, "We all have sins." And then I said jokingly, "In that case, be careful because who knows if God will forgive you!" And she replied, "God forgives everything!" "But how do you know this?" I asked. She said, "If God did not forgive sins, the world would have ceased existing a long time ago." God's forgiveness is the light beyond the window that makes all the colors visible. This woman saw hope bounding from eternity into our own day.

"God's forgiveness is the light beyond the window that makes all the colors visible."

What I Learned from an Elder

KERRY EGAN

44 | Author and Chaplain, USA

Six years ago, I met Jim. I was his hospice chaplain.

At our first meeting, he told me he had a message to get out to thousands of people. "I know what it feels like when the Holy Spirit has a job for me," he said. "I've got to get a message out, but how can I do it when I can't even get out of this recliner?"

Just the day before, a producer at PBS had asked if I had any patients who wanted to be on TV. I told her I couldn't imagine it would ever happen. It turns out my imagination isn't as big as the Holy Spirit's.

"Well," I said to Jim that first visit, "do you want to be on TV?" "Yes! Yes, I do!" he shouted.

On the day of filming a month later, Jim was so exhausted and sick that he couldn't keep his head up. "Let them in anyway!" he yelled when his wife Elaine answered the door. "This is my only chance!"

After the interview, I worried that Jim wasn't able to say what he needed because he'd been so weak. We had talked a lot that month, but Jim had never told me what the message was. The next day, I asked, hesitantly, if he'd gotten his message out.

He looked at me strangely. "Yes, of course."

"Good, good." I paused. "What was it, exactly?"

He laughed. "Well, all of you. Elaine, the nurse, you. You are the message. All of you who take care of me."

I didn't understand.

"The world needs to know that there are people out there who love you so much that they'll take care of you when you're sick. They need to know that the love is stronger than the sickness, stronger than the dying."

Jim died two weeks later.

Five years later, out of the blue, I got a message from Elaine. We talked about the things that had happened since Jim died. And, of course, we talked about their television appearance. Elaine said she never understood why Jim was so insistent on letting that TV crew in. I said that I thought he wanted people to see that love was real and strong, even though people get sick and die—that their love couldn't die.

Elaine grew thoughtful. "He talked to you so much at the end, Kerry. I know that was your job, and that Jim had a lot to get off his chest. I know you can't tell me all the things he told you." She paused. "But he didn't talk to me much those last few months. He didn't tell me. And I just really wish he had. I'm not surprised his message was all about love. That's who he was. But I wish he'd shared that message with me, too."

This is something I've heard before. I know how much patients love the people who care for them—the nurses, aides, and especially—especially—their families. Patients tell me all the time. But too often, the caregivers don't know it. They don't know how loved they are.

Yes, love is an action. But sometimes hearing it in words means everything. Sometimes, in the midst of dying, it might not seem like love is stronger than sickness; it might seem impossible that love is greater than death.

Jim's message was that love is stronger than sickness and even death. Elaine's message is that we must remind each other, over and over, that this is true.

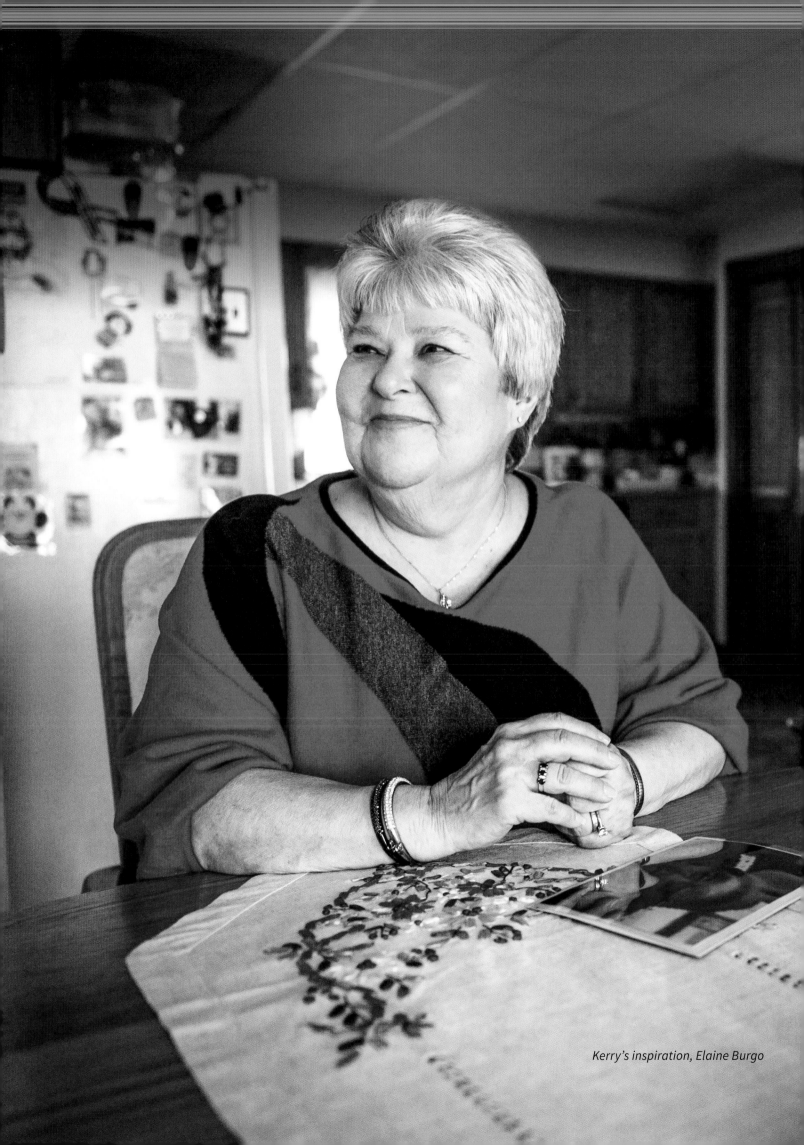

Kerry's inspiration, Elaine Burgo

"The hopes of a lifetime can be read in the wrinkles on the faces of older men and women. They are signs of blessing, of work, of a life that is offered, and of a hope that is lived."

—*Pope Francis*

HOPE

Pope Francis

I remember a lady who came to Argentina from France alone with her daughter. She risked a lot for a new life for her daughter. They boarded a ship off to a distant country where a different language was spoken—what courage. She was a laundress. She worked very hard even as she grew old and made friends with all the women in the neighborhood. At first, many things were whispered about this woman's past, but she carried herself with dignity. She was a lady. In time, no one would dare to speak badly about her. When I was a bishop, I often passed by the woman's house and always prayed for her because she was a woman of hope.

The hopes of a lifetime can be read in the wrinkles on the faces of older men and women. That is why we should be very fond of our wrinkles: they are signs of blessing, of work, of a life that is offered, and of a hope that is lived. Someone might say, "But this person has committed *this* sin" or "But this other has committed *that* sin." It is easy to judge a human life. But in the end, what I see are people who have lived. They can confess to having lived up to the end! And thinking about it does me much good. To behold wrinkles is, for me, a devotion. I always repeat what the great actress Anna Magnani said to someone who asked her if she planned to get a face-lift: "No, I do not want to; it took me a lifetime to acquire these wrinkles!" Hope can be read in wrinkles.

"Hope can be read in wrinkles."

MARGARET IRWIN WEST

91 | Artist, Ireland INTERVIEWED BY PAT COYLE

I was born in India, where there's great contrast of light and shade, so in my art I've always been drawn to what's called the chiaroscuro—Rembrandt, Caravaggio, and so on. I think that's what life is about: you can always find the light in the shadows even if it's just a tiny spark. And that is what gives you hope.

When things don't go right and you have bad experiences, you know you've got to come through it. That's hope. You wake up in the morning and the sun is there, but hope is what keeps you going. There could be hundreds of reasons you don't think you'll get through, but if you have that spark of hope, you'll follow it because it's light.

FRANCESCO INFANTINO

80 | Grandfather and Parish Director of Youth Ministry, Italy

INTERVIEWED BY ALESSIO GULINO, HIS GRANDSON

AG: Grandpa, I see that you go to church a lot, and I often see you with a Bible in your hands. Can you tell me what prayer means to you?

Francesco: Prayer is part of my daily life because I feel close to our Lord and feel great joy when I pray. To pray, Alessio, you need to be able to feel it inside you and transmit it to those people who are the furthest from Jesus.

AG: If you could ask Jesus a question, what would you ask him?

Francesco: I would really like to ask him what I could do to always be near him, but he would probably answer, "Continue to have faith and love." This is what I wish for the whole world and, above all, for you my grandson: to never drift away from faith. Let faith accompany you throughout your life.

> "Walking with hope comes from a life of faith sustained by prayer and entrusting oneself to the Lord."

POPE FRANCIS RESPONDS

For Francesco, faith is like a companion who walks beside him. He walks simply and with love and faith. That's his wish for everyone. Walking with hope comes from a life of faith sustained by prayer and entrusting oneself to the Lord. When you hope in the Lord and your life is marked by hope, it means you set your anchor deep and are clinging to the ropes. You are anchored in the Lord; you are safe. The image of hope for the first Christians was exactly this: the anchor. This is what comes to me as I read about the vision of life that Francesco shares with his little grandson Alessio.

I met Alessio! When he came here for an audience with other children, he asked me a question: "But you, Pope Francis, do you love Jesus?" I remember that burning question! It is the same question Jesus asked Peter. And I was being asked this question by a child. I felt a shiver. Today, I would answer him as I replied then: "I do not know. But what I do know is that Jesus loves me—very much." How can I dare say, with my limited abilities, that I love Jesus? He knows if I love him. He knows. However, I can say that I have no doubts about his love for me. I think Alessio's grandfather, Francesco, would understand my answer very well.

GABRIELA RESTREPO ACEVEDO

86 | Colombia INTERVIEWED BY ROSEMARY LANE

Editor's Note: *Gabriela has a disability that has progressed through the years. She has lived at a home for adults with disabilities for 10 years.*

When my parents died, I went to Medellin. I was seven years old. My aunt raised me. She took care of me when I had surgery on my leg. I couldn't

work. After my aunt died, I asked God not to leave me by myself. God's voice told me, "I am with you."

Nobody would believe that I heard a voice that said, "Gabriela, I am with you."

God brought me here. I am not alone. God never leaves us by ourselves.

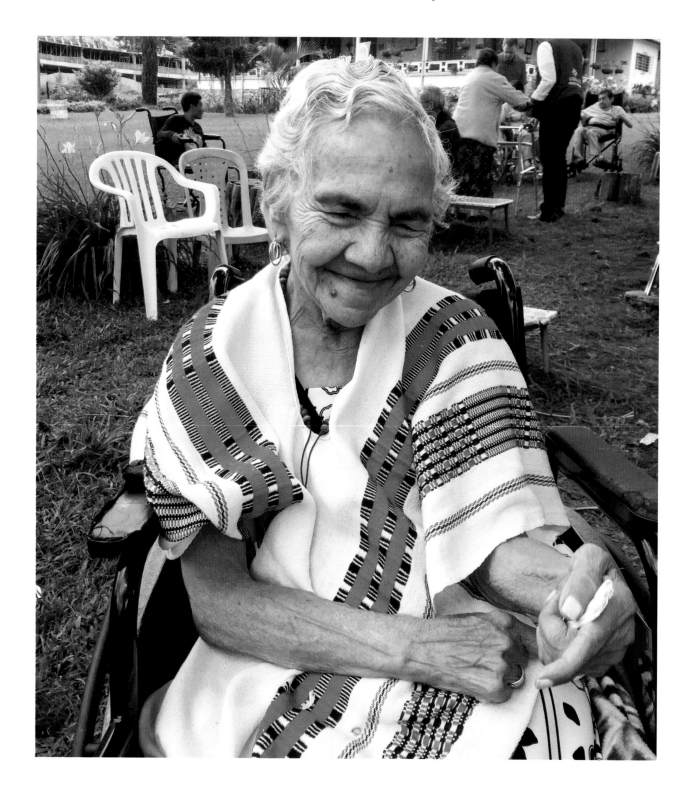

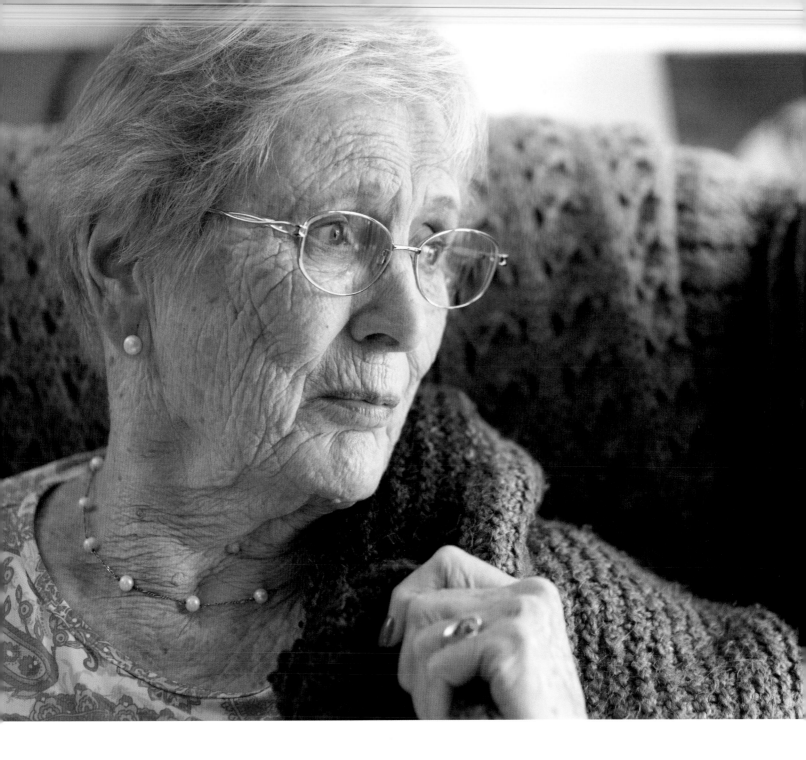

KAY THUERK

85 | Mother and Retired Business Owner, USA INTERVIEWED BY TOM MCGRATH

TM: That's a beautiful blanket. Is there a story behind it?

Kay: Yes, there is. [*takes the blanket into her hands*] I told you I am a survivor of stage 4 cancer. When I was first getting treatment, some friends made this blanket for me, and as they each worked on it, they would pray for me. They put their prayers into this blanket.

TM: It seems that it worked.

Kay: Yes. There's something about this blanket. When I would wrap it around me, I could feel their prayers [*pulls the blanket around her shoulders*] . . . even now.

TM: Kay, I know you are a believer. If you could ask God one question, what would it be?

Kay: "Stay with me. Please stay with me." [*she begins to cry*]

TM: And how do you think God would respond?

Kay: That's a good question. [*pause*] Well, I do think he is with me. [*smiles*] I think he's got his arm around me. And I think he will always be there. . . . He better be, or he's in trouble! [*laughs*]

DESMOND O'GRADY, SJ

76 | Chaplain, Dundrum Central Mental Hospital, Ireland

INTERVIEWED BY PAT COYLE

PC: I met you one day in Milltown Park last year, and you immediately said, "You will have to tell me your name, because I am not remembering names very well."

Desmond: I am very proactive like that, and why should I be embarrassed that I have Alzheimer's? It works best if I say, "Oh, I am sorry. I am suffering from Alzheimer's" or "My memory has gone."

PC: How did you discover that you had this disease?

Desmond: As soon as I would finish a job, I would forget all about it. I came to feel very awkward not being able to recount the moments in the day and what had happened and so on.

PC: It's quite moving that you are a chaplain at a mental hospital and are now suffering from your own brain dysfunction as well.

Desmond: Yeah, I think that helps me to be more aware of the disability of the patients who are suffering. Their challenges are more at an emotional kind of level, but they do realize that I have difficulty as well. That gives more ease between us and more acceptance.

I think the honest way I've been handling Alzheimer's for the past two years has been a gift to many people. People see they can get on with life without being fully healthy, fully perfect. They also see that, if you have disabilities, you don't have to deny them.

PC: How do you see God in your Alzheimer's diagnosis?

Desmond: It's not a rational answer; it's a lived answer. I live with God. I wish the Alzheimer's hadn't happened, but it has, and that's okay. I don't expect God to answer me in any normal form. I don't talk to him much, but I am aware of him all the time. And when I do forget him, I come back to him. It's just like a sick child falling into a mother's arms. The mother can't cure the disease—God doesn't seem to think that this is to be cured, OK—but I keep on trusting.

PC: People often define themselves by their memories. Your narrative has been totally disrupted. Has it changed your understanding of what it means to be a human being?

(continued on page 152)

"All those moments are what I would see as the kindness of creation. In so many ways they gave me life."

Desmond: No, memory itself hasn't disappeared; it's the short-term memories, the working memories, that go. I can still remember so vividly one evening down in Ballymartin when I was a boy. The night was pitch dark. There was nothing that I could see, and there were no lights at all. I was frightened out of my mind. I crawled to the bottom of the bed and looked out this little window at an explosion of light. I never saw such a starry night in my life. Now *that* memory will never go, and the whole lot of it is there. I can see the tiny window frame. I can see that brilliance, and there was life out there.

That made me say, OK, I live in a good place. There is someone there to rescue me, that's the cosmos being there for me. It was just a great moment. And I have so many memories. I don't know now if memory stays, but I almost feel a spring in my feet when I start taking a walk on my uncle's farm and going up through the fields. I can see when it comes near milking time that the cows start walking back to the farm and come in across from the gap of the field to meet me.

You know, all those moments are what I would see as the kindness of creation. In so many ways they gave me life. They still do. All those memories are very sharp.

PC: Looking at the way you are moved and energized telling those stories, they are *in* you.

Desmond: Yeah, there is that *hum*, which I think is a collective memory that seems to be with me all the time saying, "It is good, it is good."

"His illness seems to have given him a contemplative kindness."

POPE FRANCIS RESPONDS

Father Desmond is a chaplain who has an illness similar to what ails the sick people in his care. A situation like this really impresses me, because he speaks of Jesus in a very special way. Father Desmond very much resembles Jesus, who took upon himself all our illnesses. Jesus has drawn near to us not only through knowledge or through words or with a beautiful plan for life but also through our illnesses. He made those illnesses his own. Jesus carried all our sufferings and diseases with him to the cross. Christ serves by suffering, because he shares the same conditions as those he intends to heal. Father Desmond, therefore, gives so much hope to the people who are near him and to those who are like him. It is also wonderful to see how his illness seems to have given him a contemplative kindness that is even able to touch memories. All this deeply impresses me. I sense hope in this situation, despite everything.

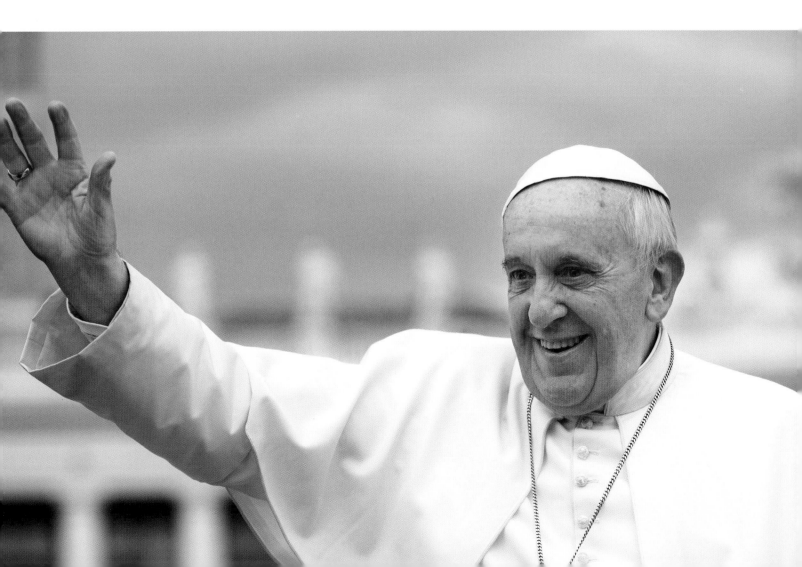

> "In my mind, I often have a conversation with God in sign language."

PETER BROADBENT

75 | Father and Member of a Catholic Deaf Club, UK INTERVIEWED BY PETER MCDONOUGH

A deaf couple I knew asked me to give them a lift to the Catholic deaf club for about two months because the husband was recovering from a heart condition. I took them and used to wait for them in my car. But one Sunday, after having waited for a long time, I gave up and went and knocked on the door.

One of the sisters opened the door and asked me to go in rather than wait in my car. I saw the deaf community, but I felt unsure and out of place. However, in time I got to know them and, being deaf, felt drawn to their Mass in sign language. I began to attend regularly. I waited seven years

before I decided to become a Roman Catholic. One of the priests gave me instructions in sign language. I was then received into the Church. I felt good within myself and realized that faith was important. I took the Church's teaching more seriously. In my employment, I worked long hours and often worried about my family. I would pray to God, sharing any other worries I had. In my mind, I often have a conversation with God in sign language.

Communication in sign language is so very important. If there were no Church service in sign language, I would be completely lost.

MARIA SOERINAH HOETOMO

78 | Grandmother, Indonesia INTERVIEWED BY VICTIMA PASKA PENTA HAPSARI

My husband and I took steps to ensure the future of our children. We invested and allocated large sums of money for a business. But our business failed, and our investment was lost. Our family fell into severe economic hardship, and my children's future was threatened.

I protested to God. I was angry with him. I felt he was unfair to my family. I did not want to go to church, and I did not pray anymore. I did not want to communicate with the "evil" God. Then one day I found an image of a cross torn in two on the floor in our home. I picked up the pieces and taped it back together. I did not know who tore it up and left it scattered there. However, the event that day changed everything. I cried, staring at the scarred image of the broken cross. I remembered the suffering of Jesus. It was like I was seeing his sorrow and pain right in front of me.

Tears fell from my eyes. I spoke to Jesus with all my heart and asked to pass through my suffering just as he passed through his death on the cross. He answered me. After that, my whole life was awakened, a clear mind returned, and I felt guided to rise from adversity. My husband and I survived the entire struggle with God's compassion, a compassion that I cannot explain.

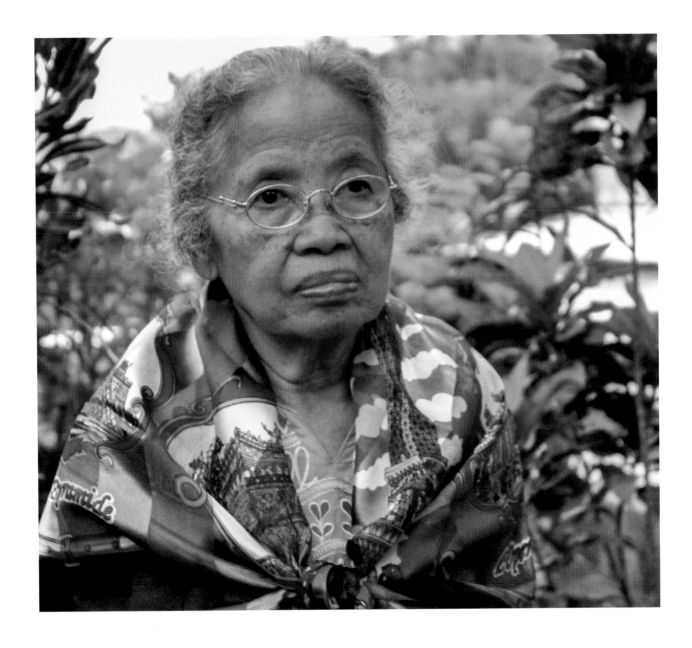

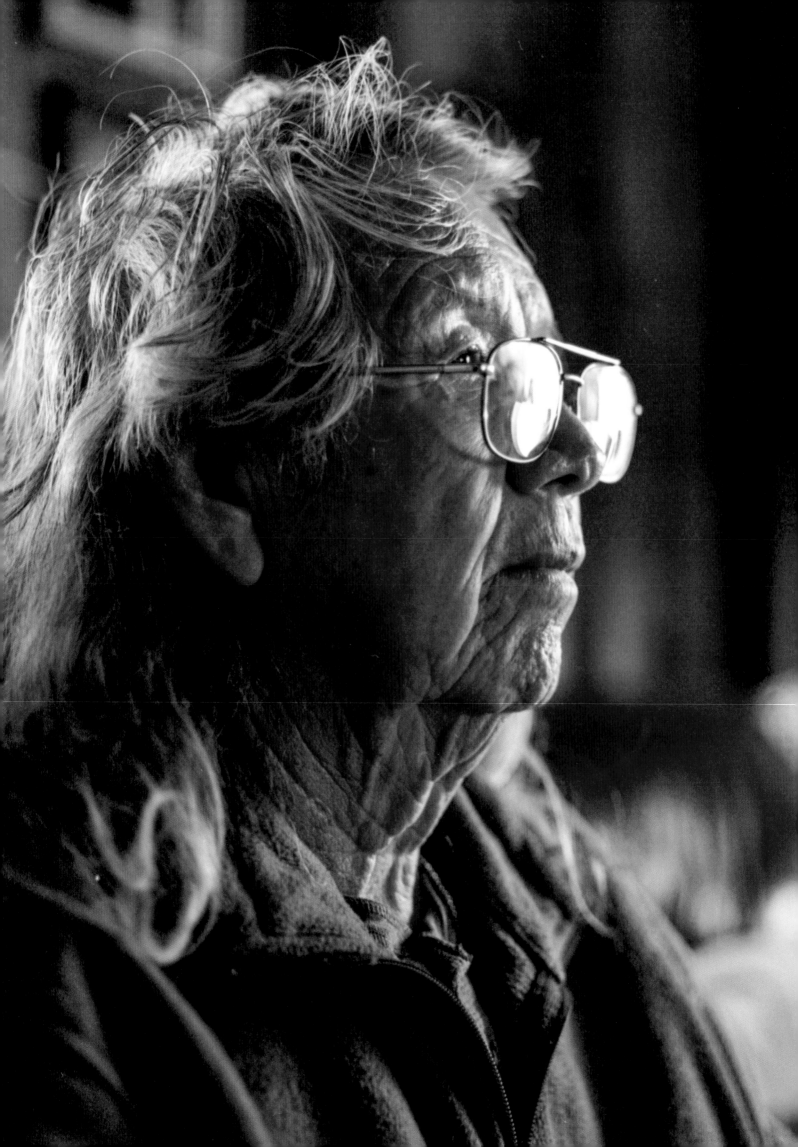

BASIL BRAVE HEART

84 | Spiritual Elder of the Lakota People, USA

INTERVIEWED BY GARRETT GUNDLACH, SJ

There's a lot of medicine that my grandmother taught me. We use the word *medicine* to mean "a way to live," and one way is forgiveness. I will give you an example. When my grandmother was teaching us about Wounded Knee, she said, "Grandchildren, there is something that was very difficult that happened to our people that I want to share. But the purpose of this teaching is not to have you hold any malice or hate in your mind or in your heart or in your soul for the people who did that. The Long Knives—that's what you call the cavalry—killed close to 300 of our people—women and children, all the people in Wounded Knee, South Dakota, not very far from where we live.

"And so my teaching is, I want you to pray for them. I want you to pray for our people and pray for their families who lost their lives. I want you to pray for the Long Knives who committed this. I want you to pray for their mothers and fathers and their grandparents."

(continued on page 158)

"We don't have to hate and retaliate and avenge these things that happened to the Lakota people."

"We're going to take what we need and leave some for someone else."

Then my grandmother said something that Christ said on the cross: they don't know what they did. They will have to live with this. We don't have to hate and retaliate and avenge these things that happened to the Lakota people. The Creator has a way to do this, but believe me, it would be done with compassion and love. That's the way, the way we want."

Here's another time my grandmother taught me about forgiveness. We used to go out and pick cherries and plums. Before we started picking the fruit, she would take a little bread and some dried meat, and we would go sit down on the canvas, and then she'd make a prayer: "These plums are our relatives, and we're going to pick them in a very careful, kind, and sacred way. I don't want anyone to break any branches. We're going to take what we need and leave some for someone else." That's an ecological, spiritual way of living. So, everything was spiritual.

Then she said, "When you were going up, somebody stepped on flowers—not on purpose. On the way back, follow your footsteps, see if you can find that flower. Then stoop down and smell it. Because you stepped on the flower, is it going to withhold its fragrance? No, it must still share it. That's nature's way of forgiveness. Even though you stepped on it."

> "We need to cultivate the ability to see that which opens our hearts to hope for a better world."

POPE FRANCIS RESPONDS

Basil speaks of his rapport with creation, a relationship marked by dialogue and a sense of friendship. Everything is connected. But to grasp these connections, we have to follow the path of contemplation and beauty. We often forget the way of beauty, even though it is a great way to reach God. We may prefer the path of truth and want to understand everything, or perhaps we want the path of good. All of this is fine. However, we can neglect creation and neglect the path of contemplating the beauty of creation. It is a close and simple path. We teach children to think and to do good deeds, but we do not teach them how to contemplate

the beauty of God's creation and all that comes from his hand. This contemplation engenders a sense of reverence and respect and harmony.

Honestly, I also think that beauty has the ability to forgive. What I mean is that beauty has the ability to put whatever is ugly into context. Beauty saves what is not beautiful from exile and "forgives" it. This is evident in art. We need to cultivate the ability to see that which opens our hearts to hope for a better world.

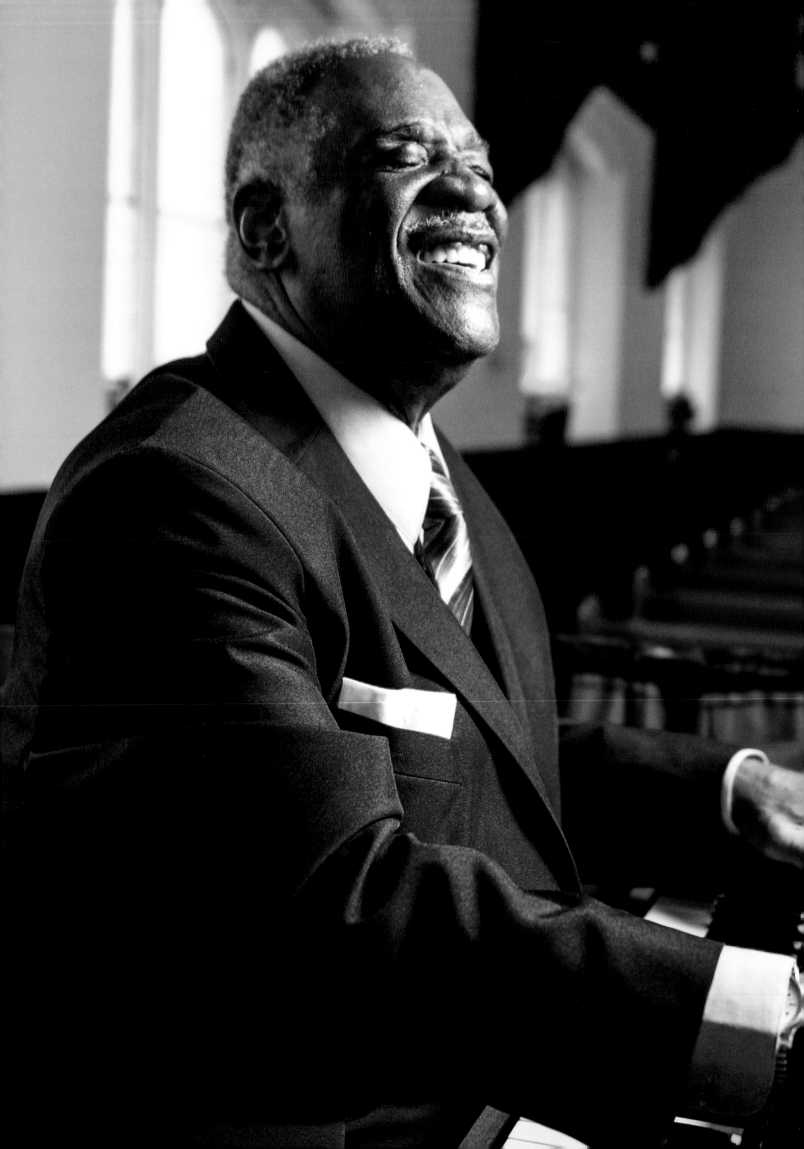

EARL FROST

75 | Pianist, USA

INTERVIEWED BY ELAINE HARTONO

EH: What have you learned about faith that you want other people to know?

Earl: I think my faith grew the most when I left home and came to Boston. I knew nobody. I wasn't going to church at the time. If somebody wanted to hire me to play the piano at a church, I'd go, but I was looking for money. Don't play with my money! But they told me I had a gift, and a gift comes from God. People would say, "Earl, come on up and play this song!" I'd look around, and people who had all sorts of degrees would be there. I'd say to myself, *Why are they asking me to play?*

I ended up playing for three churches. As I grew, I found that I enjoyed it. I saw that people appreciated the gift I had, and then I really started appreciating it. So I said, *I'm gonna do the best with whatever I got.* And that's what I've been doing. I've been at this church for 40 years. We've had more than 10 musicians, but I'm still there.

EH: Wow, that's amazing. Anything else you'd like to say about faith?

Earl: I just believe that God can do anything. And I think anything you ask, he'll do it for you. But I better hush, 'cause I'm gonna cry if I keep on talking. [*laughs*] When I first came here, I had to reach out to people. I found people would accept me. People would come out of the clear blue sky and help me. That's how my faith increased so much. God has blessed me.

EH: It sounds like he's blessed you most through the people he surrounds you with.

Earl: Yes, most of the people that are around me— I guess they like me.

EH: Oh my gosh, Earl, they love you!

Earl: They help me a lot, though! That's why I have so much faith in people. People tell me, "You shouldn't have so much faith in people." But I have faith, I take my chances, and just treat people the way I'd like to be treated.

MARIA GABRIELLA PERIN

71 | Mother and Grandmother, Italy INTERVIEWED BY MARIA LA GIGLIA

I was born in northern Italy in 1946, the year after World War II ended. My father had been a soldier in the war, and my mother, praying fervently that he would return, decided that if she had a daughter after her supplications were answered, she would name her Maria. So this is how my name came to be. However, my family's happy ending was short-lived. After I was born, my father succumbed to a grave illness due to an injury he suffered during the war. He died when I was just nine months old. I was raised by a single mother and never knew or remembered my dad.

When I was older, barely a woman, I got a job at a factory and eventually fell in love with a gentleman who did business there. With him, I felt affection, acceptance, and a *simpatico,* but the circumstances were such that it was an impossible relationship. We must have broken up and reunited a hundred times, and the incessant state of crisis and longing tortured my emotions.

The relationship was not severed once and for all before it resulted in a child—a son and the only child I would have. I named him Davide. I raised him as a single mother, just as my mom did for my siblings and me. It was difficult and isolating, but my son grew up to become a fine person. I brim with pride over him.

I often recall the sacrifices and trials I endured to raise my son. Would I say I have regret? I really cannot because this is how it happened. I know that if I'd had a father, my life might

have taken a different course. I probably would not have been drawn into that relationship, but then I would not have Davide. In turn, my son would not be here to await the arrival of his own child, who will be born soon. So now I have a legacy as well. And although it happened in my elder years, I eventually did find love again and married a man who is a treasure.

What I know is that God makes stories. In his genius and mercy, he takes our triumphs and our failures and weaves beautiful tapestries that are full of irony. The reverse of the fabric may look messy with its tangled threads—the events of our lives—and maybe this is the side we dwell on when we doubt. But the right side of the tapestry displays a magnificent story, and this is the side that God sees.

POPE FRANCIS RESPONDS

I like what Maria Gabriella says about the tapestries of God. What complicated stories we live! Threads are woven. And sometimes we understand, and sometimes we do not understand what we are experiencing. But God looks at us with the eyes of a creator and of an artist who is capable of organizing our mistakes, our sins, and the good things as if they were all parts of a tapestry. On that tapestry, there is good and bad, death and life. If I look at my life, I like to think that the Lord would say with a smile, "Look what I did with all your mistakes!" When older people gaze on life, often they know instinctively what lies behind the tangled threads. They can sense the shape.

Often, mistakes are the raw material of miracles. Peter's mistake of denying Jesus led him to the miracle of tears. The mistake of the prodigal son showed the mercy of the father. The mistake of the lost sheep revealed God's care and desire to bring each sheep home. Matthew's greed brought about the miracle of the banquet, which scandalized the Scribes. Hypocrites will be scandalized by the miracles God works with our mistakes. The hardhearted will be scandalized, and they will want to prevent the miracle. This happens even today in the Church. I think of the woman caught in adultery: the Lord performs a miracle and overturns everything. Reversing the situation is one of the most wonderful ways God acts in our lives.

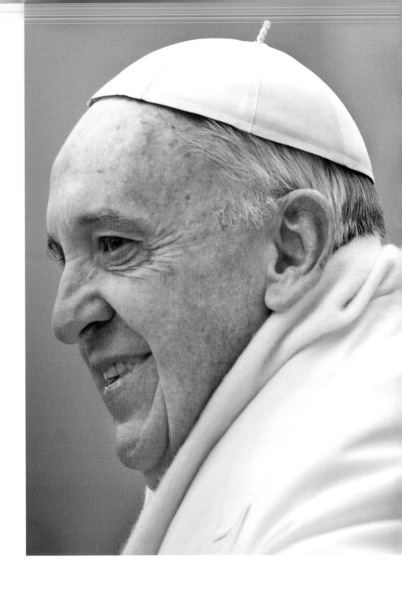

"Reversing the situation is one of the most wonderful ways God acts in our lives."

FIORELLA BACHERINI

83 | Language Teacher, Italy

When you are young, you feel strong. You have so many commitments, work, family. You are running after many things, and you are less likely to notice the needs of other people. At least that's what happened to me. As you age and life situations change, you begin to feel a sense of loneliness and sometimes even sadness knocking at the door of your heart.

Still, in spite of this, there is a flame that continues to burn, that continues to make us want to live and seek genuine human relationships, that continues to keep us desirous of hope. And despite the difficult situations we experience, there are reasons to be hopeful. Being useful to others is a great strength that allows us to continue to live serenely with a vision for the future. In the world around me, I find hope in

seeing how some of the foreign children I teach Italian to have asked us to help people living on the street. They've brought meals to those who have no homes and to those who have lost their jobs, including many Italians.

Indeed, it is true that today we are witnessing continued violence in the world and in our societies. Having experienced World War II and the negative consequences it brought to society, I would like to emphasize to everyone, particularly to those who are also elderly, the importance of peacemaking in human relationships, always, on every occasion.

I believe that elders, starting from our experience of life, have the task of bearing mildness and peace in our societies.

ANA MARIA DE CASTRO SANTOS

65 | Catechist, Brazil INTERVIEWED BY SR. SHEILA CAMPBELL, MMM

When I was 13 years old, an Italian missionary named Anna came to Brazil. We began walking around the neighborhood, making house visits to see the condition of the families in our parish.

On one of these visits we found a young woman with four children who had nothing to eat. The mother was crying and showing us the empty pots. I looked at Anna, and she looked at me. There was a lady nearby selling jackfruit, and we asked the lady for a piece. Anna shared the jackfruit with this family. The young woman was glad because the children ate, and she served the jackfruit with flour. It was a great feast! When we left the house, we said that God really used us to spend that hour with this family. Anna went back

and took the young woman's basic details. Then she brought her to the community center and gave her a food basket. In the end, this woman continued working in our community center to help raise her children.

This was a very strong experience of faith for me. If Anna and I had left and gone to her house for lunch, where would that family be? Anna did not worry only about that immediate day, but she got work for the young mother so that she would not go through this difficulty again. Anna told me, "Do not work with people and not live within their reality." I think that to live our faith in Jesus, we have to live it in the midst of people—not faith in the heights.

MOTHER GILCHRIST, OCSO

70 | Trappistine Prioress, Norway

When I was a young sister, I tended to complain. It can still happen from time to time if I don't watch it. The difference now is that I am happy and content.

I can tell you the week this changed. I was in my 40s. There was special work needed for our order, and I was one of the candidates. When the time came, however, I was not chosen. I was bitterly disappointed.

My superior suggested I spend three days alone in prayer at a hermitage on our property. While there, I received a grace that has influenced me ever since. This is the prayer that came to me:

"Jesus, I praise you and thank you for the miracles and wonders you work in my life and for your perfect plan for me."

This prayer completely lifted my spirits. The more I prayed it, the more my life became filled with happiness and peace. Now, as superior of my community, I find myself praying this prayer for each of the sisters in our community every day by name. I also teach the prayer to those who visit our monastery seeking counsel and advice. Many of them have really benefited from this grace I received almost 30 years ago.

"Praise disposes you to have the ability to see things through different eyes."

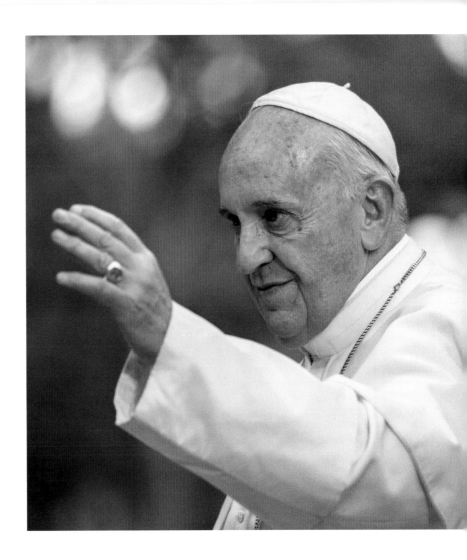

POPE FRANCIS RESPONDS

Mother Gilchrist had a difficult time, and I understand it. Hope is the engine of life, but sometimes we cling to temporary or provisional hopes. It's very much like traveling on a train. We see a station that we like, and we want to get off. But that is not our final destination. If we are thwarted from doing what our passing hopes stir up in us, we end up with complaining hearts. But complaining rusts out the soul. It makes us sad. Then life itself becomes a litany of muttered complaints.

But Mother Gilchrist went on a retreat and experienced an inner wake-up call. Her turnaround happened because of her prayer of praise. Complaints can be driven away with prayers of praise, which are very powerful. But when we pray the "Gloria," do we know that we are praising God with the angels? If we only thought about it! Praise disposes you to have the ability to see things through different eyes. A sense of humor is another result of praise. Where there is a sense of humor, there are no complaints. It was said that the Jesuit General Father Peter-Hans Kolvenbach had an exceptional sense of humor. He knew how to laugh at himself, at others, and even at his own shadow!

MARIJKE ELSENBURG

76 | Former Social Worker, The Netherlands

INTERVIEWED BY NIKOLAAS SINTOBIN, SJ

"I want to end it," I said to him. I had known Clemens for a year and a half, and we were officially engaged. One evening we went out for dinner together. I loved Clemens. But without really knowing why, I felt I needed something else. *There will be someone else,* I thought. As it turned out, I have gone through life unmarried. I don't regret it. Was I called, then, to religious life? No, my freedom was too precious to me.

Years later, Debby, the daughter of a good friend, came to visit. She had just discovered that she was unintentionally pregnant. I held back from saying much; I only listened. I was just there, for her and with her. There was trust. She felt welcome and safe. The picture of her daughter now hangs in my living room.

People often tell me: because you are unmarried, you can do what you want. That is not true. Freedom, I have learned, is synonymous with availability for others. As a Christian, I know that God's hand rests on my shoulder and that he does not always do what I want. He's just there for me. In the same way, I want to be there for others. That's my place in the world and in the Church.

What I Learned from an Elder

JOHN NYAGI

32 | IT Manager, Kenya

Three years ago, I was having lunch with my mother, and she asked me how work was going. At the time, my company was downsizing, and I was worried about keeping my job. My mother told me that there is more to life than having a job and that the two most important aspects of life are religion and family. She encouraged me and said I had enough experience to start my own company.

She also reminded me that life will always present hardships and that, sometimes, I will have to accept situations that aren't going my way. But I should always have courage and keep praying. She advised me to pray for a good spouse and healthy children and to always put God at the center of my life.

Behold! Three years later I have a thriving technology company. I have a loving wife, and we are hoping to have children soon. My faith has never been stronger, as I continue to put God in the center of everything I do. I found my purpose in life, and I am happy living it every day.

MIDGE SWEENEY

77 | Quilter and Grandmother, USA INTERVIEWED BY JANE KNUTH

My daughter, Elizabeth, died from cancer after eight years of fighting it every inch of the way. Elizabeth was a medical doctor, happily married, a mother of five children at home, and a religious-education teacher at her parish. During her struggle, I felt that God was not answering our prayers for her healing. Yet I saw God's presence in all the support she received from family and friends, her church members, and the larger community of bloggers and moms who have children with Down Syndrome and children with rare metabolic disorders.

As my daughter's condition worsened, I couldn't pray. Any attempts at meditation or spiritual reading led me to thoughts that made me sad. So, I went back to prayers I had memorized years ago and concentrated on finding small things to be grateful for.

My prayer each morning is this: "This is the day the Lord has made; let us be glad and rejoice in it." I pray this because, even if the day turns out to be not so good, I still want to find some reason to be grateful.

GREG BOYLE, SJ

63 | Founder of Homeboy
Industries, USA

INTERVIEWED BY ROSEMARY LANE

Editor's Note: *Homeboy Industries offers training and support to previously imprisoned men and women and former gang members.*

RL: If you could give a message to the kid who feels a sense of shame and disgrace, what would you say? What would you want to say to the person reading this who feels unworthy of God's love?

Greg: We never have to change God's mind about us. People get stuck on the one-false-move God. That's part of our hardwiring—one false move, and I'm going to put the smash down on you. That we're always just this side of disappointing God. I believe that God doesn't want anything *from* us. He only wants *for* us.

I remember giving a talk once; there was a little kid named Diego sitting in the front row. He was the only kid in the whole thing. He was 10 years old and howled with laughter at anything I said that was funny. At the end, I told a story that's heartbreaking about enemies who work together. One of them gets beaten to death when away from work and the other one says, "He wasn't my enemy, he was my friend. We work together."

Well, the kid is sobbing. He is just wailing, rocking, crying. He was having some kind of an out-of-body experience. I'm looking at him and still finishing my talk. Just as I'm doing that, his mother slowly puts her hand over him. The minute she makes contact with this kid, it's a showstopper. He turns to her and goes, "WHAT?" I stop speaking, and everybody turns and looks at him. He looks at his mother. *"What?"* Well, anybody who has ever been an adolescent or raised an adolescent, you know exactly what that is: finish that sentence. "What do you want from me?" "What have I done that's

(continued on page 172)

> "God doesn't want anything *from* us. God only wants *for* us."

embarrassed you?" "How am I not measuring up to your expectations?" That's our hardwired response to who God is.

But it was abundantly clear that the mother only wanted to communicate two things to this kid: "How did I get so lucky to have you as a son?" and "What breaks your heart breaks mine, too." That's it. So God doesn't want anything *from* us. God only wants *for* us. Even when we're being invited to the margins, it's still *for* us. It's joy because that's where the joy is—that my joy may be yours and your joy may be complete. But we think it's about produce and perform. "I wish you could do better than you're doing" or "Could you at least do more?" Nonsense. That's the total creation of God in our own image, but that's not who God is.

It's about being drawn to this God who just wants to love us, just wants to give us joy, just wants to return us to ourselves. And God wonders, what's all the measuring about? No matter what, you don't have to change my mind. It's already set. I already think you're great. There is nothing you can do that will make me feel less about you, ever. Ever.

> "Faith is not paying a toll to go to heaven."

POPE FRANCIS RESPONDS

Father Greg is an educator and knows that young people can be restless. This, however, also tells us something about ourselves. Sometimes we are also restless, and our restlessness manifests our need to break out of rigid frames of mind. Is my heart open or closed? Is it locked up in a kind of museum of set knowledge and hard-and-fast methods? Even our restlessness does not separate us from God if we are open to his grace. He puts his hand on our head.

Greg speaks to us about the utter graciousness of God that frees us from the false ideas about him that get formed in our minds. Faith is not paying a toll to go to heaven. We don't pay for salvation. Faith means going forward by God's freely given grace. He only wants to love us and to give us back to ourselves. God does not want anything "from" us; he wants everything "for" us. Salvation has no price, and I cannot save myself just with my own efforts. To speak about the grace of God is to speak about a great mystery. It welcomes us and sets us free to grow, starting from just where we are and from just who we are.

Franciscus

ACKNOWLEDGMENTS

A project of this magnitude involved the help of many hands. We are forever indebted to the global team who helped us gather the stories and images that make up *Sharing the Wisdom of Time.*

That includes **Unbound** (unbound.org), a nonprofit sponsorship organization, who dove into this project with reverence and generosity and who were, quite literally, a godsend: Andrew Kling, Loretta Kline, Liz Espino Reynoso, Larry Livingston, Dora Tiznado, Gabrelle Wise, Gina Paola Moreno, Alley Stonestreet, Xander Jobe, Mary Geisz, Jordan Kimbrell, Maureen Lunn, Claudia Vázquez-Puebla, Joe Sundermeyer, Scott Wasserman, Regina Mburu, Tristan John Cabrera, Daniel Perez, Diamond Dixon, and the rest of the Unbound staff, families, and elders all over the world, as well as their team in Colombia, Henry Flores and Mónica María Gómez Arias, who created an incredible immersion experience for Loyola Press staff members. Thank you, Elizabeth Hughes, for referring us to Unbound and for your support of this project. Our Jesuit publishing partners were also instrumental: Anja Celarec, Pat Coyle, Fr. Daniel Stevens, SJ, Juan Bernardo Ordoñez, Paulo Moregola, Milene Albergaria, Fr. Jerry Sequeira, SJ, Endang T. Lestari, Olaf Pietek, Edyta Drozdowska, Ramón Alfonso Diez, Tony Homsy, SJ, Stéphane Dupuis, Jean Hanotte, and Charles Delhez, SJ. A special thanks also to our early partners, Eddie Siebert, SJ, and **Loyola Productions Inc.** and **Little Brothers – Friends of the Elderly**.

We also want to acknowledge all the individuals who connected us to elders, including Mateo Arteaga, Jan Benton, Flavio Bottaro, SJ, Paul Campbell, SJ, Sr. Sheila Campbell, MMM, Conny Caruso, Phyllis Cavallone-Jurek, Jan Celarec, Sr. Sheryl Frances Chen, OCSO, Joellyn Cicciarelli, Maria Cuadrado, Maria Dolores Enríquez de Guevara, Bridget Gamble, Julianne Gazal-Rizk, Ceci Greco, Antonia Guaci, Garrett Gundlach, SJ, Josephine Hathway de Orellana, Thomas Howard, Maria Infantino, Sunny Jacob, SJ, Elizabeth Kaye, Subhash Khandelwal, Heather King, Jane Knuth, Maria La Giglia, Terry Locke, Chris Lowney, Jim Manney, Peter McDonough, Margaret McGrath, Chris and Mike Morkin, Elizabeth Muir, Martha Nyagi, Mary O'Meara, Ehi A. Omoragbon, SJ, Fr. Vincent Pereppadan, Gaston Philipps, María Catalina Mūnoz Soto de Philipps, Enid Sevilla, Nikolaas Sintobin, SJ, Jennifer Smith-Mayo, Fr. Antonio Spadaro, SJ, Larry Sutton, Jennifer Tan, Joseph Thera, José Victoriano, SJ, Kevin Virostek, Rachel Zhu Xiaohong, and Maura Zagrans.

Our sincerest gratitude goes to the man behind the camera, photographer Paul Audia, whose gift for capturing the dignity and majesty of a person shines through in each of his photos. Many offered their help to him along the way, including Andrea Abenoza-Filardi, Aída Abu Orabi Alarcón, Lucía López Alonso, Ivana Audia, his cousin, Paul Audia, Thomas Boland, Guido Bonelli, Mark Brady, Ricardo Carlucci, Melinda Carney, Anja Celarec, Pat Coyle, María Dolores, Elias Archelia, Jason Filardi, Maria Infantino, Magdalena González Parra, Katarzyna Hushta, Sr. Maria McCready, Fr. Jude Molnar, Julia Płaneta, Bonnie Reid, Łukasz Szczepaniak, Carol Tully, Giovanni and Giluia Vinciguerra, and Maura Zagrans. We also thank Luigi Faura, Tom Hopkins, Brigitte Lacombe, Lucy Lean, Jaclyn Lippelmann, Itânia Neri dos Santos, Ruby Rideout-Koprivica, Steven Sulewski, and Matthew Ryan Williams for their extraordinary photographs.

We couldn't have completed this book without a talented team of coordinators, editors, translators, and designers, including Donna Antkowiak, Kathy Burke, Fr. Louis Cameli, Elisa Ciaglia, Caitlyn D'Aunno, Joseph Durepos, Michael G. French, Becca Gay, Beatrice Ghislandi, Erica Jeffrey, Elizabeth Kennedy, Josef LaHood-Olsen, Serena Linguanti, Nikki Limper, Kevin McLenithan, Yvonne Micheletti, Bret Nicholaus, Beth Renaldi, Sol Robledo, Alexis Rueda, Irina Ruvinski, Joel Sanchez, Carrie Schuler, Kathryn Seckman, Wendy Dongwon Shon, Silvia Stangalino, Micol Werner, Kathryn Wilson, Mike Wincek, Vinita Wright, and Jason Zech. A special acknowledgment to Jill Arena, who used her incomparable creativity to envision a design for this book and then executed it with excellence.

We are also grateful for our own wisdom sharers who helped us steer this project forward: Joellyn Cicciarelli, Maggie Lane, Terry Locke, Gary Jansen, Santiago Cortés-Sjöberg, Maria Cuadrado, and Vinita Wright.

Most especially, we are grateful to Pope Francis for his vision for this project, his generosity in sharing his own life stories, and his deeply perceptive and appreciative responses to the contributors who shared their stories with the world. This book's creation is also due in large part to Fr. Antonio Spadaro, SJ, editor of *La Civiltà Cattolica,* the international forum on religion and culture published in Rome. We thank him for his creative partnership throughout the project but especially for his wise and sensitive sessions working with Pope Francis that elicited His Holiness's responses.

And finally, we want to thank the young people who answered our call to share what they learned from an elder, the interviewers who sat down with a family member or acquaintance, and the elders who showed a vulnerability and willingness to share that opened vaults of wisdom and grace. We hope their words continue to inspire generation after generation.

Wisdom Sharing

Help Pope Francis build a new alliance between the generations. Pope Francis believes that younger generations can find inspiration and guidance within elders' stories. By fostering more opportunities for conversation, you can invite the elders in your family, congregation, and community to share their wisdom. Visit sharingwisdomoftime.com to learn how.

In Your Family

Discover ideas and practical suggestions on how to spark conversations between the generations.

In Your Local Church

Celebrate the wisdom of the generations in your congregation. You'll find

- *suggestions for involving youth ministry, religious education, and senior groups;*
- *ideas for intergenerational events that focus on the wisdom of the elders; and*
- *ideas for youth service projects.*

In Your Community

Find ideas for connecting with local senior care centers, neighbors, and other elders in your community to help facilitate conversation and capture the dreams and hard-earned wisdom of elder citizens.

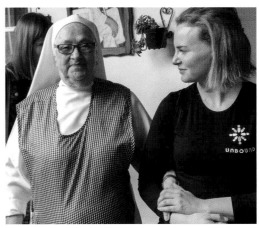

www.SharingWisdomOfTime.com

PHOTO ACKNOWLEDGMENTS

front matter

ii–iii giulio napolitano/Shutterstock.com. **iv** (l) Photo by Steven Sulewski; (c) Rosemary Lane/Loyola Press Photography; (r) Unbound.org. **v** (c) Photo courtesy of Fr. Antonio Spadaro, SJ; (r) www.audia.net. **vi** (left to right, top to bottom) Photo courtesy of Lucy Lean of LucyLean.com and author of *Made in America*; Unbound.org; www.audia.net; Photo by Jaclyn Lippelmann; Unbound.org; www.audia.net; Unbound.org; www.audia.net; Unbound.org; giulio napolitano/Shutterstock.com; Itânia Neri dos Santos; Rebecca Findley/Unbound.org; www.audia.net; www.audia.net; www.audia.net; Rosemary Lane/Loyola Press Photography; www.audia.net; Unbound.org; Photo © Tom Hopkins; www.audia.net. **8** Photo courtesy of Fr. Antonio Spadaro, SJ. **9** Photo courtesy of Fr. Antonio Spadaro, SJ. **10** Yannik Bikker/Shutterstock.com. **12–13** Boris Stroujko/Shutterstock.com.

work

14–15 © iStock.com/yavuzsariyildiz. **16** giulio napolitano/Shutterstock.com. **17** Photo courtesy of Lucy Lean of LucyLean.com and author of *Made in America*. **18** Unbound.org. **19** giulio napolitano/Shutterstock.com. **20** Rosemary Lane/Loyola Press Photography. **21** (t) www.audia.net; (b) Photo courtesy of Joan Lawson. **22–23** www.audia.net. **24** (l) www.audia.net; (r) Photo courtesy of Jesús Landáburu Sagüillo. **25** giulio napolitano/Shutterstock.com. **26** Rosemary Lane/Loyola Press Photography. **27** (t, b) Unbound.org. **28–29** Unbound.org. **30** Unbound.org. **31** Drop of Light/Shutterstock.com. **32** Photo courtesy of Sunny Jacob, SJ. **33** Diamond Dixon/Unbound.org. **34** Photo by Jaclyn Lippelmann. **35** Philip Chidell/Shutterstock.com. **36** www.audia.net. **37** (t, b) Unbound.org. **38–39** Unbound.org. **40** Unbound.org. **41** neneo/Shutterstock.com. **42** © Brigitte Lacombe. **44** Fred W. McDarrah/Getty Images. **45** neneo/Shutterstock.com. **46** (t) Photo courtesy of Julianne Gazal-Rizk. (b) Photo courtesy of Thomas Howard. **47** Unbound.org. **48** Rosemary Lane/Loyola Press Photography. **49** giulio napolitano/Shutterstock.com.

struggle

50–51 © iStock.com/JimmyFam. **52** Polifoto/Shutterstock.com. **53** Unbound.org. **54** www.audia.net. **55** giulio napolitano/Shutterstock.com. **56** www.audia.net. **58** www.audia.net. **59** giulio napolitano/Shutterstock.com. **60** (t) Photo courtesy of Yvan Boquet; (b) Unbound.org. **61** www.audia.net. **62** www.audia.net. **64** www.audia.net. **65** praszkiewicz/Shutterstock.com. **66** Photo courtesy of Hannah Ng. **67** Rosemary Lane/Loyola Press Photography. **68** Photo courtesy of Ignacio Guzmán Burbano. **69** giulio napolitano/Shutterstock.com. **70** www.audia.net. **71** Unbound.org. **72–73** Unbound.org. **74** Unbound.org. **75** neneo/Shutterstock.com. **76** Unbound.org. **77** Unbound.org. **78** www.audia.net. **79** MikeDotta/Shutterstock.com. **80** (t, b) Unbound.org. **81** www.audia.net. **82** www.audia.net. **83** neneo/Shutterstock.com. **84** Photo courtesy of Shemaiah Gonzalez. **85** www.audia.net.

love

86–87 © iStock.com/jacoblund. **88** neneo/Shutterstock.com. **89** Rebecca Findley/Unbound.org. **90** Photo courtesy of Cedric Prakash, SJ. **91** giulio napolitano/Shutterstock.com. **92** Unbound.org. **94** www.audia.net. **95** giulio napolitano/Shutterstock.com. **96** www.audia.net. **97** Photo © Tom Hopkins. **98–99** www.audia.net. **100** www.audia.net. **101** neneo/Shutterstock.com. **102** (t) Photo courtesy of Dr. Gopal K.R.; (b) Unbound.org. **103** www.audia.net. **104** www.audia.net. **106** www.audia.net. **107** giulio napolitano/Shutterstock.com. **108** © iStock.com/Nredmond. **109** © www.rubyrideout.com. **110** www.audia.net. **111** Andrew Kling/Unbound.org. **112** (t, b) Photo courtesy of Klaartje Merrigan. **113** softdelusion66/Shutterstock.com.

death

114–115 © iStock.com. **116** giulio napolitano/Shutterstock.com. **117** Unbound.org. **118** Unbound.org. **119** Drop of Light/Shutterstock.com. **120** www.audia.net. **122** www.audia.net. **123** Drop of Light/Shutterstock.com. **124** (t) Unbound.org; (b) Photo courtesy of Igor Chezganov. **125** Photo courtesy of Kathleen Kenny. **126** www.audia.net. **127** giulio napolitano/Shutterstock.com. **128** (t, b) Photo courtesy of Antonio de Jesús Rodríguez Hernández. **129** www.audia.net. **130–131** www.audia.net. **132** www.audia.net. **133** giulio napolitano/Shutterstock.com. **134** Photo courtesy of Sunny Jacob, SJ. **135** www.audia.net. **136** Photo courtesy of Gabriel Frade. **137** giulio napolitano/Shutterstock.com. **138** Photo courtesy of Sr. Sheryl Frances Chen, OCSO. **139** Polifoto/Shutterstock.com. **140** Joshua Aaron, photo courtesy of Kerry Egan. **141** Photo by Steven Sulewski.

hope

142–143 www.audia.net. **144** giulio napolitano/Shutterstock.com. **145** www.audia.net. **146** www.audia.net. **147** giulio napolitano/Shutterstock.com. **148** Rosemary Lane/Loyola Press Photography. **149** www.audia.net. **151** www.audia.net. **152** www.audia.net. **153** neneo/Shutterstock.com. **154** (t, b) www.audia.net. **155** Photo courtesy of Maria Soerinah Hoetomo. **156** © Matthew Ryan Williams. **158** Photo courtesy of Garrett Gundlach, SJ. **159** Drop of Light/Shutterstock.com. **160** Photo by Steven Sulewski. **162** www.audia.net. **163** giulio napolitano/Shutterstock.com. **164** Photo courtesy of Francesca Fattorini. **165** Itânia Neri dos Santos. **166** (t, b) Photo courtesy of Sr. Sheryl Frances Chen, OCSO. **167** Polifoto/Shutterstock.com. **168** (t) Photo courtesy of Robert Kibi; (b) Photo courtesy of Nikolaas Sintobin, SJ. **169** www.audia.net. **171** www.audia.net. **172** www.audia.net. **173** giulio napolitano/Shutterstock.com.

end matter

175 (t) Rosemary Lane/Loyola Press Photography. (c) Andrew Kling/Unbound.org. (b) Andrew Kling/Unbound.org.

A special thanks to Unbound.org for photos throughout.